Mark Gonzales

Photographs by Sem Rubio

Art, Poems, and Skateboarding by Mark Gonzales
Created and Photographed by Sem Rubio

First published in the United States of America in 2020 by
Rizzoli International Publications, Inc.
300 Park Avenue South
New York, NY 10010
www.rizzoliusa.com

Copyright © 2020 Mark Gonzales and Sem Rubio

CASCADE

For Cascade:
Editor: Lou Andrea Savoir
Designer: Albin Holmqvist
Producer: Julian Dykmans
All photography by Sem Rubio unless otherwise stated.
All interviews by Lou Andrea Savoir unless otherwise stated.
www.cascade.berlin
www.semrubio.com
www.albinholmqvist.com

For Rizzoli:
Publisher: Charles Miers
Editor: Ian Luna
Project Editor: Meaghan McGovern
Design Coordinator: Olivia Russin
Production Managers: Barbara Sadick and Maria Pia Gramaglia
Copy Editor: Angela Taormina
Proofreader: Sarah Stephenson

Printed in Italy

2020 2021 2022 2023 / 10 9 8 7 6 5 4 3 2 1

ISBN: 978-0-8478-6870-4
Library of Congress Control Number: 2020937374

Visit us online:
Facebook.com/RizzoliNewYork
Twitter: @Rizzoli_Books
Instagram.com/RizzoliBooks
Pinterest.com/RizzoliBooks
Youtube.com/user/RizzoliNY
Issuu.com/Rizzoli

Mark Gonzales

Photographs by Sem Rubio

RIZZOLI
NEW YORK

New York · Paris · London · Milan

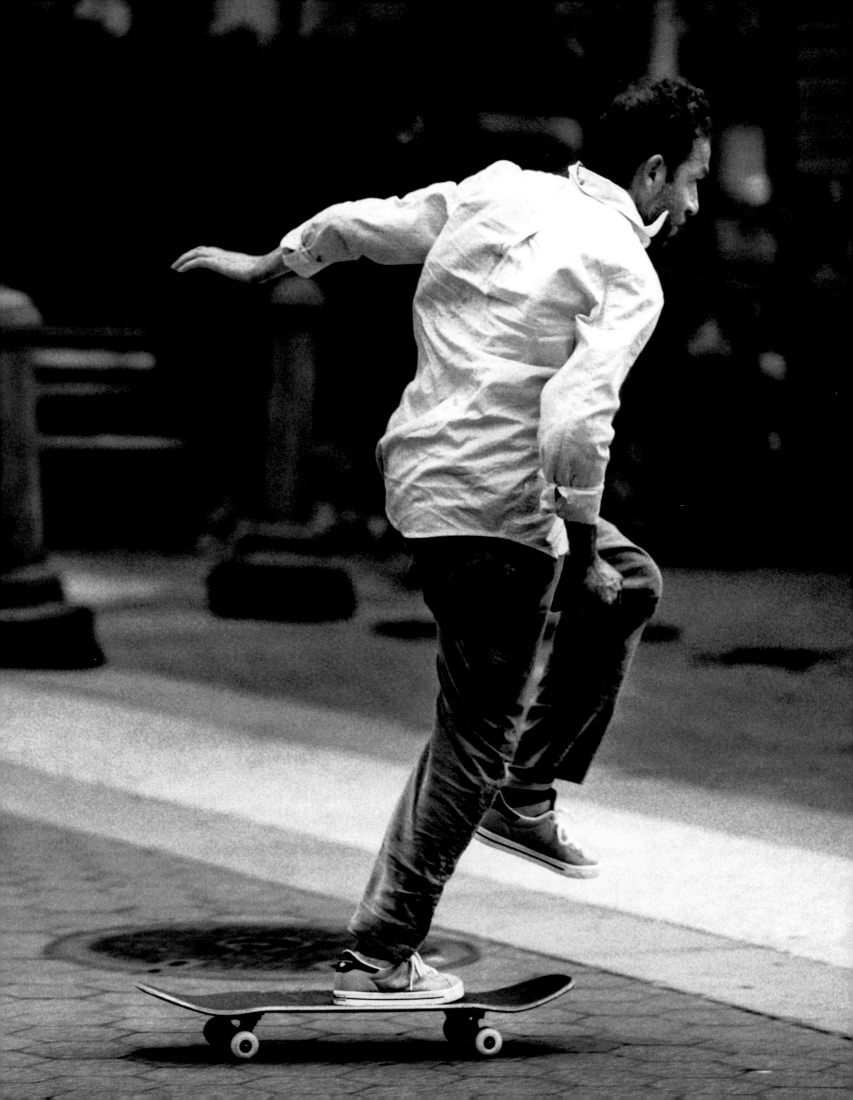

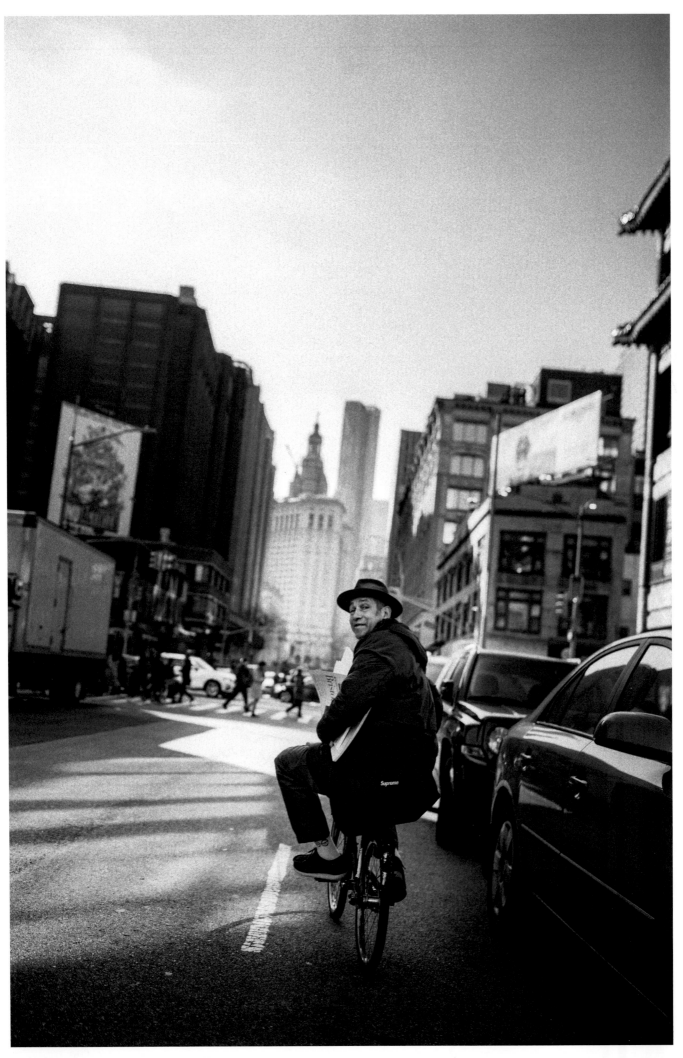

"MARK IS ONE OF THE MOST DIFFICULT PEOPLE IN THE WORLD TO PHOTOGRAPH. HE IS TOO CREATIVE, TOO UNPREDICTABLE."

In the final days of editing this book, Sem's senses are heightened. He has spent the last 2 years traveling around the world, photographing Mark and a few mutual friends, rounding out 10 years of collaboration. All of it is coming to a culmination of sorts, although the closing of one chapter inevitably brings about the next one—and a smile to his face.

Back in the day, you'd typically be given 2 reasons why a skater might pick up a camera: one, "I wasn't good enough on a board," and the other, injury. Sem falls in the latter category, although his modesty would argue this point. In any case, the culture has always been about more than the act of skateboarding.

I ask Sem about the first time he ever saw a photo of Mark—a frontside boardslide on a handrail in London's Southbank—but the two didn't meet until 2010 in Brazil, on a trip spent scouring São Paulo for skate spots and Pichaçao graffiti. Pushing around the city, Sem realized that the more he hung out with Mark, the more questions he had. Who is Gonz today? How does he spend his time? What is he creating, and with whom? They've been shooting together ever since.

A steadfast, lone wolf who dwells in his birth town of Blanes, Catalunya, Sem strikes out on image hunts with just about every new moon. Mark, on the other hand, is a California-born cat with 9 lives who's been slinking around the streets of New York City, turning them and the rest of the world into his playground for the past 30 years. Both are dedicated family men, both are great image-makers. Both are wary of words, but know their way around them.

Street skating, street photography: both put you at the mercy of imponderables. Cops (official or in spirit), weather, personalities, traffic, yesterday's hangover or hang up—the list is as long as life. In this book, we chose to explore the idea that there is no freedom without friction. It is a running theme in Mark's skating and artwork, in our contributor interviews, and it is crucial to Sem's work: the equanimity that comes with capturing dozens of attempts at a trick on the same spot, the poetic eye one develops to cheat boredom, the centeredness that emerges when circumstances can change drastically at the drop of a hat.

All of it comes in handy when you find yourself at the wheel of a car, screeching away from a pack of wild dogs, Mark half hanging out the doorframe after a piss-break by an airfield in the middle of Sicily while the radio blasts Italian pop songs from the 80s. That particular ride, on the final trip for this photo book, has remained on Sem's mind for other reasons as well. With dusty hours ahead of them, they discussed art, the feeling that it should be honest and authentic. No embellishment, no pretension. Mark's voice—so particular its patterns seem to imprint permanently on anyone who interacts with him even once—echoes throughout this book. You feel it in Sem's images, in Mark's own work, of course, but also in the sincere affection and respect of his friends and collaborators.

We hope you enjoy this ride into the work of 2 wonderful artists, and a few of the people who love them.

Foreword by Lou Andrea Savoir

FUCK I DON'T
WANT TO GET UP
EARLY TOMOROW
I HAVE TO MEET
THIS FRENCH ~~████~~
HIS NAME IS BURNARD
WE MIGHT WORK TO
GETHER ON A REMAKE
OF MIDNIGHT EXPREESS
THE ACTERS ~~██~~ WE
HAVE IN MIND
ARE AMERICAN
KANU REVES
MAY BE
RIVER VINIX
OR
ADUM SPEGALL

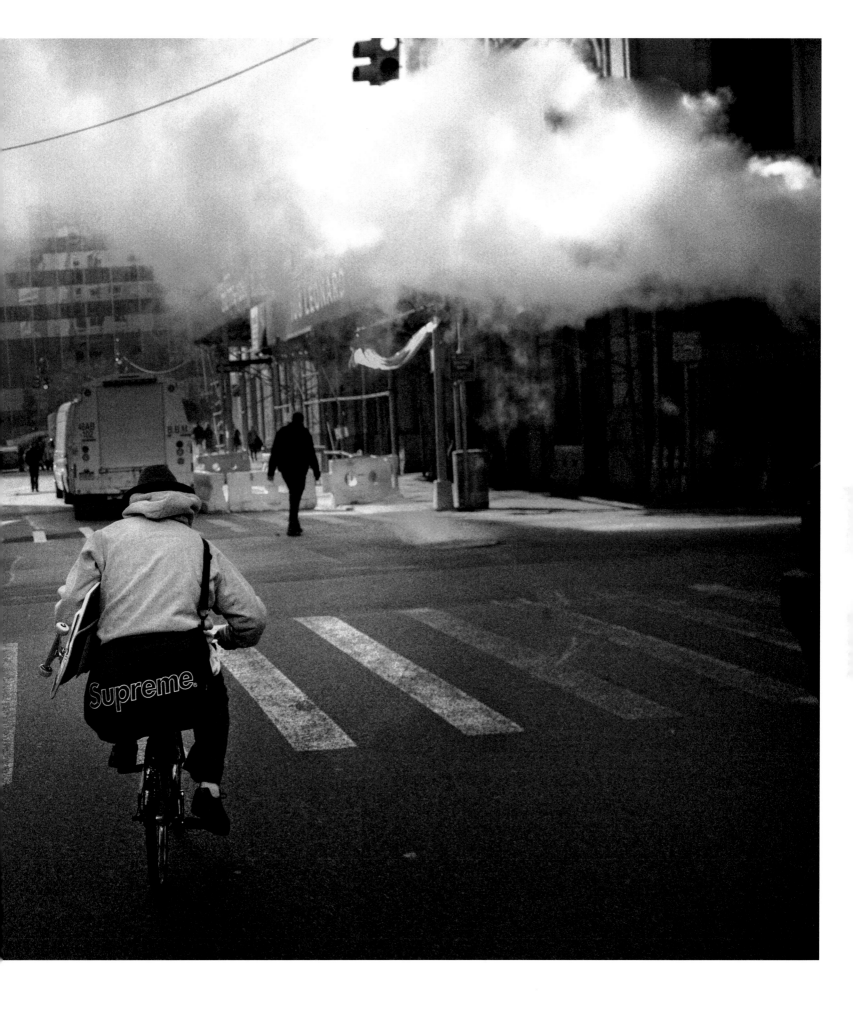

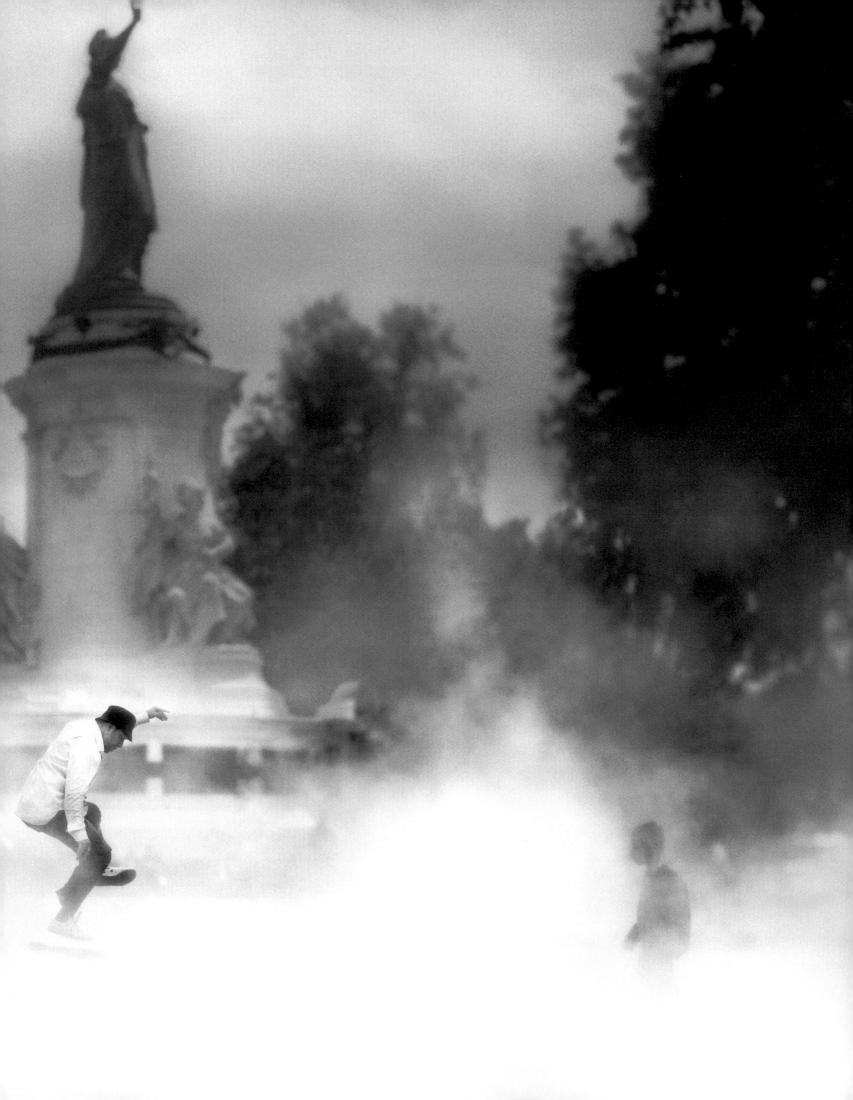

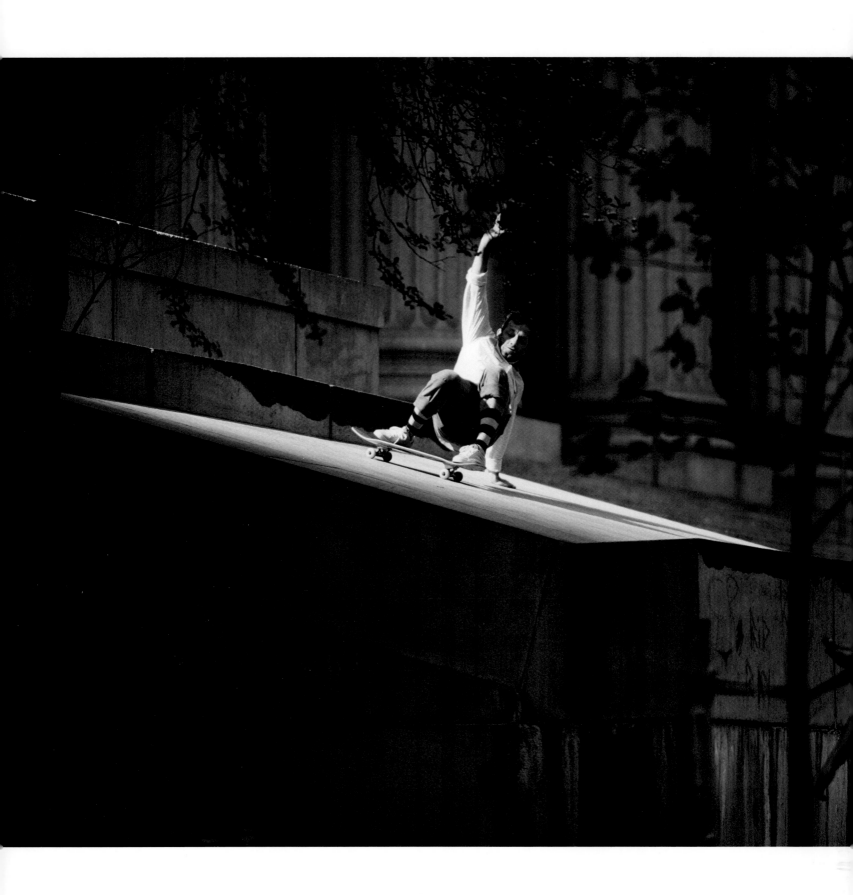

OFCORSE
I USE
TO LOVE
YOU .
UNTIL
I REALIZED
LOVEING
YOU
WAS NOT
CAREING
FOR
MY SELF

Ed Templeton

Templeton is a professional skateboarder, artist, and photographer.
He is also the Founder of Toy Machine

Whatever wires are crossed in Mark's brain it has created the world's most original skateboarder and artist. He is the godfather of street skating, and his major influence on every generation of skateboarders and artists since he came on the scene is indisputable. No matter if you have never experienced him firsthand, what you do and how you skate was shaped by the trails he blazed. He has retained his childlike view of the world as he grew into an adult, and it oozes out of him in how he acts, skates, and what he creates as an artist. I don't think we will ever see someone like him again.

-

Innocence and the untainted and truthful way of looking at the world are worth preserving. Photography is a child who can't yet speak, pointing at something so his mother can see what she is seeing, what she is struck by.
Children's drawings are pure imagination, simple shapes and lines that represent something else, that is art in its purest form. Skateboarding is this too, the world is a playground to be used in a way other than its intended purpose, it's pure play.

-

Watching and recording have not taken over. There's nothing to watch or record if there's nothing happening.

-

Q — What does the skate world give you, that the art world doesn't?
A — There's little chance of breaking your neck in the art world.

Q — What makes Mark timeless?
A — When you invent most of what people are still doing every day, you are timeless.

-

Political arguments with young people who think voting doesn't matter are always worth having.

-

I think the clip in *Blind Video Days* where Mark 50-50's a bench to frontside boardslide another bench in a line is the best of skateboarding in a nutshell.

-

Q — Something he once told you that stuck with you?
A — "Isn't your mom retarded?"

-

Q — In which ways do you feel more free now, than when you were younger?
A — I have to earn freedom now, or take it. When you are young, freedom is in abundance but you are not totally aware of it.

-

Q — What still drives you nuts?
A — That facts don't matter anymore.

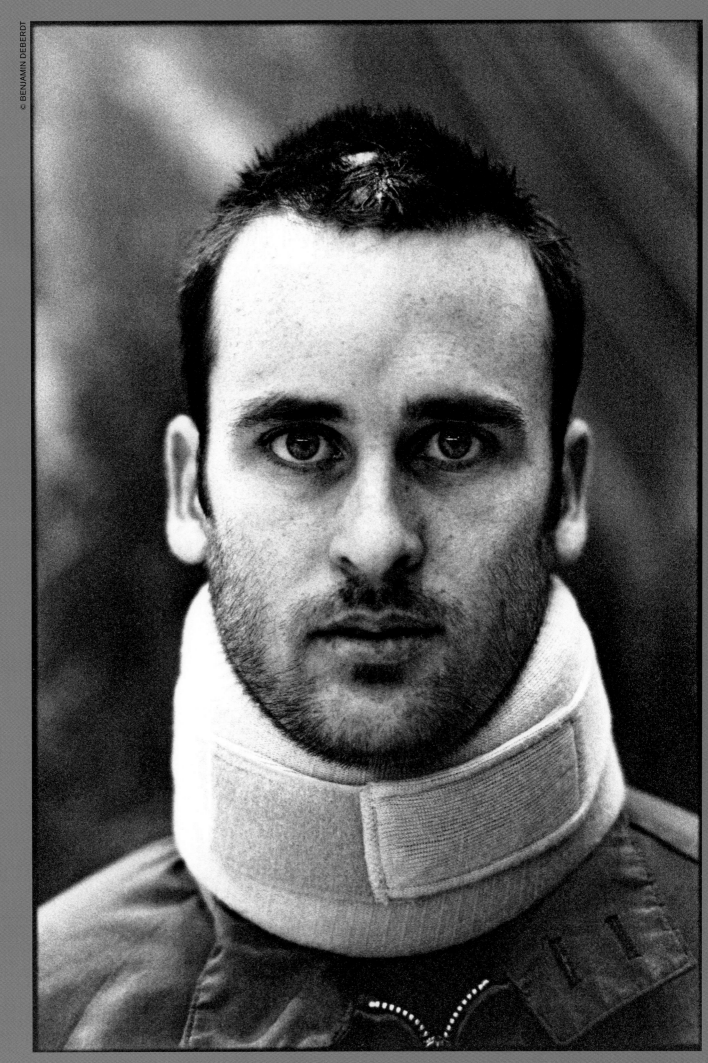

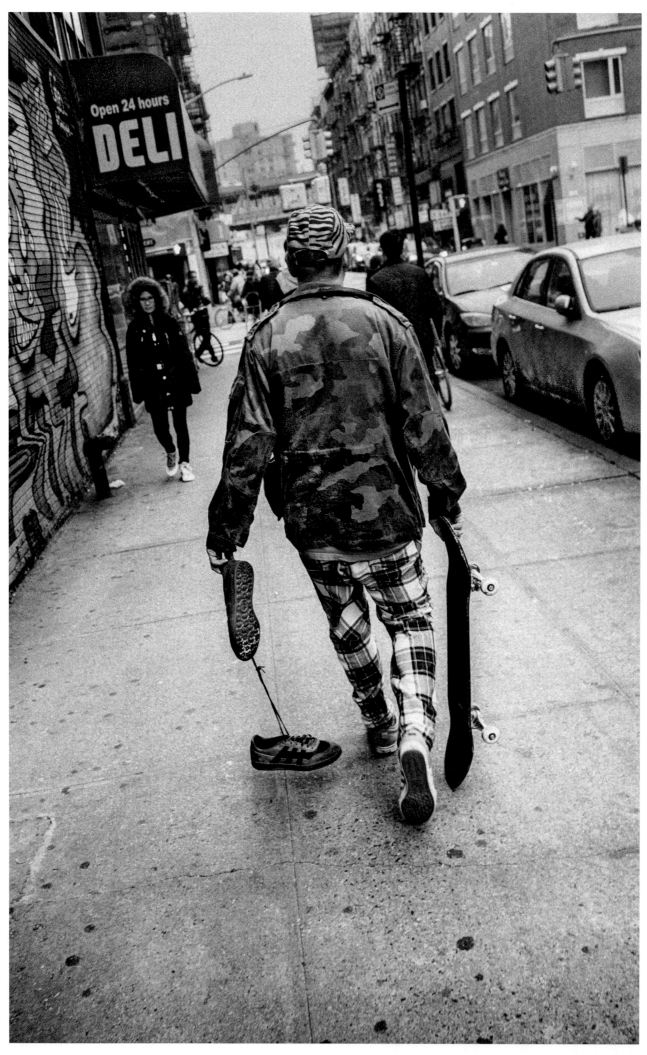

I HOPED INTO
MY WIFES RIDE
SHE BE WIPPING
DIRTY IN HER WHITE
BENZ

PUTTING
CAN
CURE
THE
ILLS
OF
iLLie
WILLie

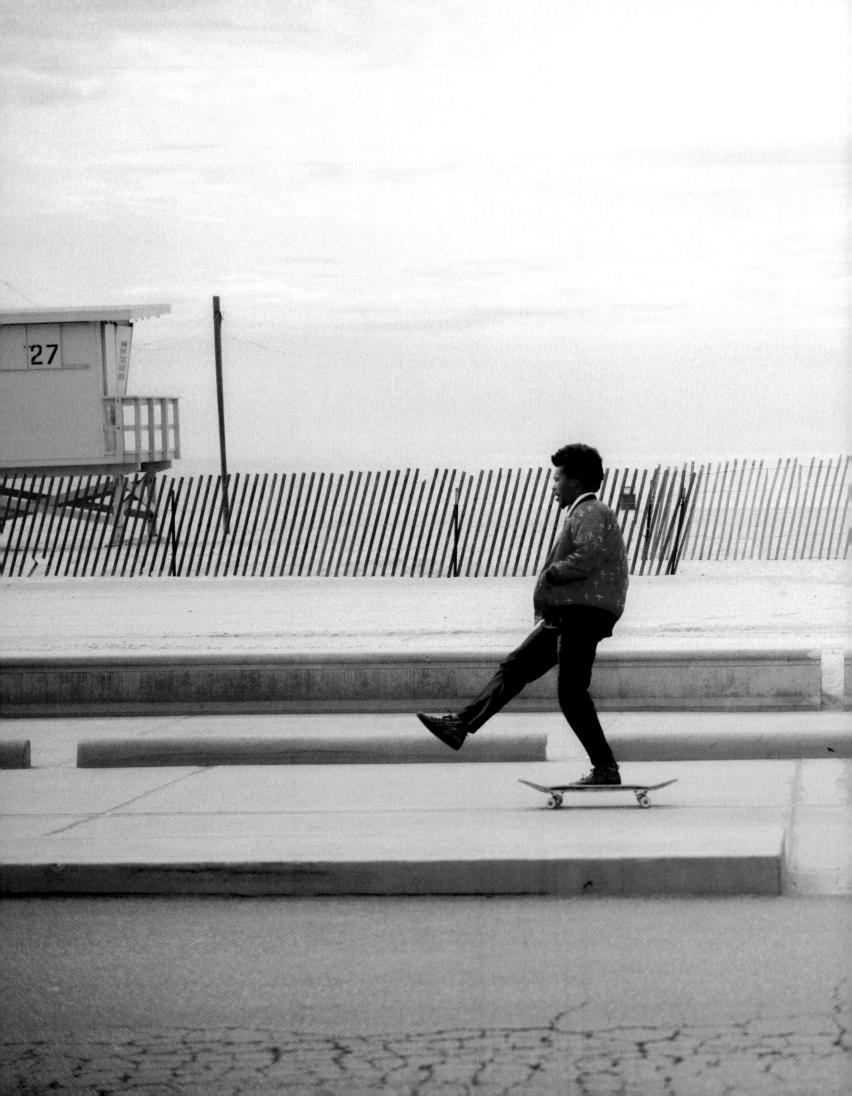

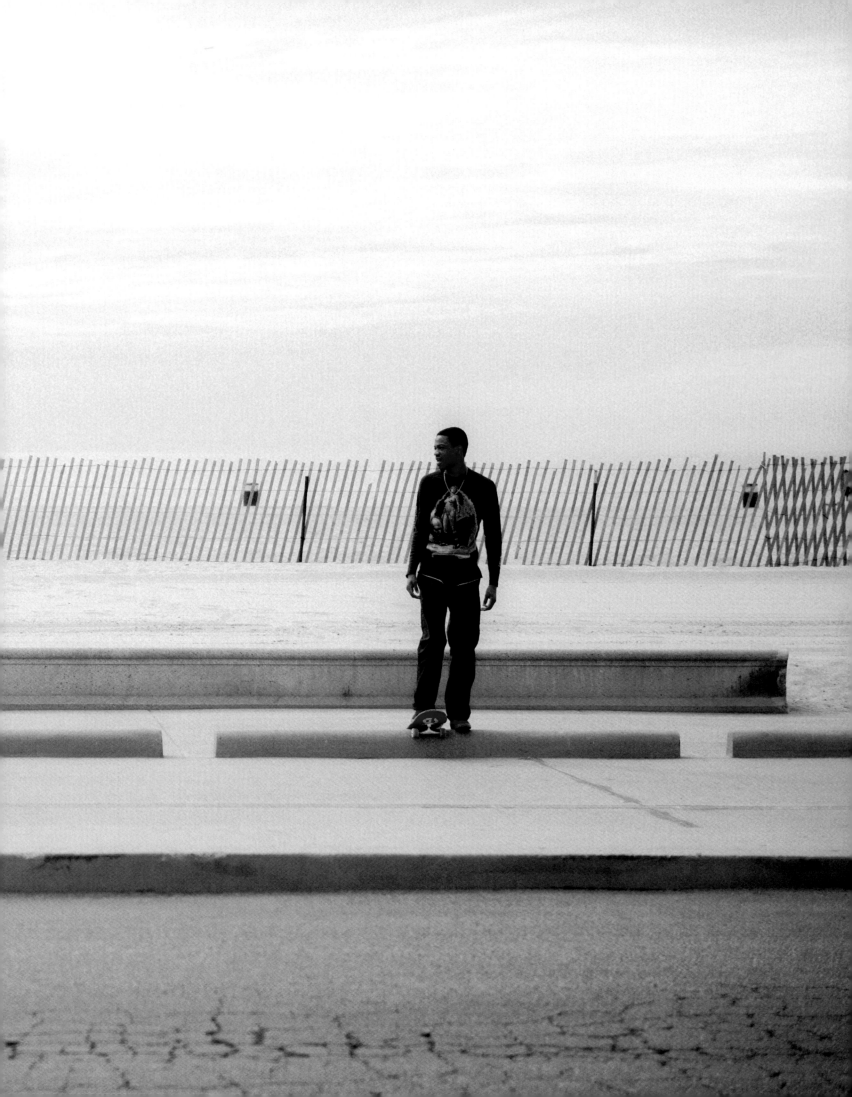

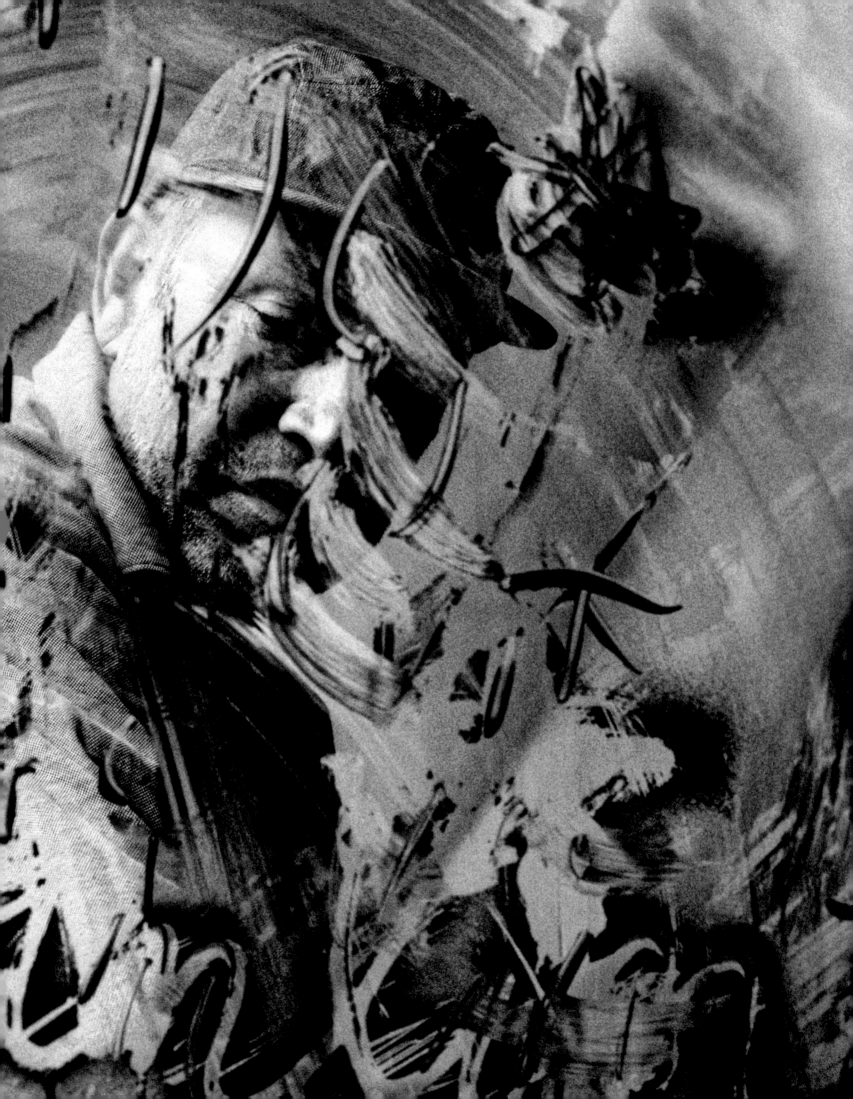

KAWS

Brian Donnelly, known professionally as KAWS, is an American artist and designer who lives and works in New York.

L — What was your first interaction with Mark?

K — Me and Mark happened to have our kids on the same exact day in the same exact hospital in New York. I had known Mark just in passing, saying hello at different things, but had never really kept in touch with him. When my wife gave birth, I spent the night at the hospital, and the next morning I was in the elevator going down to get tea. The doors open and its Mark [Kaws leans in and points an excited finger]—"Dude, did you just have a baby too!?" It was just surreal—you're already in a haze— having your first child and going through a night like that.

L — Had you been awake the whole night?

K — It's such a blur. I had both my kids in the same hospital so it's hard to separate the 2 experiences. My wife would probably highly disagree.

L — My husband and I have a book, where I wrote down my birth experience and he wrote his, the 2 versions.

K — He's like: "3 a.m., getting coffee." You're like: "3 a.m., still pushing, crying." I wish we'd thought to do that. You need to do that like 2 days after, or something. I mean, how can you know what to expect? We wanted a natural birth, and I remember the nurse being like, "You can do this!" Just the fact that we had a nurse who was cool and supportive changed everything. So even after seeing him in the hospital like that, we still didn't keep in touch for a while. But then we started to, because it *is* kind of special to think of 2 kids born on the same day in the same hospital. And our daughters really click, they're really sweet to each other. Kids bring you together in new ways. I think as an adult it's harder and harder to bring new friends into your life.

With kids you kind of give people a chance, you're just open, you want to see them play. So, we'd go visit each other.

L — Do you feel there's a deeper alignment with somebody if you agree on how to handle the kids, or how the kids get on?

K — Yeah, I mean Tia's amazing and Mark is amazing too. I remember him teaching my daughter how to take a fall. Running through the house and falling. I was like "What are you doing, don't teach her how to fall!? She's not supposed to go around falling!" But he has great energy. You spend time with him and you understand why any kid would find him fascinating.

L — Of course you don't want your kid to fall, but it's good to learn how to.

K — He's not irresponsible. In the building where I used to live, we had this outdoor encased area. Our living room door opened up to this big space, where the kids would ride bikes when they were really little. I remember Mark coming from out there saying, "Sunny took a hard fall." And my heart sunk because I was like, "If Mark is saying that Sunny took a hard fall...." It was like the last thing I ever expected to come out of his mouth.

L — He is more sensitive to it in regards to a kid.

K — Yeah, but he's also indestructible, so it's kind of like.... I think he's always been very fit. He swims. I wouldn't want to go to the gym with him! He asked me to go, that's comical, I was like "You just want to see me winded and laugh at me!"

L — When you think about Mark being creative, what comes to mind?

K — He's definitely a real creative being. I think he uses every opportunity as an outlet, whether it's what he chose to wear that day, or what he paints or how he skates, or the zines he makes. I think he's very conscious of putting work and feelings out into the world. He changes a room when he walks into it. You know he assesses a situation, and tries to redirect it in the way that he wants. I remember I bumped into him on the street years ago, like well before kids, and we chatted for a few minutes and I said, "All right, take it easy." And he was walking away and he yelled back at me: "Never take it easy!" I grew up skating, I knew the stuff he was doing graphic-wise for boards, but I wasn't aware of the zines that he was making, or the poems and the paintings—that kind of work. Immediately, once it crosses into your life, you're aware there's a presence there that's not like the others, you know?

L — What does he bring that you might have felt was missing before? What spoke to you about the way he skates?

K — A swagger. Is that a good word? Maybe because he's a street skater and that's what you do, but that sort of interaction with the environment, making the environment obey his needs and seeing it in such an eloquent way. It makes you look at things, the next time you're walking down the street. There's sort of this energy to it that is very complementary. I forgot I did boards for him. Do you know when? I have the date somewhere....2005.

L — How did that come about?

K — I forgot. I don't remember [checking his phone]. I think it was Jim Thiebaud.... Oh! I turn 45 on Monday! I honestly have no memory of how that came about. I just remember being like— "Krooked? Mark? Yes. Yes." We had no interaction, it was just me fucking about. Whenever I accept anything like that,

"WHY ARE YOU MAKING A TOY?"

it's just whatever I'm doing with my own practice at the moment, is what comes out in that work.

L — So that's how you keep it real?

K — If I were to take something on in 2020 it would look a lot like the paintings that I'm doing at that moment. And if that doesn't work, then I don't do the thing, you know? So I guess so. I only do things I want to do. Knock on wood, I'm in a position I can say something as arrogant as that. It needs to fit within wherever my mind is at.

L — How do you find the strength to just do your thing? Because you're doing things on a scale now where that friction can be pretty big, or intimidating. The strength to say, "This is what I'm doing now. This is what I'm producing. Like it or leave it."

K — Yeah, because I'm just very selfish I guess. You know, you realize that you can only do the things you want to do, or else you're grasping at nothing. Sometimes I've had great opportunities to do something I'm not interested in, and I just can't. It just wouldn't work out.

L — Is it something you learned little by little? Were there times that it didn't work out and you realized, "Oh, this is what happens if I push the ball just a little too far, or if I compromise just a little too much?"

K — Yeah, I think the only way anybody gets more in touch with themselves is by screwing up a lot. And I have definitely had my share, but you just realize, "What is this?" You're just making art, it's not like lives are getting lost at your mistakes. You just have a day, month, year, and you move on and you make other stuff. The benefit for me is I look at a lot of different artists, I'm really interested in other artists and collecting, and I study their trajectories, and I see everything. No matter who you are, no matter what artist—you do not always need to go up and down in order to rejuvenate.

Where was I recently? What's the natural park, Yellowstone? I was riding through Yellowstone with this guy who was giving a tour. We were looking for bison, bears, elk, that kind of thing. And we're riding through these roads that just go forever through this forest and then we hit sections that were all black little sticks, all from forest fires, they'd all been burned down. I was completely shocked, "This is so horrible." The guide looked at us and was like, "No, actually you need the forest fire, because it's the only way to get rid of a lot of the stuff that has been building up. It needs to clean out, seeds will drop, and then in 30 years you're going have a good healthy forest again."

Without burning, it would just suffocate itself.

L — You can correct me, but that's definitely not a New York-style rhythm. It's more like the Berlin rhythm.

K — You know my first time out of the country was to Berlin. Do you know Loomit? The graffiti artist?

L — No, sorry.

K — Come on, he's like the pride of Germany! So in 1996, Loomit arranged this graffiti jam, or whatever it was called. And their—*your* government—paid for my flight to go be a part of this thing and my mind was blown. You know here it's "Eradicate.

Eradicate. Eradicate." and suddenly you're getting brought to another country to paint [graffiti]. So we went to Berlin to do some painting.

L — When was this?

K — '96.

L — Yeah, I mean at that point it was a free-for-all for painting in Berlin.

K — Definitely, I mean it was a free-for-all here, kind of, but there it was like, with German spray paint which was a real novelty. I mean we had legal walls here where people would be like, "Paint it and we will not arrest you." But to have somebody give you paint to paint a wall was just mind-blowing.

L — What was your impression of Berlin then? Have you been back?

K — Back then it was a playground. I remember doing billboards and the guys saying, "Why are you wasting your paint, painting over billboards? It's just going to get changed." And I was like, "I know, but I'm gonna get my photos and it's fine."

L — I love that images of graffiti make time and space exist more and less at the same time.

K — That's why I got more interested in painting over billboards, and that led me to paint over advertisements. Because it places you in that time. For example, in 1993 I painted over Captain Morgan. In 1995 they came out with another Captain Morgan billboard campaign, which I painted too. It just really catalogs it. Whereas if you're just painting walls, that could be any date, you know? I'd paint the work and I'd come back and photograph it in the morning, night, whenever. Sometimes it would last 2 months on the street.

L — How do you feel about advertising then, and now? Is it part of the things that you appreciate and like? Or is it a way to re-appropriate something you dislike?

K — This is the world around me. How do I use it to my benefit? That's why I never really identified with [magazines like] *Adbusters*, or any of that stuff. I just was like: advertising is everywhere, and I like making work, and I want to make work that interacts with it and uses it as a vehicle to disseminate.

L — So that's something you have in common with Mark, I guess. To use your surroundings to re-create and bend the world to your vision.

K — Yeah. I used to find it fun to be in another country. It's illegal, so working under this duress, but in a situation I am very familiar with. There's a comfort zone, and complete anxiety at the same time—and then, there's the painting part of it. So there's a lot there to maintain my interest over time.

L — How did people in Paris react if you were spotted, versus here or somewhere else.

K — I don't know, I didn't find out.

L — You always managed to get away with it?

K — Yeah. Whenever I was doing graffiti or painting advertisements, I never felt like I was doing anything wrong. In my mind it's not really a crime, even though in New York it got a little severe with penalties. You're just putting an image on an image, so I felt morally in the right, and that the consequences shouldn't be that bad.

L — So that you're not against, but you are more outside of the rules?

K — I just try and make life interesting.

L — My parents never taught me to respect authority for authority's sake. They were very into ethics, "Sometimes the rules are stupid, don't follow them."

K — My parents weren't like that. I just did whatever I wanted. They didn't take part.

L — All creative people create a world around them that allows them to keep working, and they have their habits, they have their friends. What are yours?

K — I spend a lot of time in the studio, and then I have a family. So it's a lot from the home to the studio, studio to home. I do go out a tiny bit. I think the friends that I have—I am very slow to make friends—I think that the friends I do have, I've had for 15 to 20 years. I am in a lot of situations when I'm traveling and meeting people and that's great and fun, but I think I feel like my real commitment is to my studio and my family. I definitely make a lot of friends. I don't want anyone who hears this to be offended, but it's like, at the end of the day, really where I want to be is in the studio. And then with my kids. And it's fun when that can parlay into hanging out with other people, eventually getting out the house. Like tonight I'm going to an opening.

L — It takes a lot of time to make art.

K — I don't think people really think about that. They go to the show and they're like, "Great." But you don't realize the months and months you're spending in front of those canvases. Or even just the logistics, like an inflatable piece or a sculptural piece and all the back and forth, you know it just sort of builds and takes time and it's easy to not find a lot of creative time. Or, somebody comes and wants to interview you. And your whole day is a bust.

L — [laughing] Production-wise, because it's so many different mediums, every time it must be a new set of problems.

K — Yeah, in 2006 I started my own company called OriginalFake, where I had a store and partner in Japan, and that was because I was curious to know what it was like to have a company. I'd worked with all these different companies and then I kind of wanted my own, and I got to fund all my other projects through that. But in having that, I realized that I don't want to have a company. I mean, we had a good run, it was 7 years. But I closed it. We had about 80 wholesale accounts, we were doing really well, but it just was like: I don't want this much of my mental space allocated to logistics, you know. It was creating logistics. So yeah, I kind of cut it off which was a big thing to do.

L — It must have felt liberating.

K — Yeah, you always get into these comfort situations, and you realize if you cut them, it's not always the end of the world.

L — Going back to creative habits and rituals. Your studio downstairs is extremely clean, is it always this clean and organized and perfect-looking?

K — This is actually pretty messy, like this right now. [smiles] I try to keep a clean studio. Things I make, they're really clean, they don't do well with handprints or dust. It's just my personality. I've always had that kind of studio practice. That OCD approach to it. I feel like I'm a very habitual person. I'm sure any image you ever find of me, I'm wearing this same outfit.

L — You were saying earlier, "Of course nobody has all A's in their life". Do you think that's something that the audience has patience for, or gets?

K — You can't think about the audience. I mean, you can't, you just have to think about what you can do to fill the void of what you think you're making, you know? And I think if *that's* your focus, then—things could be good, or bad, or whatever—but you'll have a place as a starting point. I remember when I was doing graffiti and I started painting over ads, I don't think a lot of people took to that. It was a bit dismissed. And then when I started making toys, it was another, you know: "Why the fuck are you making a toy?" That's like the worst term in graffiti I think [*toy*]. But it was something I was interested in. In my mind I was looking at it as a progression of tradition—Pop artists, and what they'd be doing if they had access now. So you've got to find your own curiosity.

L — Do you think those people thought of themselves as purists?

K — Yeah, you always find those people in different realms. And even now, everyone has their own guidelines that they try to, I don't know why, stand by. But to me, I'd rather be very open and fluid. If there's an opportunity to learn, then learn.

L — Do you ever give thought to where as an artist you'll be remembered, or who you would like to be next to in a museum?

K — Nobody hopefully. You can't control that. The only thing you could do is be smart about how you set things up, so when you do die, you're not a burden on everyone around you. That's the only thing that I've learned in recent years. You know you go through the first half of your life thinking about, "If only I could make this thing." Make, make, make. And then you start to go over it like, "What happens to this stuff I make, make, make?" You know? How does it affect people around me?

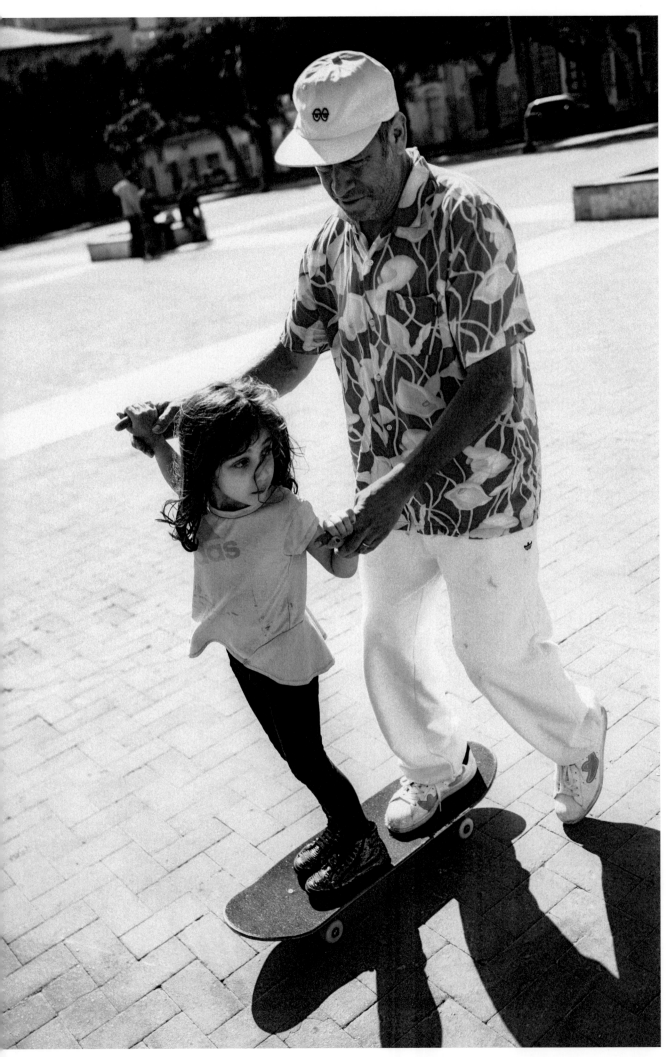

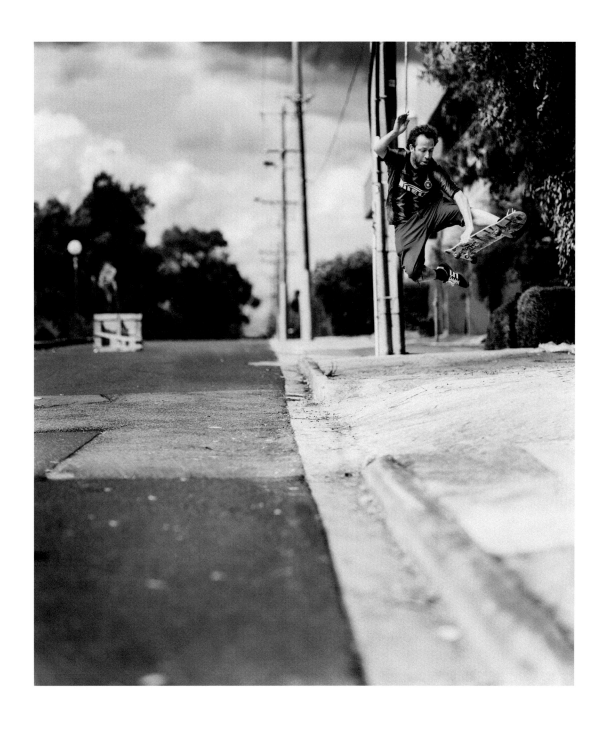

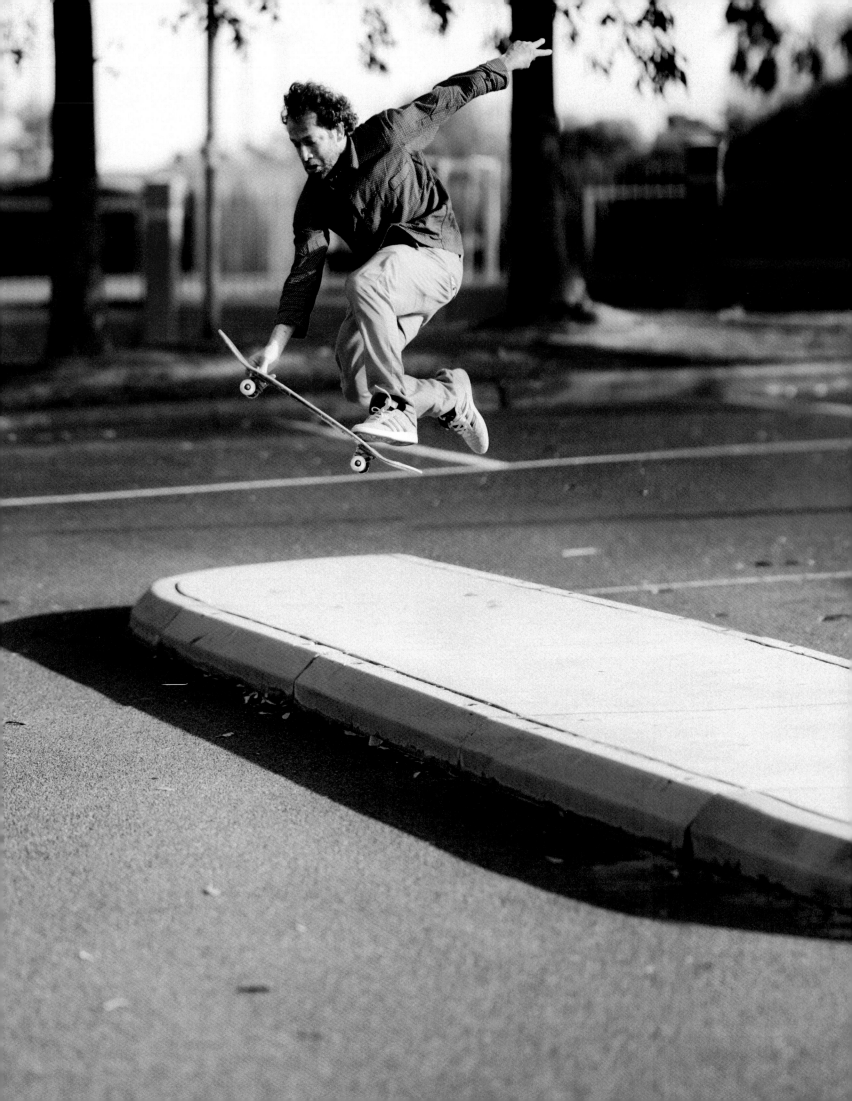

Gus Van Sant

Gus Van Sant is a film director, screenwriter, painter, photographer and musician.

If I could bottle one Mark moment, I think it would be the circular skateboard.

-

I imagine Mark has been part of many different families, but for me he plays the part of the joker, or the comedian.

-

Q — What was the last argument you are glad you got into?
A — It was a discussion about the reasons some people create what they do, what graffiti artists are making, what JR is photographing, what Blues music is—the argument was about our instincts and inspirations, which are more economic than what I had perceived—many creators are inspired by a strong perspective of social and economic situations.

-

Whatever happens next will be put on film, I think it depends on the future of skateboarding. I remember when it was a big deal to ride up on the tiles at the top of the pool, because it was so close to the edge—and skateboarders finally rode up on the ridge and stopped on it, or rode out of the pool. But then someone grabbed on to their board and flew out of the pool and then back in again which was so radical. It took years for that to happen.

-

I think that because skateboarding is an art form, it naturally attracts expression of identity.

-

The most free you feel is when you forget that something matters. When you are free of feeling that something matters so much, then you are free to change the things that matter.

-

When you are older you realize that things aren't such a big deal, and that's something that I wasn't aware of when I was younger.

-

Q — What still drives you nuts?
A — Really small things, like losing something really small, like a tiny screw on my airbrush.

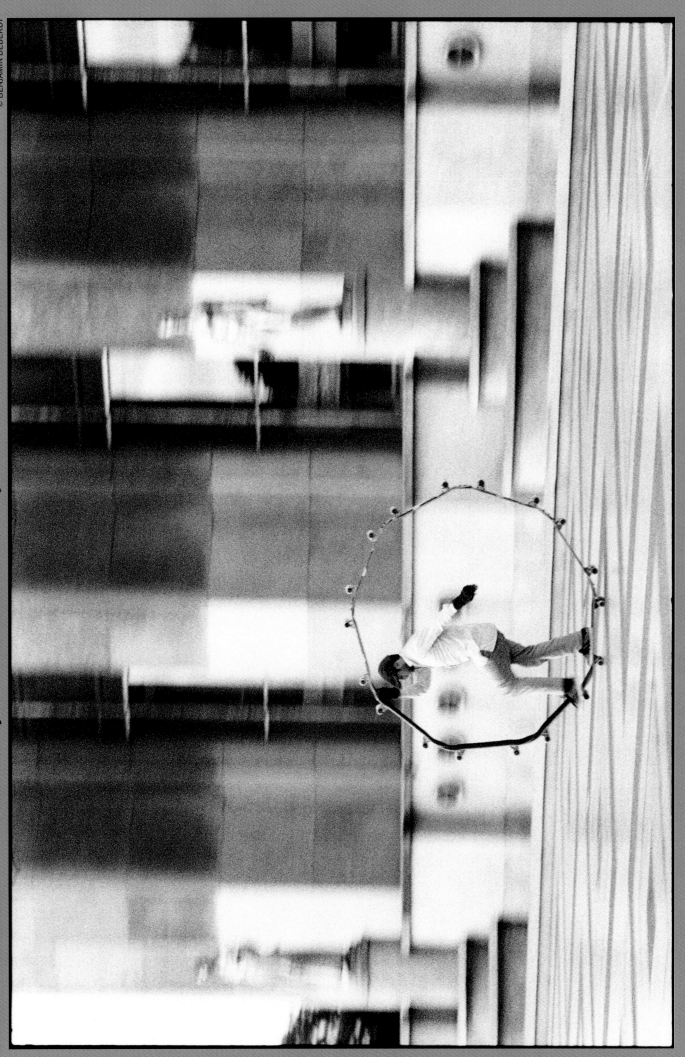

FRICTION – SLOW, SCARY, STOPPING
FREEDOM – FLYING, SAILING, FALLING
BALANCE – LOSING, STRUGGLING, CROUCHING

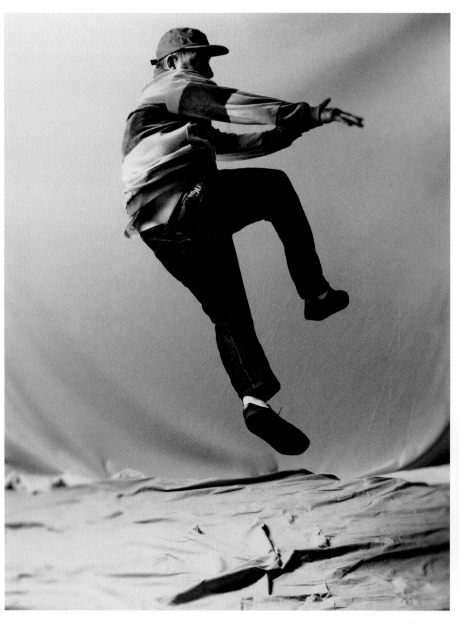

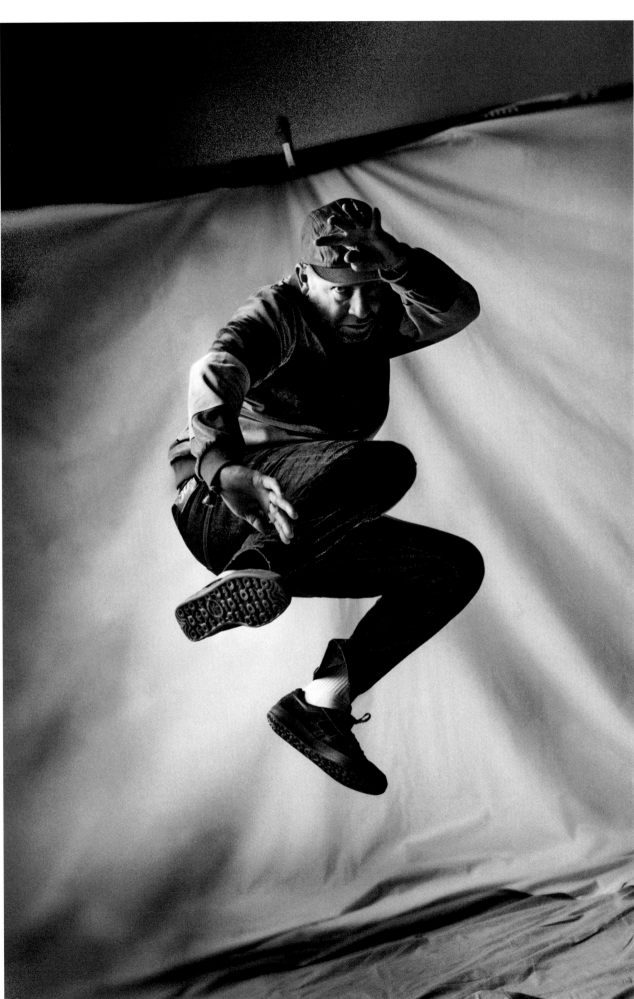

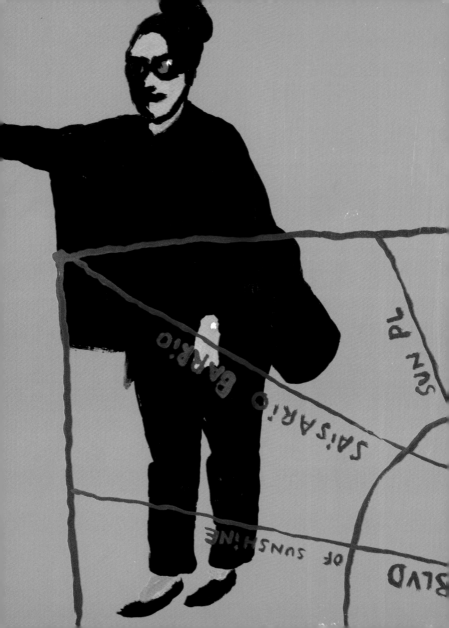

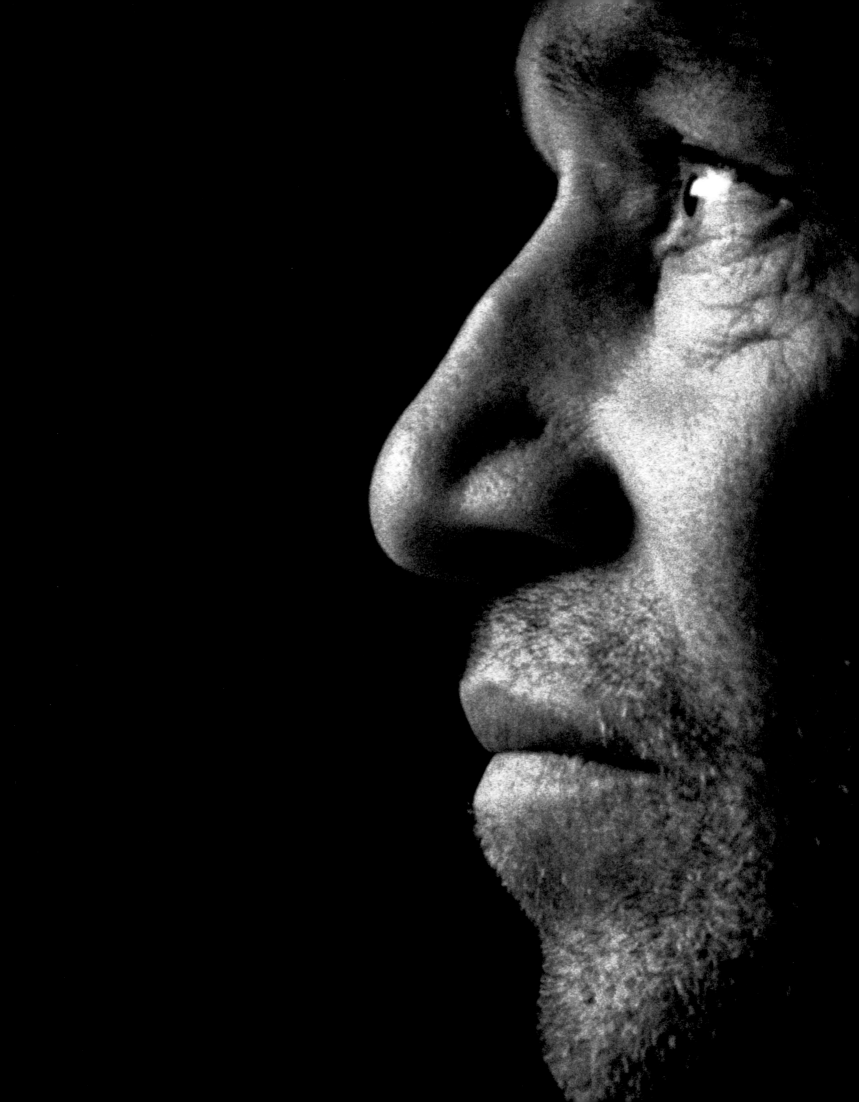

Tony Hawk

Hawk is a skateboarder, businessman, and activist. He is the Founder of skateboard company Birdhouse and the Tony Hawk Foundation.

Mark and I are the same age, only a few months apart, so he hit me up to shoot a picture of us skating doubles as we both neared age 50. I was in New York City on a brief overnight trip, so we agreed to meet at the Chelsea skate park one morning. The challenge was that I only had an hour in between other obligations, and Mark is not always the most punctual. He showed up on time but needed to set up a new skateboard. It was painful watching him struggle to find hardware after he dropped all of it in the bowl we were planning to skate. And his board was a ridiculous rocket shape, nearly a foot longer than a standard skateboard. He finally got it together and we started skating. At this point, I only had 20 minutes left. As I watched him warm up, I was immediately struck by how effortless his skating was, especially on the monstrosity he just assembled. Here he is, nearly 50, skating a vert bowl when he is widely regarded as a street pioneer. He asked if I could do a trick *underneath* his Frontside Boneless; something I've never seen done and a stunt that could put us both in great danger. We tested the timing with practice runs and then immediately started going for it. 15 minutes later, we made it and got an epic photo thanks to his friend Pep. The whole experience was typical Gonz—rushed chaos and creativity molded into something innovative that nobody else has imagined. To put it in perspective, I have skated vert and bowls my entire life, and I would never consider doing a Boneless over someone. But Mark has the talent and drive to explore the unknown and make it beautiful. Skateboarding is lucky to have him.

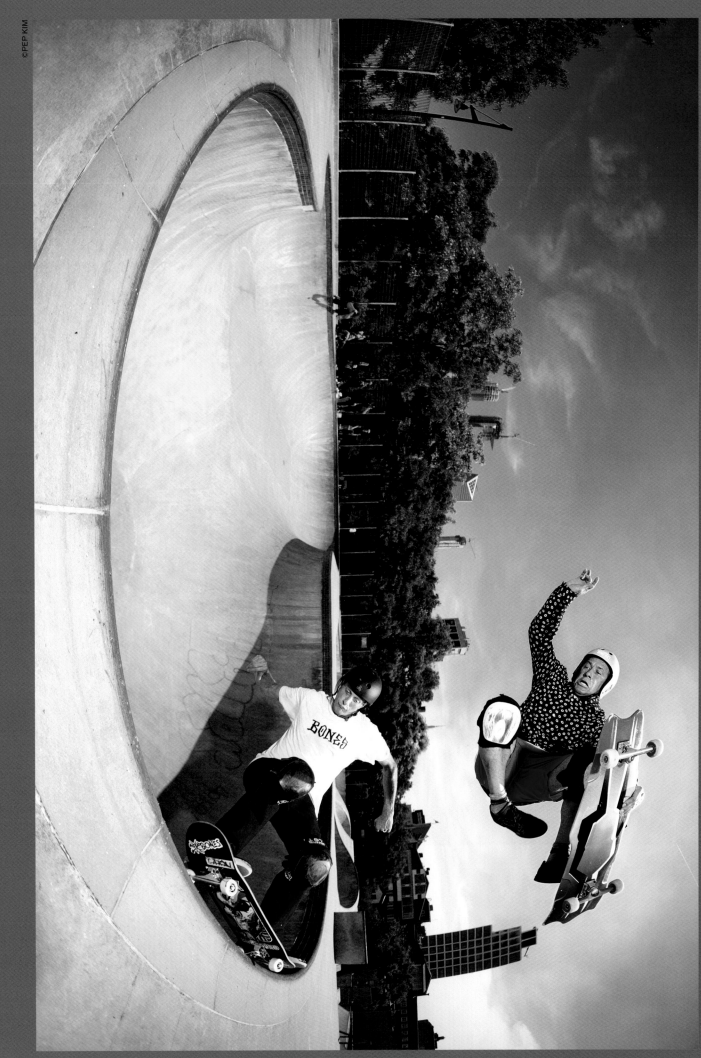

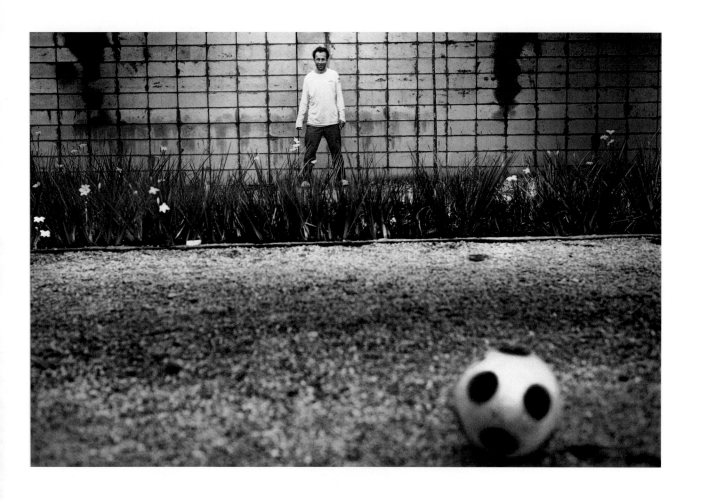

Lance Mountain

Mountain is a professional skateboarder and artist since the 80s and his early involvement with the Bones Brigade.

Q — You say: "Skateboarding is and always has been an excuse to be immature." What about immaturity is worth preserving?
A — You could definitely argue the use of the word "immature" as a license to be foolish/kook. But the awe of skateboarding, ideas & dreams when you're young & innocent is worth preserving in our lives.
-
I would bottle the moment I saw Mark jump out of my car and ride down the street to the bus stop. I realized he lifted the limitations skaters had, every bit of the street was rideable now with the ollie. To chase a dream, ideas with childlike reason leads to special things.
-
Q — A little-known fact about Mark as a young man:
A — Not sure if it's known, but I would love to see it again if you could dig it up: he was in a video somewhere stage-diving with only one shoe at I think a GBH [Grievous Bodily Harm] show.
-
Q — A little known fact about Mark as a grown man:
A — Only he knows that one.
-
Pioneers will always be timeless.
-
Never glad to be in an argument where I open my mouth, I am glad when I quietly & patiently work my hardest to do my best at something others think differently about, and later I see them mimic or trying to convince others about it. They don't even know I won the argument.
-
Skateboarding used to be an open canvas that not many had used or knew about. In other sports you knew the rules, you knew the field, court or course. The top professionals don't have a say on how the game is played, just in how they can improve themselves within the parameters given. In skateboarding, an unknown kid can come and look, act, find or make new terrain, ride or develop new moves that can change everything overnight. It is like music or art in that way. Skateboarders celebrate the ones they know who lead and develop new things. Whereas sport lends itself to celebrating those who can copy and perform someone else's art in the most consistent way. Skateboarders can take this toy and still do whatever they want with it, and end up doing something no one else has ever done.
-
Q — In which moment did you feel you found yourself?
A — When I gave my life to Jesus Christ at 10 just before I started skateboarding.
-
Q — In which moment did you find Mark?
A — He used to come skate my ramp as a little kid, I didn't know his name—until I drove him to the bus stop that day when he jumped out of the car and skated in a way that told me who he was.
-
You are only free when you first get on your board, but very quickly after you look over and see someone else doing it and they, you or others start judging who is better. As soon as we expect anything from it or it becomes a way to make money and you have to fight off the burden of that. We had to work hard and do a lot of things to pave the way for it to be a way to make a living for us and others. The freedom comes as we decide for none of that to own us.
-
Q — Does skateboarding still make you feel free?
A — Yes.
-
Q — What still drives you nuts?
A — Myself.

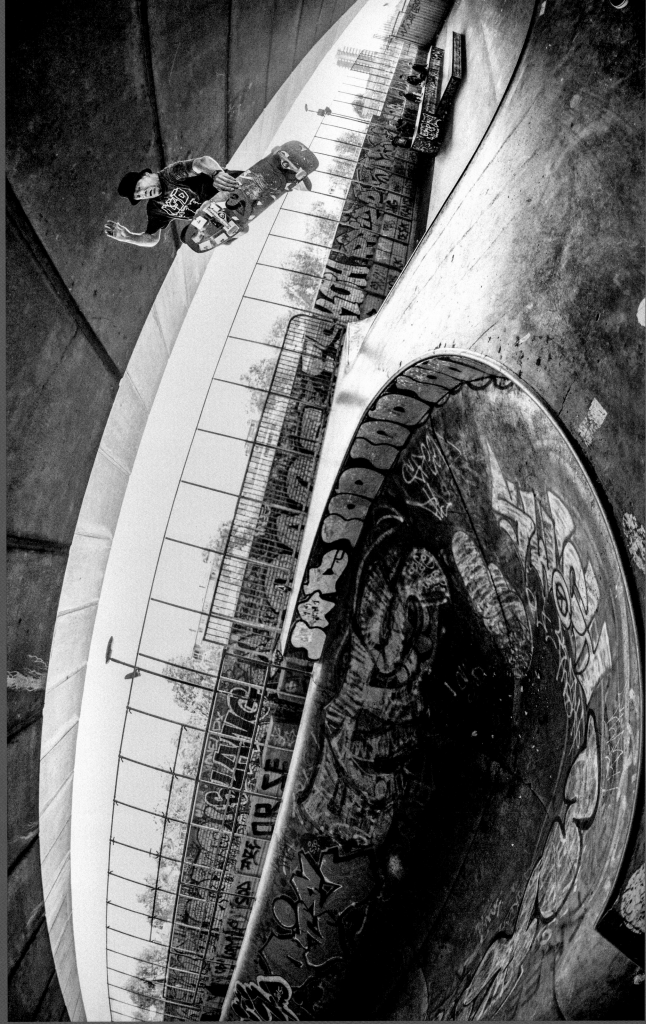

FRICTION – GROWTH
FREEDOM – COST
FUNCTION – REPEATS

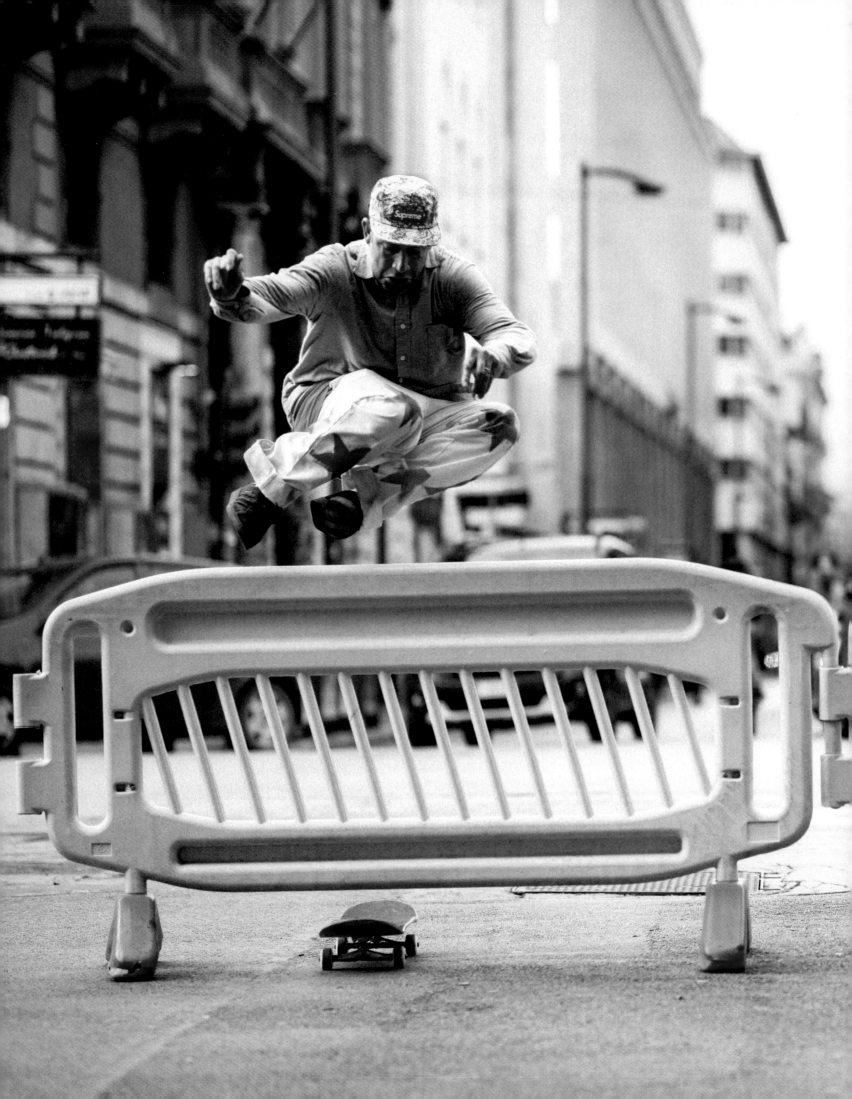

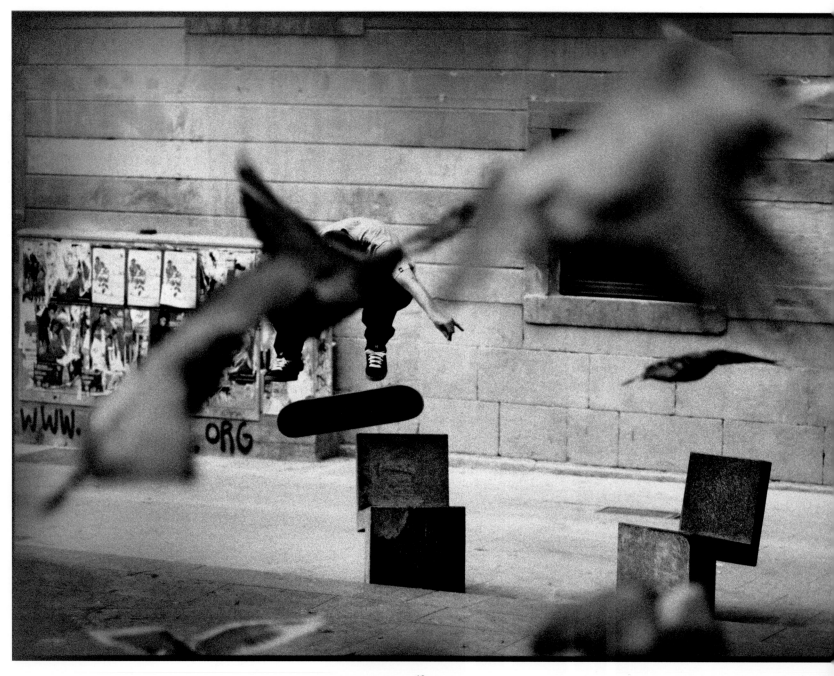

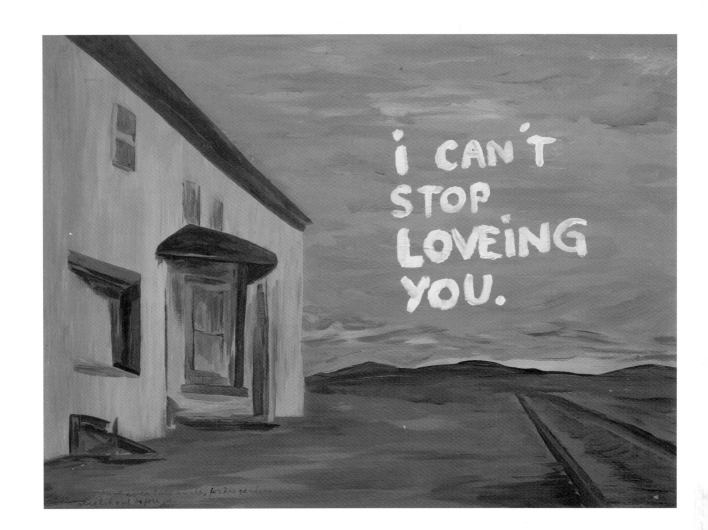

TOM SACHS

Sachs is an American contemporary artist who lives and works in New York City.

Y — How did you first meet Mark?

T — Before I ever met him, I heard him. I heard the pop of an ollie like halfway down the block on the other side of the street, and I turned my head. So the first time I ever physically saw Mark, his feet were chest-high off the ground popping into an ollie. It was on Centre Street with Aaron Rose.

Y — Aaron introduced you?

T — Yeah, that was our mutual friend. We had both done a lot of work at Alleged Gallery in the early 90s, when Alleged and Ludlow were really happening. I never had a whole show there, I was in a lot of group shows and Mark did shows there too and I felt like in a way I was part of that community.

Y — But you knew of him, right?

T — Yeah of course, because I skateboarded and he was already the greatest skater of all time. But I don't know that the world had universally understood him to be the greatest of all time at that point. I think that skateboarding was going through a transition at the time and street skating was just on the rise. It had been on the rise but it certainly hadn't been commercialized to the full extent that it has been now.

Y — So that's 20- or 30-something years that you've seen him evolve. I'm sure his work and skateboarding have gone through so many phases. Why do you think people continue to have this fascination with him?

T — I think some skateboarding magazine, like *Transworld,*

interviewed the 100 best skaters of all time a couple years ago. Everyone had to name their top 10, and Mark was the only one who was on every list. He's the guy who made street skating a thing. Before that, it was ramp skating or freestyle. He did this special hybrid, and that's become the dominant thing. It also made it more accessible, because you can do it anywhere. He's the one who subverted architecture more than anyone else. [Another reason is] Phil Aarons. Phil is the most important zine collector in the world and he believes that there are only 4 "Masters in the Universe." They are: Ari Marcopoulos, Dash Snow, Raymond Pettibon, and Mark, who make the best zines and make a lot of them. Since then, I think Mark has done a lot less, because he makes these YouTube videos and that's been a way of fulfilling all those needs.

Y — He's switched mediums, but he still doesn't have a smartphone, does he?

T — No, he's got one of those phones that children have.

Y — Like a burner phone?

T — No. It's an emergency phone for children and it's got like 3 numbers on it. Like Mom, Dad, and Other and I think...

Y — —and Tom.

T — So it's like Tia, and me. And I don't know who the other one is but I know for some reason I'm on that. Which I consider an honor and a terrible responsibility.

Y — Has he used it?

T — Yeah, he comes over to use the bathroom. And the bandsaw. I don't know if you know this but we provide Mark with technical assistance. So when he needs something, we make it for him. We do whatever he needs. It's called community service. And it's not us servicing Mark, it's servicing the entire community by making Mark's dreams come true.

Y — That's a very good service. Has working with him in these different ways and in varied materials over the years allowed you both to evolve creatively?

T — Well he's taught me a lot about skateboarding. When I look back on my life, I wish I had spent more time in the past decade skating with him. But you make choices with time. But I think Mark has really taught me a lot about freedom in art, and taking chances and making bold moves. The main thing that Mark taught me about skateboarding is to be a lot more aggressive. And to really lean into it. And to skate with much more force and vigor and not to—I don't want to say "be afraid"—but to put more force into it. That's helped me a lot. It helps with landing things and getting through things. Mark's style is—it's Drunken Master style. It's Jackie Chan, Drunken Master style. When he lands it, it's not elegant. There's the Yogi Berra/Mark Gonzales comparison—I don't know if you know who that is?

Y — The baseball player?

T — He was called Yogi Berra because his last name was Berra. And he walked around clumsy like a Yogi. He also had this kind of Zen way about him. Very clumsy to watch but unbelievably athletic and always getting to the right place at the right time, but not smoothly, kind of stumbling. And that's clearly Mark's way.

"I'M GONNA SLAM MY BLOODY CARCASS AGAINST THIS PIECE OF CONCRETE UNTIL I OWN IT ON SOME TERMS."

Y — The way you approach art-making seems more organized than Mark's approach.

T — I think it's a challenge because I want to get stuff done and he's all process. And I think that's why skateboarding really works for him, and that's why some of his paintings are really good and others aren't. I think Mark's uneven and not everything that comes out of his studio is perfect. But the best things are untouchably awesome amazing things, and some of the other stuff is shitty. I think he indulges himself because he's figured out his lifestyle. I still have this Depression-era "the Cossacks are coming" fear that it's all going to come crumbling down, so I wouldn't go all the way. But Mark is 100 percent fearless.

Y — Watching this fearlessness, has it influenced your art making?

T — Mark is bold and messy, yet he possesses unbelievable draftsmanship skills. He can outdraw me and everyone I know, but he doesn't really take advantage of it. I always tell him he's kind of lazy, but I think I might be misreading him. Because Mark's an enigma. If I had that skill I would exploit it more. I have some early drawings that are very neat with the perfect pen. And he just likes to make a mess. But I respect that because it's kind of more fun and quicker—and violent—and there's some virtue to that.

Y — People have called both you and Mark "troublemakers" in interviews I've read, which I thought was interesting because I don't see either of you as a typical troublemaker.

T — I don't know about being a troublemaker, but I think I know where that's coming from. It's again about fear. Mark to me is a fearless person, and I don't really believe in that concept, because I think what I do *looks* like I'm fearless and I don't give a fuck, and I really work hard to cultivate that. Not the perception, but the action. For me and certainly for Mark there's like an intuition in making decisions that is followed, and Mark has this incredible discipline: first with his skill of drawing, which is athletic, and with his skill of skateboarding. I remember skateboarding with him once, and he was just trying to do a manual, which is like an ollie into a wheelie off a very small curb. I don't know if I could ever do it once, and he's done it like a million times. He kept missing this curb and he fell and he did it like 30 times before he was done. Because he could do it eventually, but he had to do it 4 times in a row perfectly before he felt like he had owned that spot. Not that move, but that move on that spot. So he has incredible—I don't know if you call that discipline—sounds like discipline, maybe it is.

Y — Sounds like discipline.

T — Yeah. On one side it's very indulgent—skateboarding's an incredibly indulgent activity. It's the anarchism of the body subverting the totalitarian aesthetic of modernism. It's like, "I'm gonna slam my bloody carcass against this piece of concrete until I own it on some terms." There's a fearlessness to that.

Y — Going back over and over sounds ritualistic. I know you have many rituals in your studio practice. Does Mark embrace rituals?

T — Yeah, he has all kinds of rituals. The way he dresses, smoking cigars. How he approaches his life in making food and stuff. He likes to do the same thing over and over again as a way of making them his own. Rituals are everything, they're essential to

what I do. I mean the actual making is ritualistic, and making the same moves over and over again makes it that you can't take that away from me. You could say that my art sucks, and you could be right or you could be wrong, but you can't argue with the time I put into it. Whether that's working on building something, or skateboarding over and over again.

Y — Are you more free with how you approach art making today?

T — I don't want to get too into me, but I notice that as the projects get bigger I get less free because it is more architectural and set out, and we have to execute it, so that's tough.

Y — On the one hand success is amazing to have, but on the other hand maybe it's confining in some ways.

T — God punishes us by giving us what we want? Something like that?

STUDIO ASSISTANT — I think the ultimate thing between you and Mark is there's no separation between life and work for either of you.

Y — That's a really interesting point.

STUDIO ASSISTANT — "It's not work, it's a way of life."

T — Thank you.

STUDIO ASSISTANT — *Your* quote, it's in the New York Times. [laughter]

T — It's 100 percent a way of life. I've dedicated everything to it. So in that way maybe we're a lot alike, because skateboarding is an important part of Mark's life. By the way, he keeps getting better and better. I was at a bar with him, we were outside on the street, and we had skateboards. Some young punk was like, "Oh, you old guys...you know how to skateboard?" He was like: "Show me a trick!" And it was like, come on...but Mark did this trick called a firecracker where you skateboard off a curb, and the tail of the board hits the curb and makes a really loud noise. It's all about making the loud noise. I think he was trying to fuck with the kid because it's kind of an unimpressive thing unless you do it really hard, and make it real loud—as loud as a gun or a firecracker. You have to be Mark Gonzales to do it so loud. But the kid was super unimpressed.

Y — He was?

T — He was unimpressed 'cause it didn't look like much, but it sounded like a gun going off. If *I* did it without falling—which I'm not sure I could do—it would sound soft. He kept coming up and pestering us, "Show me another." So Mark threw the skateboard *really* high in the air, and looked at him. As it came down, Mark caught it on his foot and put it down without making a sound. And we just walked away 'cause it was lost on this guy, he didn't get it. Both impossible things to do. And I thought, we measure skateboarding by different metrics. I always thought that I wanted to do choreography and dance with Mark—even with things without skateboards, he's so good at movement. We were skateboarding together at the Park Avenue Armory ramp. All these kids were launching this one way, and it was an awkward ramp—the "Gonzales Crater." And he just came at it from the other way and ollied off it, then rode it down. That was all he did. Just that one thing. But there's a creativity, finding a new way of

looking at it.

Y — So the mind pushes you to do things that you've never done before, even if physically he's probably not how he was 20 years ago, but he's still evolving.

T — Right, and that's also why Tony Hawk's not on everyone's top 10 list. Because Tony Hawk is kind of like the God of skateboarding but Mark is the Devil of skateboarding, and everyone knows who runs the show.

Y — But it's funny because in an interview I read, he described himself as an outsider in skateboarding.

T — Sure, 100 percent. Skateboarding is an anarchistic activity like we were saying before, so it makes sense. And it's kind of sad that skateboarding's not a crime anymore. "Skateboarding is not a crime" is not a viable bumper sticker because it was an outlaw activity. We're approaching the Olympics—the first year that we've got skateboarding in the Olympics. The first year in the X Games that someone won something, it was a snowboarding thing. [The snowboarder] stood up on the podium and got the gold medal and took it off and threw it into the crowd. And I thought that was pretty—

Y — —pretty badass.

T — That was cool. But it's kind of why skateboarding is like an artistic activity, there are many ways of doing everything. But traditionally, I think skateboarding was done for the individual, like surfing, right? There are some great skaters who would never compete, and in a way Mark is in that mold. He competed a lot and won a lot, but that was probably mainly to make ends meet. Now, it would be a different story. But obviously, he created what is now.

Y — In a couple words, how would you describe Mark as a person?

T — Wow. He's very sweet, and intuitive...

Y — I watched an interview and he was showing his studio that had a piece of yours in there, and he described you as a crazy New York artist.

T — That's insulting!

Y — But I think he meant it in the best way.

T — I'm sure. I always feel like we don't spend enough time together. Like of all the people I've met in my life I consider him a living treasure. And I don't know, if you could go back in time and you knew Bob Marley, wouldn't you regret that you didn't spend more time with him? Or Noam Chomsky or Muhammad Ali or Mozart. He's an artist of that caliber. And I'm so busy doing my own thing...

Interview by Yasha Wallin

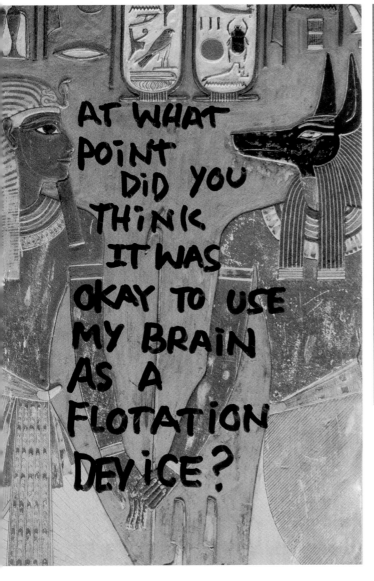

Tyler Gibney

Gibney is a curator and Co-Founder of HVW8 Gallery in Los Angeles and Berlin.

A great moment was when Mark came to install his 2013 exhibition "15 Years of Mark Gonzales" at HVW8 Los Angeles. The gallery walls were already covered with photos of Mark from some of his closest photographers, including Gabe Morford, Joe Brook, Skin Phillips, Brian Gaberman, Benjamin Deberdt, and Sem Rubio. All capturing all these amazing moments of Mark's history. There were a few sections of the gallery prepped white and left open for Mark to paint if he desired. He looked around, took in the photos of his life, then proceeded to skate around the gallery, paint and visit with his friends. Natas Kaupas, Skin Phillips, and others laughing and cheering him on, reminiscing about old times and the stories behind the photos, watching him run across the walls and fall on the curb attempting a slappy. It was so natural and fluid. But at the same time if the vibe wasn't there, you know Mark would be gone in a minute—surely in a prayer position on his back down Melrose. He did an amazing piece in the midst of everything. It was a great moment to witness.

-

Mark approaches his artwork the same as he approaches skateboarding, he pulls from a vast array of things from the past but at the same time is completely fluid and spontaneous, and in the moment. He builds upon his previous experience and creates something new, while being totally present, and himself. It's this freedom and natural approach and being so damn genuine that I love about Mark.

-

One thing he wrote sticks with me: "This is not a black or white Ishue." I love Mark's truisms. Childlike but right to the point.

-

I think Mark is the true essence of the skater/artist. There is no one better than him. I think he encapsulates and embodies what that is and represents it to the fullest. It's him. Here's a good story to reference. At Mark's opening, his sister from San Pedro came to visit the exhibit. She shared a time about Mark when he was younger, when he called them to visit them in San Pedro from Long Beach. Mark was going to skate over to their house, which was going to take about 3 hours. He made the trip over and they had a visit, and then his sister and cousins went out and left Mark at the house. When they returned Mark had left, but he had gone through the entire cupboard and relabeled all the cans with his own artwork. Classic!

One thing I'm always happy being involved with as an artist or curator is politics. I was happy being involved with the Bernie Sanders "The Art of a Political Revolution" campaign. I need a moral compass. I've always tried to push the boundaries and limits of what a gallery is supposed to be, and being an artist within those constructs. Being involved in how an individual can help with the greater good.

-

I think you have a better sense of yourself as you get older. You become less hindered by what others think and are more motivated by what drives you. This is freeing.

-

What still drives me nuts is the sense of urgency that some artists feel. That we're living in this immediate culture with a constant need for instant gratification. Artists forget to give themselves time and space. And that the aspect of "branding" has entered the vernacular of what it is to be an artist. Artists never spoke about "branding" before.

-

Going on a walk or a drive, or talking to an old friend helps me keep my perspective and think clearly. Experiencing things outside of the studio and away from the screen. Having a random encounter, being in nature. Playing and making music also are a great relief and help me feel and think clearly. Painting is also good for the soul.

-

Q — What unspoken rules would you recommend people respect?
A — Originality and space.

-

Q — Which ones should they break?
A — Fashion and trends...don't follow trends. It's pop culture, remember. It will eat itself.

Artists and Skaters—it's about Freedom. It's also about solidarity arts and practices.

-

Yes I think Walter Gropius would've been into skateboarding. Bauhaus was like a skate team—Alvar Aalto, Ludwig Mies van der Rohe, Le Corbusier, and Frank Lloyd Wright riding for Modernist.

FRICTION – PAIN OR PLEASURE
FREEDOM – ALWAYS
FUNCTION – DESIGN

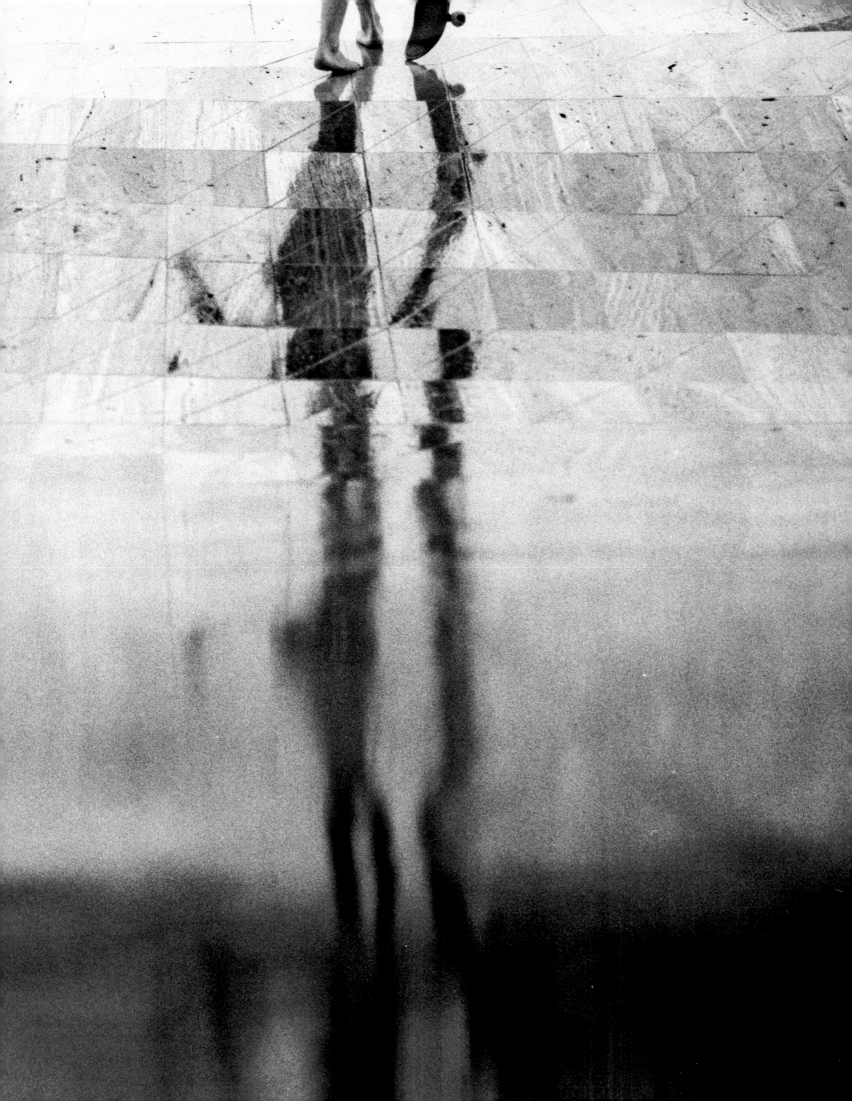

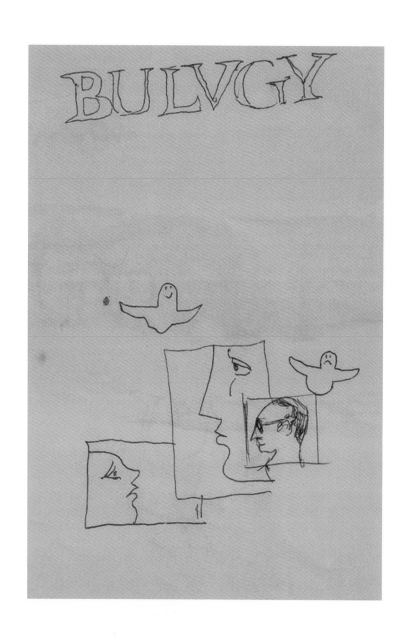

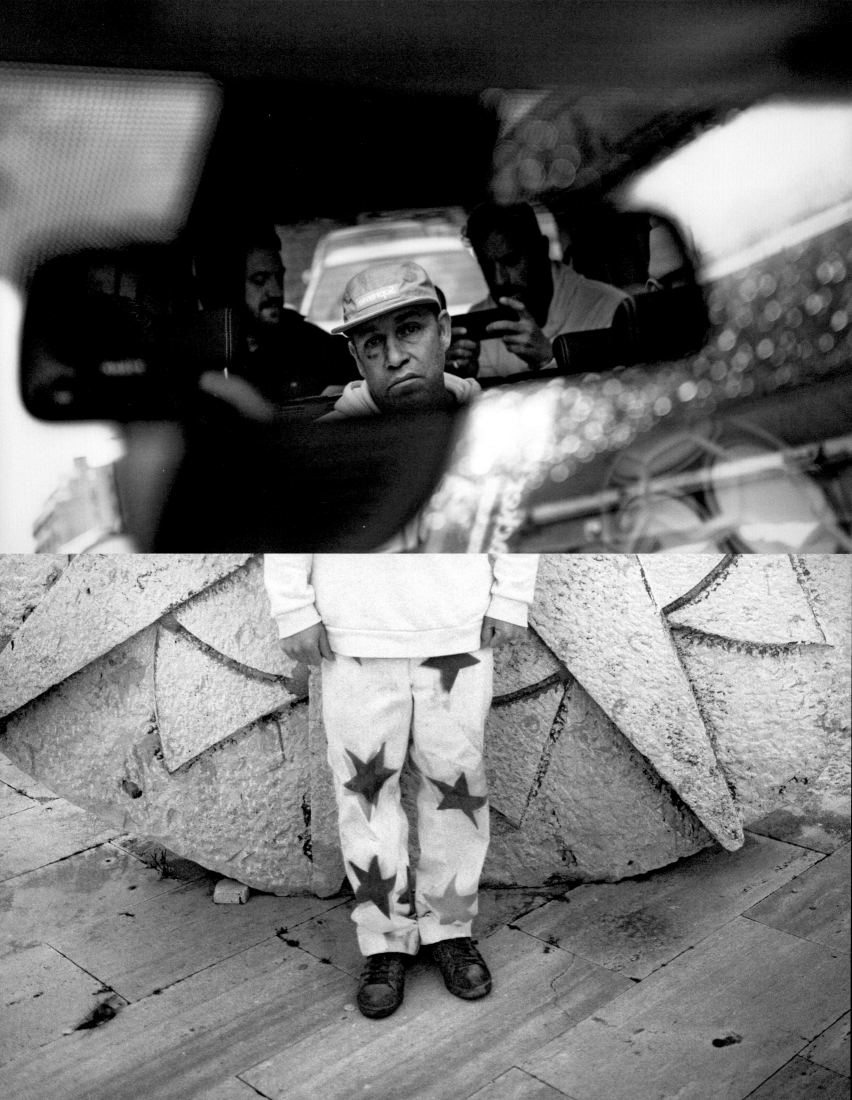

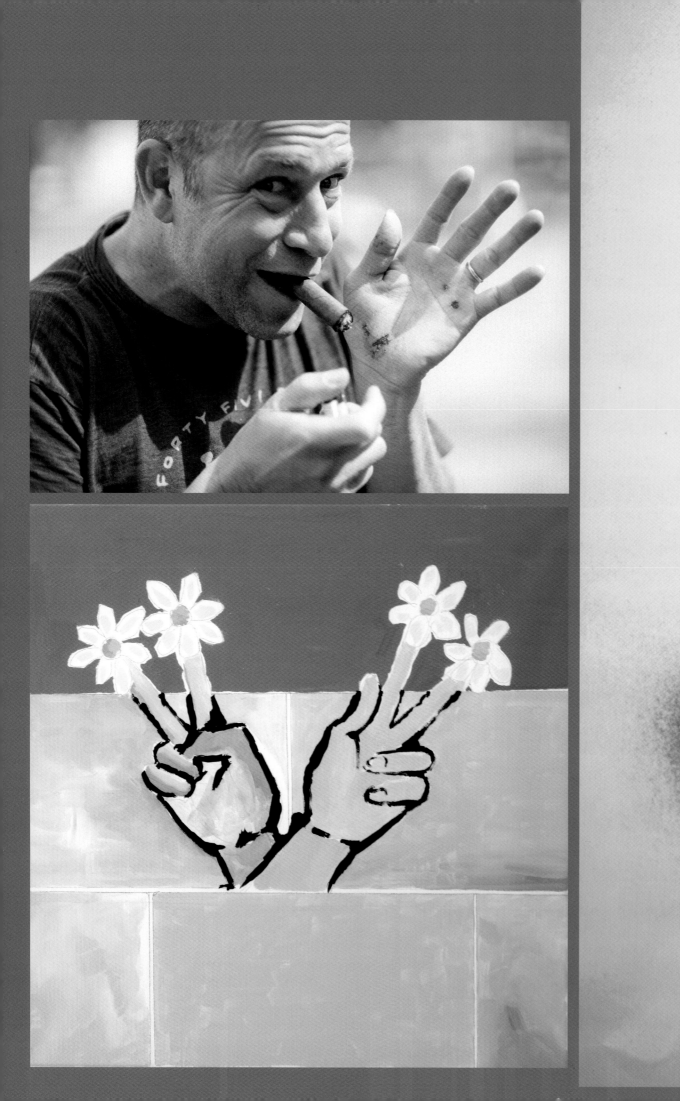

Emma Reeves

Reeves is the Executive Director of Free The Work, a global talent discovery service for women and underrepresented creators and the people who hire them.

I don't think you can separate Mark's personality and his skateboarding. He skates in a unique way that is synonymous with his personality.

-

Mark has always been cheeky, super curious, and engaged.

-

I watched him paint by hand 1,000 bubble-blowing priests for Hardy Blechman at the Maharishi DPMHI Gallery in London in 2006. It took days and nights.

-

I cornered Mark behind a table at Pizzanista! In DTLA back in 2014, he signed copies of *Non Stop Poetry* for 3 hours solid. He kept trying to sneak off but the fans kept coming. Salman Agah produced a special limited-edition Gonz pizza box.

-

I am sure people don't realize quite how few zines he produces each time he makes one. He gives them away so owning a collection of them is really difficult.

-

Q — When was the last time you had fun pushing some boundaries?
A — I do it every day.

-

Passing up on things, turning them down, this happens all the time, the more times you go round the block, the better you are at saying no.

-

Q — What's the last argument you are glad you got into?
A — I am battling with my health care provider right now.

The system in America can be such a nonsensical scam that I am glad I am in fight mode.

-

Q — What makes you feel free?
A — Learning makes me feel free.

-

Q — In which ways do you feel more free now, than when you were younger?
A — I give less fucks about everything.

-

Q — What still drives you nuts?
A — Ignorance, bias, capitalism, greed, Trump, bags of chips that are full of air and no chips. Bleh. And Christmas Muzak.

-

Q — Your website Free The Work promotes underrepresented creators. How would you characterize the friction underrepresented creators encounter today versus 10 years ago?
A — This is long-term systemic underrepresentation that has been perpetuated for hundreds of years. The difference between now and 10 years ago is minimal. There is such a long way to go. But change is slowly happening.

-

Q — What rules should we respect?
A — Respect respect.

-

Any attempt to please everyone is a race to the bottom and results in mediocrity.

-

As my mum would "What doesn't kill you makes you stronger."

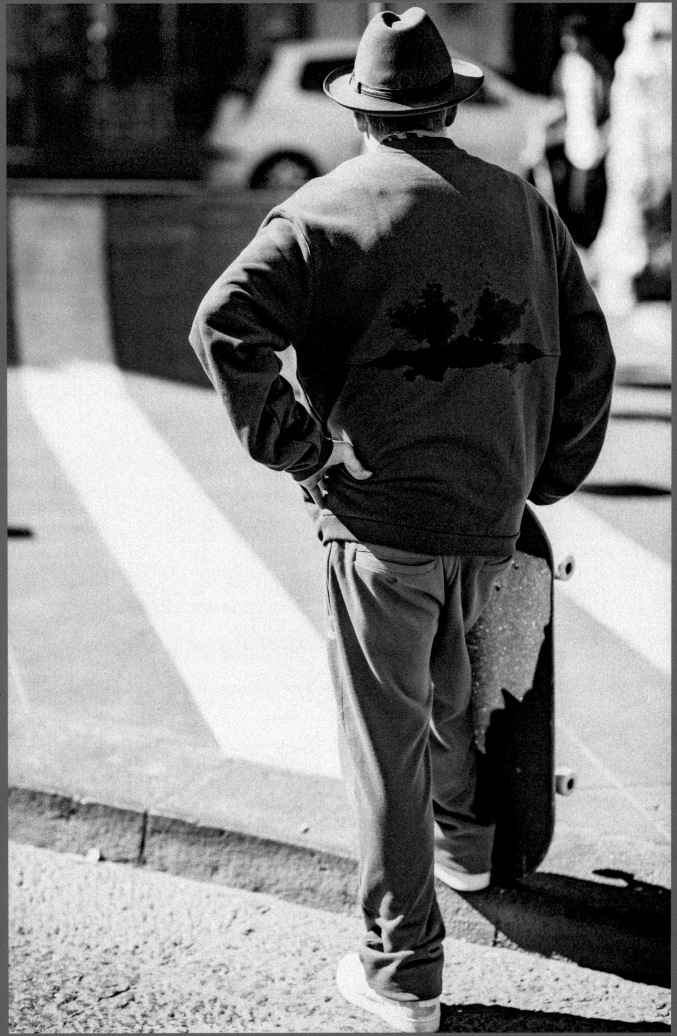

FRICTION – CREATIVITY
FREEDOM – LIGHTNESS
WORK – PLEASURE (IF YOU GET IT RIGHT)

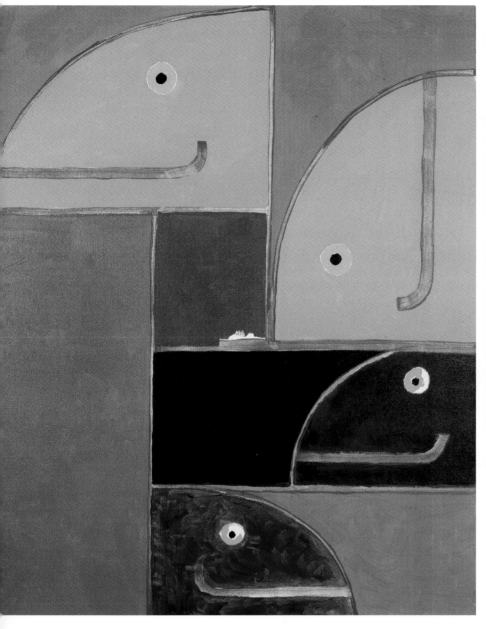

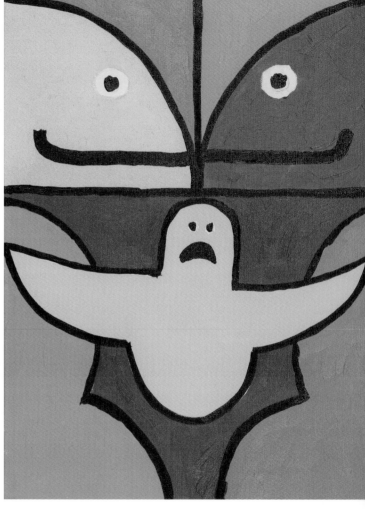

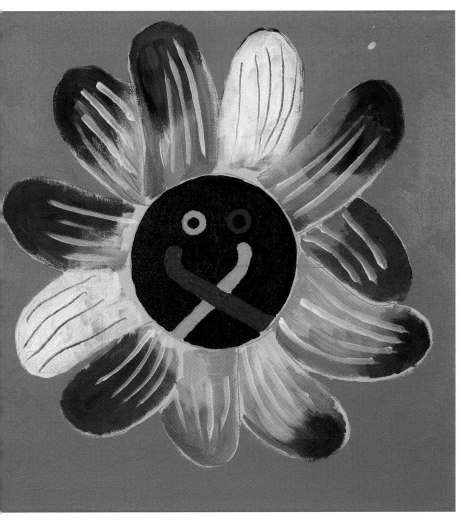

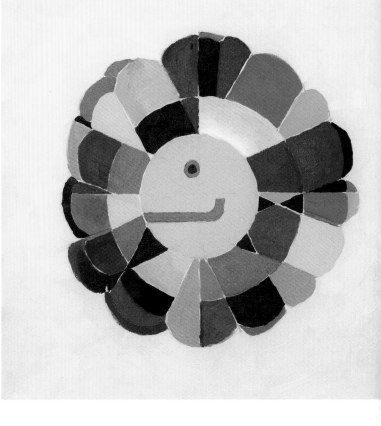

MARK SUCIU

Suciu is an American professional skateboarder from California. He lives in New York.

T — Here we go, interview about Mark Gonzales. December 8, MG interview for Cascade with Mark Suciu. Let's rock and roll. Thanks for coming to the new spot, dude. Good to see you.

M — Good to see you, Theo. Thanks for the invitation. Thanks for the wine.

T — If you could bottle one Mark moment for people to see in 100 years that would preserve his spirit, provide future creators or activists in any field, which one would it be?

M — So much pressure dude. WTF. That's an insane question. Should it be something I've experienced with him?

T — Something you've experienced.

M — OK. So that's pretty limited. But the first time I ever saw him was great. He noticed us because my board went into the bay, and my friend rescued it in a very different kind of way, shimmying under a thing, grabbing a pole and using the pole, taking like 45 minutes to get my board back, and Mark came over and said "Are you Frank? You got his board? That's right man, you're awesome." That's the first time I ever saw him, 10 years old or so. And then watched tons of videos of him, and probably first met him again in 2012 when I was getting on Adidas. He went, "Oh you're Mark too, hi!" And then we skated a bunch. I had a good moment with him, just a little ice-breaker moment where he thought I was walking funny 'cause I was trying to stretch out my leg. He saw me doing it, and he like nervously broke down laughing, 'cause he loved my walk so much. So I started really emphasizing it. He was just bubbling up, "Oh my God, look at his walk!" That was awesome. That was the first moment when I

felt like a kinship toward him, not a kinship, I mean a friendship towards him. From then, we'd kind of see each other around, we hung out in Paris, in Madrid. I think the most inspiring moments with Mark are when he's got such directed attention… not to say laser focus, it's not quite that, but he really directs his attention toward one thing that he's stoked on, and he does that thing. It can be making art or "What the hell's that?" or "Look at his walk!" or skating some random obstacle. When he gets stoked on what you're doing as a skater, he'll just come over and skate with you, or make you do the thing, or start filming you with his tablet. Those moments are really special for me, having him take an interest. But I think probably I'm still trying to work through it, because I don't classify things as "inspirational for an artist" or "for people who are creative," but I mean you can plain boil that down to saying: if you're at all accomplished in your field and you can take an interest in other people, you are bound to inspire creativity. One time he got so stoked on a trick I was doing that he drew it up on his tablet and made it into an animation.

T — That's so cool.

M — Another really inspiring moment was when I just got out of class and stopped by the cafe right by my house. His studio was pretty close to my apartment, I was sitting in there reading and he was in there too. I said "Hey, what's up Mark, how's it going?" He said, "Yo, I'm just at the studio, do you wanna come by, I'm doing an ad for Krooked." Well yeah, of course, and I was picturing there being a whole crew of people, but when I got there it was just him, just him in this small little studio, super cluttered, stuff everywhere, and he was just handing me the things like, "Oh you should read this; you should look at this; do you want this? You can have this lighter; you want this sticker? Do you like this?

What do you think of backside airs?" It was probably February, I wa wearing a long coat and he used my silhouette as the backdrop for the ad he was making.

T — That's so cool.

M — Yeah. He made a little collage of somebody just standing there, and that was my silhouette. That conversation with him was so fuckin' funny—OK, this is kind of relevant.
So he was just ideas, all over the place, just spitting out whatever came into his head. Hilarious shit. Shit about the locker room talk Trump had been mentioning at the time and what maybe someone had do to do with Trump in their locker room, and Kanye West being full of himself: "Man, it's hard being that crazy, like I've been there, you know when you're really thinking that shit, you gotta be locked up dude." And because he was doing the collage, but also because he was sending me all these things, I started to see him as an artist, as just like a collagist—not to in any way undervalue his role as an artist. Like he's a true artist, but he kind of gets there through a kind of collage. And, as all artists do, sure, different inspirations, storyboarding and all that. I'd just gotten out of literature courses and writing classes that day, so I was thinking of it like, "Oh, how could you do this as a novelist." He's such a particular person—so talkative, so happy, so motivated—it's infectious. So, in answer to the question: his presence, being able to spend time with him, if you could bottle that, you would have something that would inspire creatives for years to come.

T — You've got a lot of great stories. You undervalue the amount of good Gonz stories you have.

M — They all feel so fragmentary. This last story was the only time

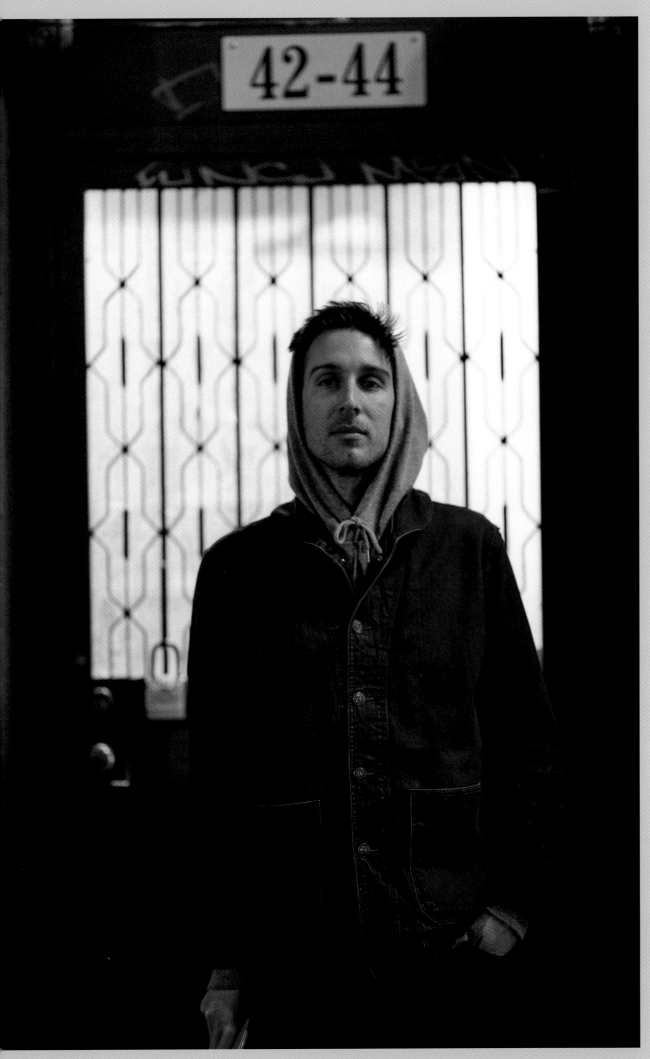

that I spent time one-on-one with him. So that's kind of like one good story I can tell. He brought me over to his studio, and I was the silhouette of the ad, having a great time. And I went home and wrote everything down, everything he'd said, 'cause I could still hear it ringing in my head, the locker room shit. [Laughter]

T — So if Mark were a movie character?

M — It would be Benjamin Button 'cause he gets younger as he gets older.

T — As humans, we are constantly defining and testing boundaries, society's as well as our own. What's the last argument you are glad you got into?

M — So like arguments test boundaries? Well, I dunno if this is the right answer, but I'm glad that I mentioned in a skate interview that back 5-0 back 180 is a bad trick, and now everyone gets into arguments with me about it. And it's a classical rule, but it would be broken much more, I think, if I hadn't brought it up. Because now, every time someone does that trick, they think of me and it's become a joke: "If you do that trick, you know Mark wouldn't approve of that!" I get tagged in that shit all the time.

T — Word. So you argue with people all the time about this?

M — It's a constant argument that is being had with me. I don't always respond.

T — OK. And why are people arguing against you?

M — Because they feel like you shouldn't say any trick is a bad trick.

T — Really? But that's not true. That's like saying everybody's gonna fuckin' be a millionaire and live the American Dream, it's just not true.

M — Yeah. But you can reserve judgment, you don't have to tell everybody that. I could have just reserved judgment.

T — But is it a bad trick?

M — Yeah, it is a bad trick. I don't feel I'm overstepping my boundaries, to have the argument back, telling them why I think it's a bad trick. There're physical properties that just make it look less appealing.

T — Are there people who agree with you, that's it's a bad trick?

M — Yeah. But it's not necessarily objective. The only reason I answered, is 'cause it's the boundary of skateboarding society. Whether a trick is good or not. Or whether you should judge tricks before they happen.

T — So the people who argue against you are saying, "Don't pass judgment...."

M — ...on a trick before it's happened. Like, it's gonna look good when somebody good does it.

T — But you're saying even somebody good can't make it look good.

M — Just saying that even someone good, I would rather see

them do a different trick.

T — Awesome. I respect that. So—a big part of skateboarding is identity: finding yours and expressing it. What is it about skating that makes this possible?

M — The fact that it's not a competition sport, not a competitive sport. I mean like, *really* not a competition-based sport. When you skate you get out there, you do shit by yourself, you do it the way you want to do it, and you do it based on what you've seen—which is the basis of all art. You aim toward the greatest people you've seen do it, and the people that you're obsessed with watching. You're inside their minds, how do they do what they do, and try to emulate them while creating your own path. I think it's the solitary-ness of it, and then the fact that it's—

T — 'Cause even with all those people around you, it's still solitary.

M — I mean, most people that grow up skating are kind of on their own. They have friends around but you're still gonna skate in your driveway by yourself. So yeah, you do skate with friends but you're going home on your own. You're looking at your board in your room by yourself, and you might lace up your board with stickers or whatever, or do some drawings 'cause so many skaters are artists too—whether doodlers or full-on, paid artists. In tennis, you're not drawing on shit in tennis. And a lot of people make their own clothing and shit. So skating has accessories, and it doesn't have the regulations from being a competition-based sport.

T — Like you say always, we're all biting at this point. A lot of people talk as an original, as an innovator. And you say you emulate people, and then you go work solitary. The thing is, inside of skating, with so many unique personalities, how do you stand out? Is that something that is just organic and natural? Or is that something that is sculptured, carved?

M — I think it's definitely natural because in film and narrative arts, you could say, "I've lived an experience that hasn't been told. I wanna tell that experience." But you can't really do that in skate, you can't be like, "I thought of these new tricks, and I wanna do 'em," because it's really hard to think of tricks that haven't been done, that are actually possible.

T — Just learning how to push, dude.

M — Oh yeah.

T — I mean, I guess it's the same, you have to learn how to sew and cut and all those things.

M — I was just thinking you have to learn how to ollie that set of stairs, grind that rail, do those ledge tricks and flip tricks and ramp tricks before you can.... You have to learn how to skate really well before you can do anything with a career, or your own name, you know? You have to be *so* talented in order to create a new way of flowing. 'Cause that's what it is, when you see somebody do something new. They're just flowing.

T — And you think that's what Gonz represented earlier in skateboarding? 'Cause skating was so new, yeah? It was only a decade old....

M — Yeah, he invented so much, he was very early-on, he did have

that. He could say, "Oh well, what if you grab the board like this!?" That's a very straightforward grab, you just go like that. Stalefish. And he invented that. Now at this stage, it's a little different.

T — I found out about this Suciu Grind.

M — Yeah. That one's just another technical shape, you know, if you get technical you can do all these tricks.

T — Where did that trick come out of though? What was the inspiration for it?

M — It's just like a hard trick that hadn't been done. There's so many other tricks that are like, "Oh, nobody really does this one," because early-2000 handrail skating is nothing compared to what's going on now. There's a lot of progression. So technical ledge tricks brought to handrails is a really fertile ground. You could do a trick on ledge, pretty easily, that's never been done on a rail or mini ramp, so that's always been my thing. So, I had this trick on mini ramp, that I hadn't really seen many people do, and I did it on a handrail. I lucked out and it became more simple just to refer to it as—

T — As the Suciu Grind. Got it. You know Gonz, it's his stratosphere, it's his realm, but I think it's interesting, you're definitely in your own realm of being that innovator, looking at skateboarding in a totally different way.

M — Yeah, with this trick in particular, what came out was modern.... Handrail skating hadn't seen that much progression when I did it in 2012, it was still a lane that was opening up. For Gonz, he was back at the point when all skateboarding was opening up and he was at the fuckin' forefront. So he was just like, "What if we grab a board like this, what if you slide down this rail, what if you do a 360 but you come back out this way." And he could just go and do it. It must have been amazing to have that talent at a time when everything was much more open than it is now.

T — In which ways do you feel more free now than when you were younger?

M — I think I feel very free not to have to live with my parents. It's a really strong answer. I think it's fuckin'.... It's so hard to do justice to the feeling of being trapped up in your parents' house, like how closed off you are from the world. How insane that is. And also the fact that the rest of the world looks at you before the age of 21 as this person who shouldn't yet get to decide really important things. Often I see people breaking out of those bounds, and doing really important things before they're fuckin' 18. Even up to about 20, I felt like I could do so many things with this life, and so many things are important to do—but I have no idea where to start because I have no momentum. So finally I got the ball rolling and did some things, and they all pertained to what I care about—skating and literature and aesthetic forms and shit. Storytelling basically.

T — Sure.

M — And it's being with my creative family, with my chosen family. And I got to create the family along the way. I feel freed by the fact that I get to choose to include my parents in my life, instead of that being a given. And that I get to choose my own friends, who I surround myself with. I get to choose where the fuck I live, that's amazing. My daily environment, what I see

around me.... Skateboarding, I've always felt pretty free, but the fact that I have a career behind me now, and momentum. The very basic quality of momentum is I'm motivated just by the fact of already being here, in it. I'm motivated because I've put stuff out and I wanna put more stuff out, that reacts to the earlier stuff in a different way. So I feel free by having a skate career, because now there's so much to build off of and play with. I feel free by having stuff on the table already.

T — Yeah man. It's a family. Back to that question that we couldn't answer but on some real shit that's so beautiful. There's a lot of freedom inside of that, and that's so beautiful.

M — Yeah for sure.

T — Created and biological. That's an awesome answer.

M — Thanks.

T — Done. So what drives you nuts?

M — Lying, littering, bad grammar.

T — Beautiful. Advice to a young creative—which rules to bend, which rules to respect?

M — That's too general. Doesn't make any sense to me. A young skater? Young artist? I would just say.... You fuckin' ask me, even though this is general as fuck, I will answer by saying: respect a lot of rules. Break only the ones you know you have to.

Interview by Theo Constantinou

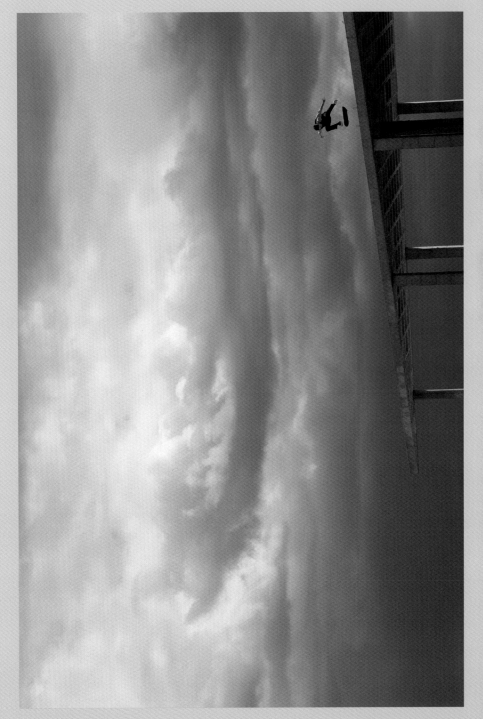

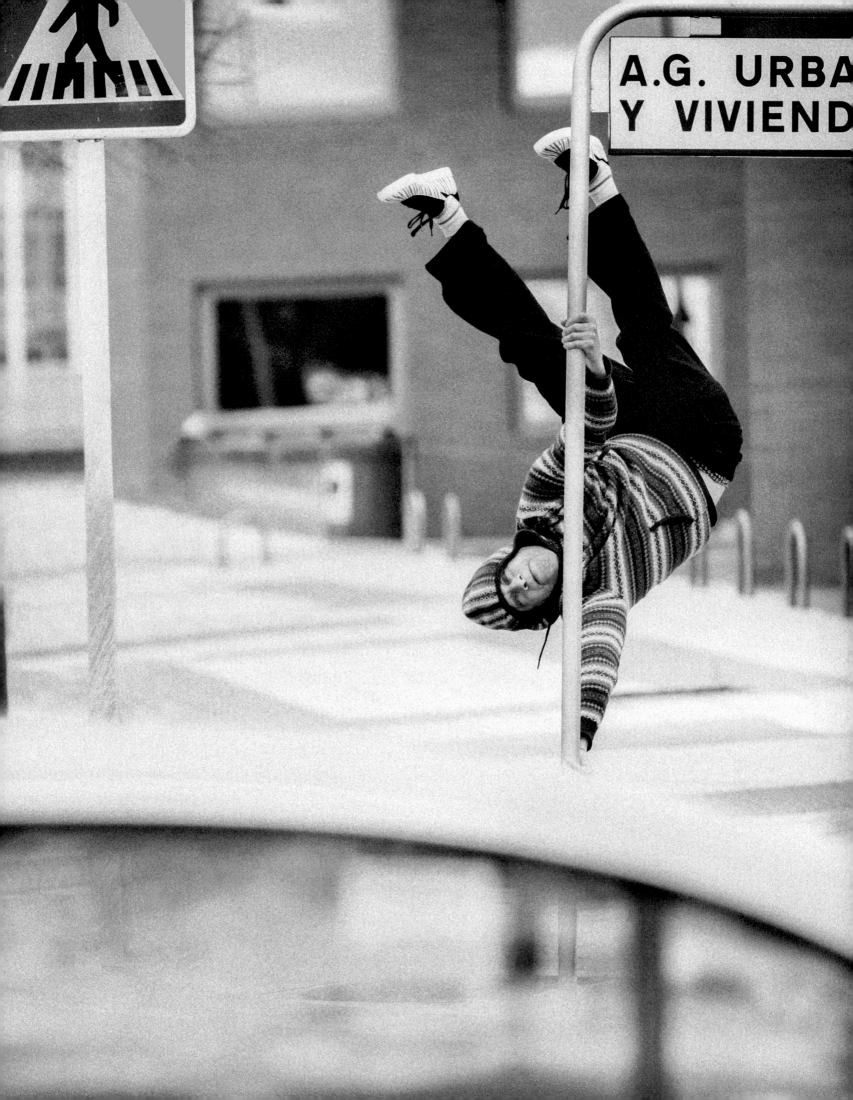

SHE
WISHED
THAT
I WOULD
NOT
SET
THINGS
TEETORING
ON
THE
EDGE.
 WHER
 IS THE
BALANCE
OF NATURE
SQUAR
IN THE
 CENTER

Nora Vasconcellos

Vasconcellos is a professional skateboarder and artist. Originally from Massachusetts, she lives and works in California.

Okay, I'll just say the first thing that comes to my mind about Mark. Just recently, this past summer, we were skating back in Massachusetts. We drove by this little granite curb. If you ran it over in your car, it's the kind of curb that would pop your tire. The way he skated this... I wouldn't even look twice at this spot. He ollied up, rolled across, frontside boardslided it, and came off it in a rock n roll. The way he can still slam and roll around like an 11-year-old. I can't imagine skating with him and not having fun. Him driving around in his classic Benz.... he's timeless, and gets better with age. Or rather, he doesn't age. Nobody is like him. Nobody reminds me of him. He's unique and contagious. To see him with his kids—he's so built to be a dad, he's just always playing anyway. And creating. It's great to see that side of him. It's a perfect extension, like a dad from an 80s movie. He's very in it. If he has an idea in his head... nothing is going to get in his way, he has to follow through with it. Unless HE is not feeling it. It could be anything, like he had to get a special kind of paper for a stencil. He can visualize something, and then go create it.

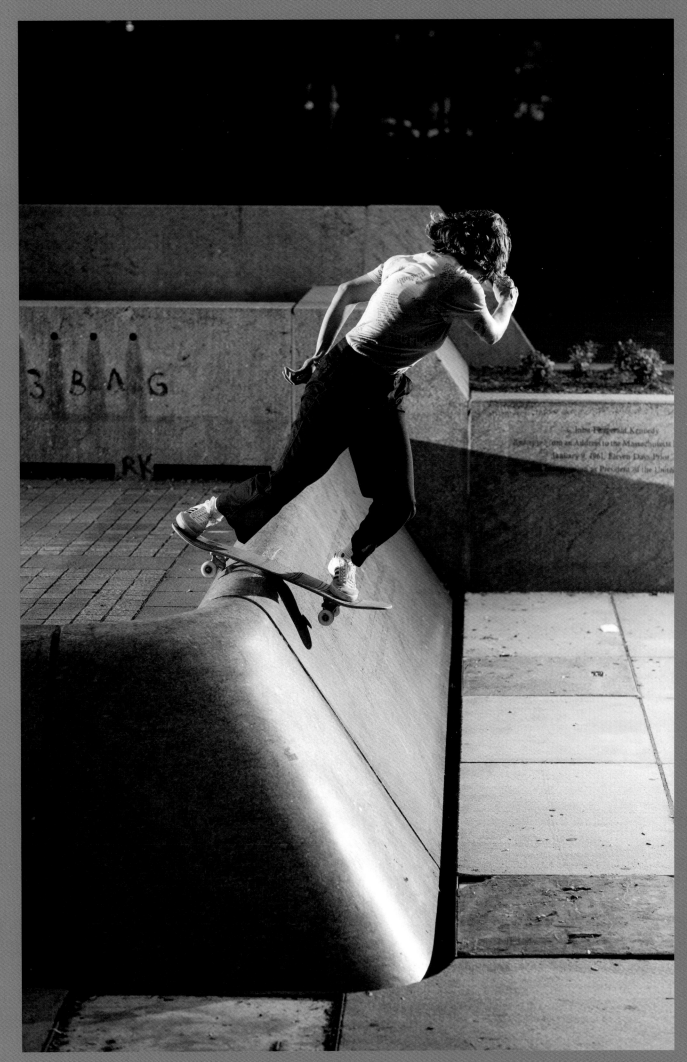

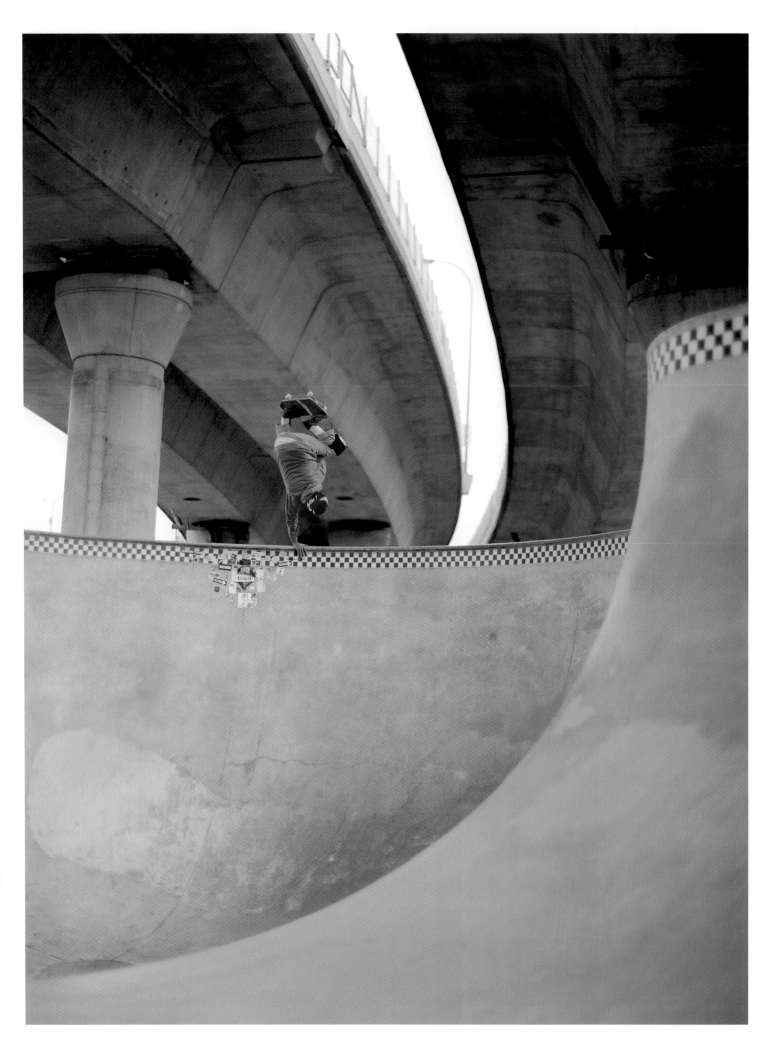

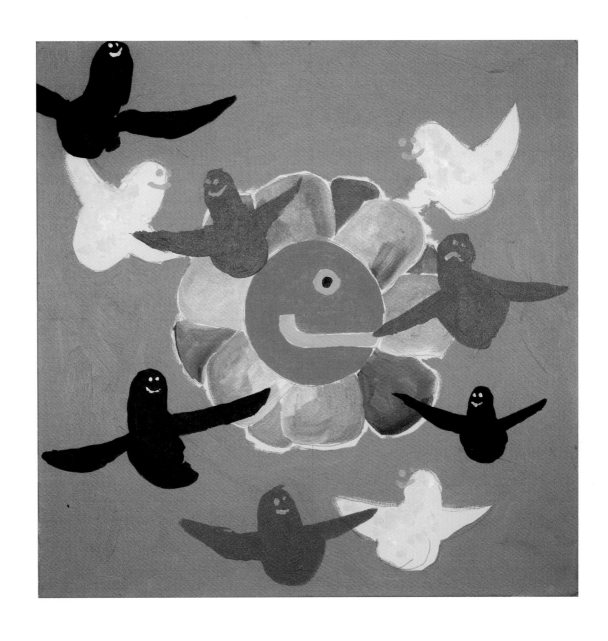

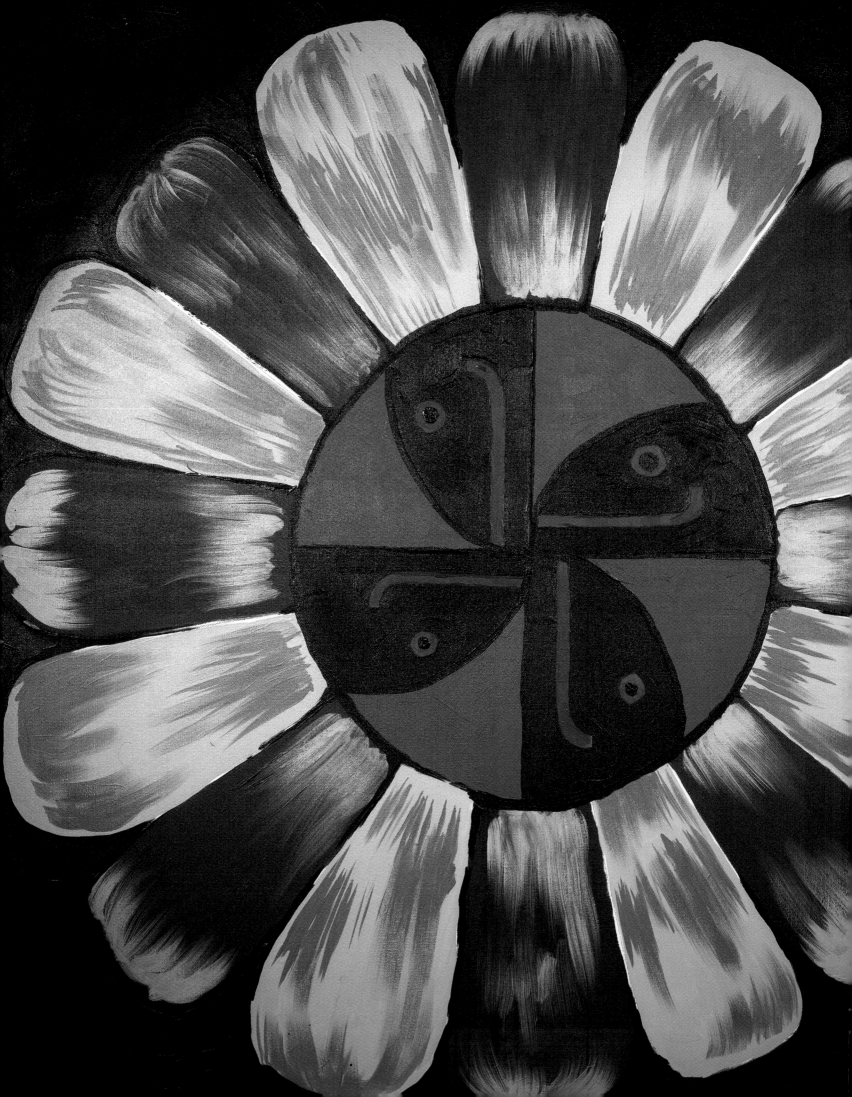

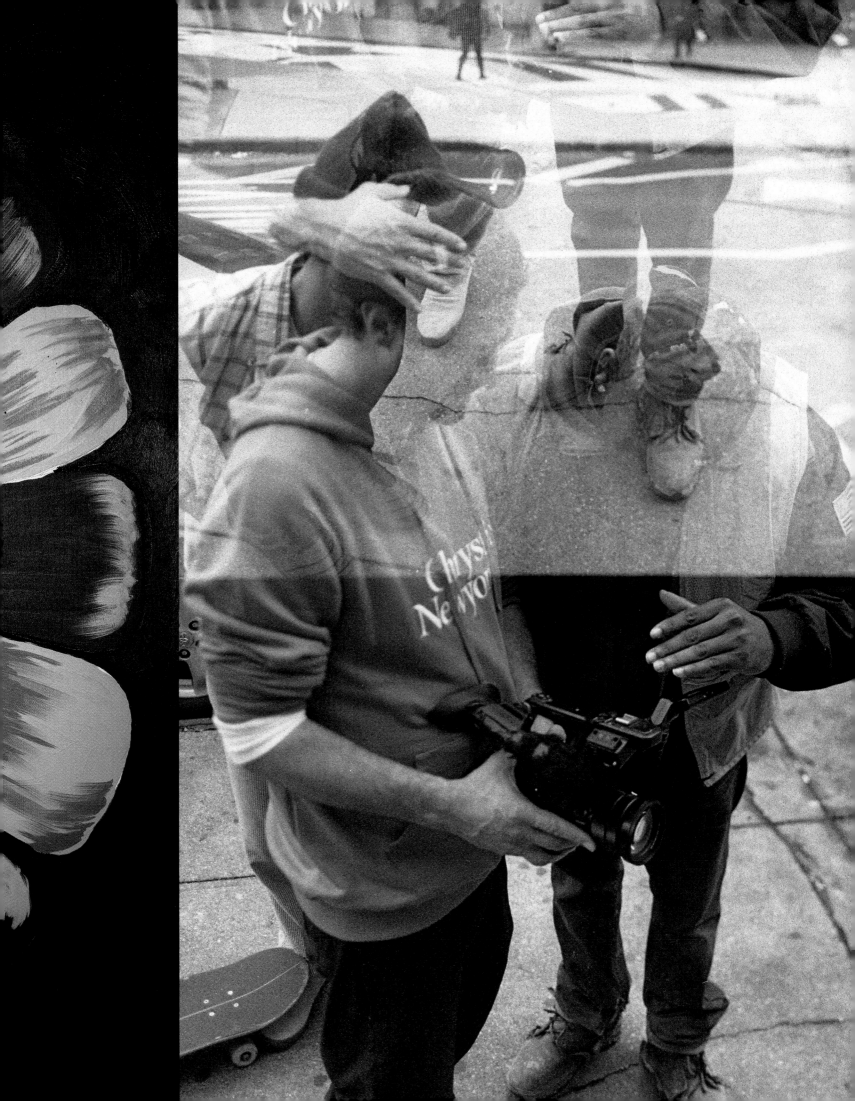

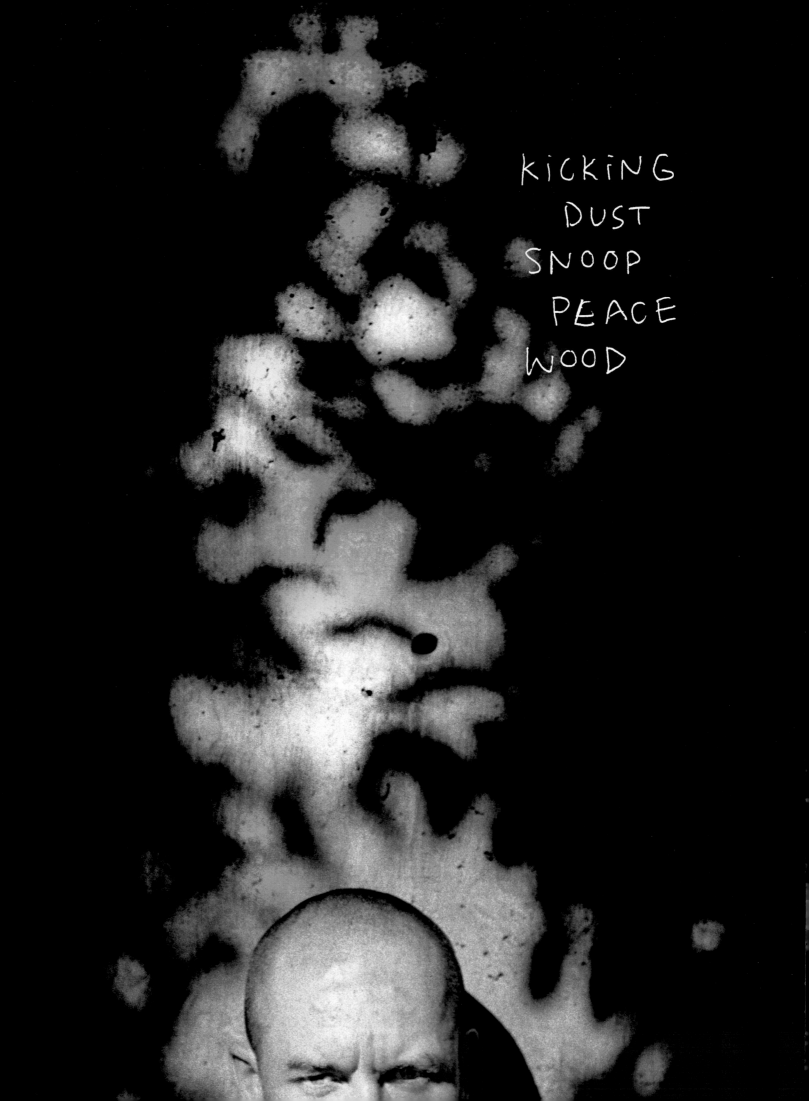

KICKING
DUST
SNOOP
PEACE
WOOD

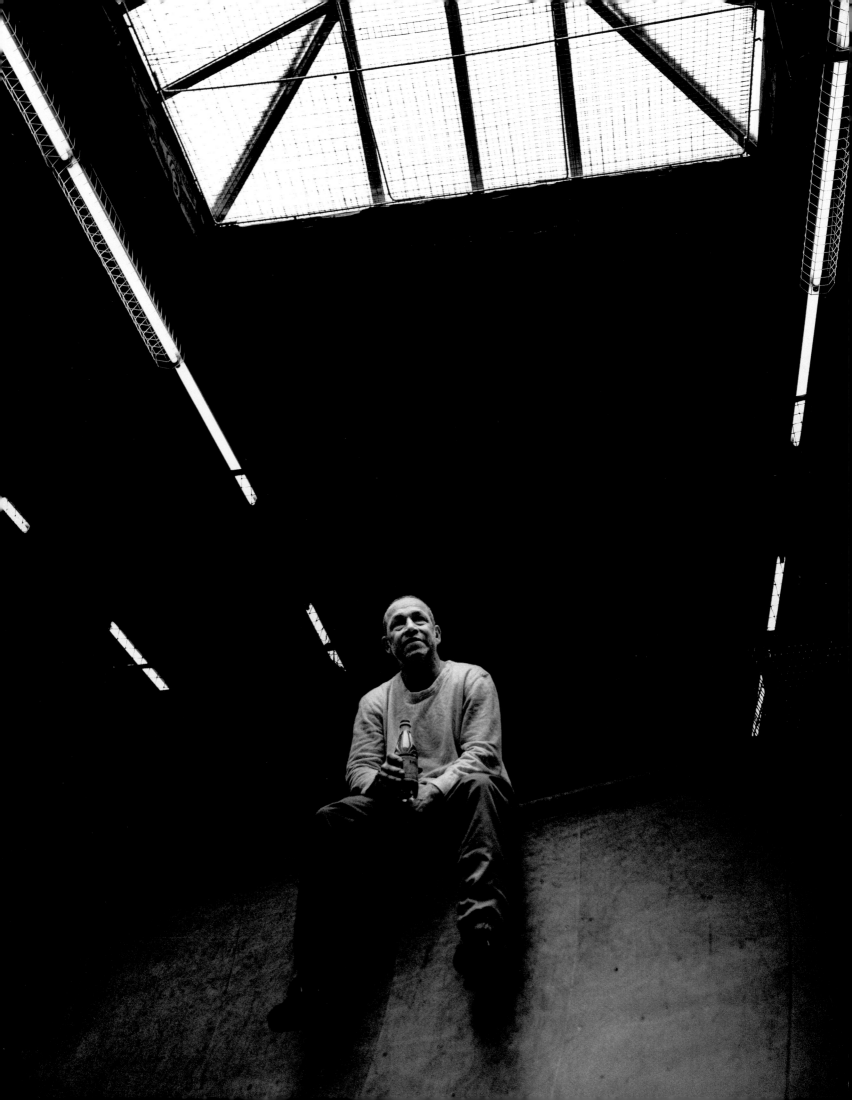

Neil Blender

Blender is a skateboarder, artist, and Co-Founder of Alien Workshop. He was one of the first skateboarders to draw his own graphics.

A — There's a certain mentality in skateboarding that's focused on progression—faster, higher, harder. Counter to that, I feel like we're all chasing the thrill we got when we first started. How did skating feel to you when you first found it?

N — It was just a gradual feeling that kept getting better over time. I remember in the very earliest part of my skating with clay wheels, I would skate on my stomach and push with my arms because standing up felt a little scary—too many rocks making the wheels stop and you fall.

A — This ties into the Streetstyle contest in Tempe, Arizona, when you famously opted to paint one of the walls with a character for a good portion of your run. What inspired that?

N — It was really hot in Tempe...kinda the worst feeling in that parking lot. I didn't want to skate it, I just wanted to ride the vert ramp. I drove there and had a small can of spray paint in my car, so I put it in my pocket thinking, "Well, if I can't do much at least I can draw something."

A — The section in G&S Footage (1990), when you're critiquing board graphics stands as one of my favorite parts of a skate video ever. It was exactly what a lot of people were thinking about at the time. A lot of companies were still stuck in the 80s aesthetics and you chose to call it out in your part. Why was it "time to get rid of the skeletons" back then?

N — It's always time to get rid of them. It's not that being cool reminded of what you look like under your skin and stuff— death kind of sucks really. Skulls are weak.

A — What was important to you about using your graphics as a vehicle for expression rather than something with your name on

it that someone else drew?

N — Steve Cathey, the team manager of G&S, suggested that I should draw something for my graphics. That was the early 80s and I just kept drawing them throughout the years.

A — Do you recall the first time you met Mark and the impression he made on you?

N — I think it was an Upland contest in the early 80s. He was skating the parking blocks doing street plants and stuff.... I was hyped. One time we were skating Lloyds Bank in Santa Ana and we were riding home from there and he was in front of me. He cracked an ollie up onto a bus bench and kept riding. I just about shit myself.

A — I attached the Grant Brittain flick of Mark with "Yes, I try to act weird" written on his grip tape. Do you think Mark actually "tries" to be weird?

N — Not really. Maybe sometimes if someone is bothering him.

A — You and Mark are talked about together so much because of the creative impact you had on skating that's still present today. In what ways are you and Mark similar and what's something very different about you?

N — We both like handplants and axle stalls. Where we differ is skimboarding—he still needs to start going! We went together early on, but he never kept at it. It's a lot like skateboarding. You need to do it a lot to get comfortable.

A — Pinpointing Mark's influence almost becomes personal preference, he's impacted skating in so many ways. What do you

think his biggest contribution to skating has been?

N — There's more than one big contribution. His part in the Blind video [Video Days, 1991] says a lot—his handrail stuff was great...the kinked rail in Costa Mesa, his long boardslides, and his ollie style is top-notch. His ollies now are super sick still— handplants, too.

A — I think about the fact that a lot of skate history was never documented, and when we lose people such as Jake Phelps, we lose actual historians. That being said, is knowing who invented what trick or the evolution of skating important, or is it all better suited as folklore?

N — It's cool to know how—or where—something started. In Orange County, the invert was supposedly invented by a guy named Simon. They called it the Simonize, like the car wax. He skated Mission Viejo Odyssey skatepark—that's all we knew about it. Everything is all happening. East Coast dudes have their stories, like Mark Lake and the "Lake Flip." From here [California], there was Darrell Miller inventing the "Miller Flip."

A — What's something Mark said that stuck in your brain?

N — I feel when he says "birthday cake" or certain other phrases, you can hear his accent come out. That's cool. Also, just his skating in general is great, he makes you want to try harder.

Interview by Anthony Pappalardo

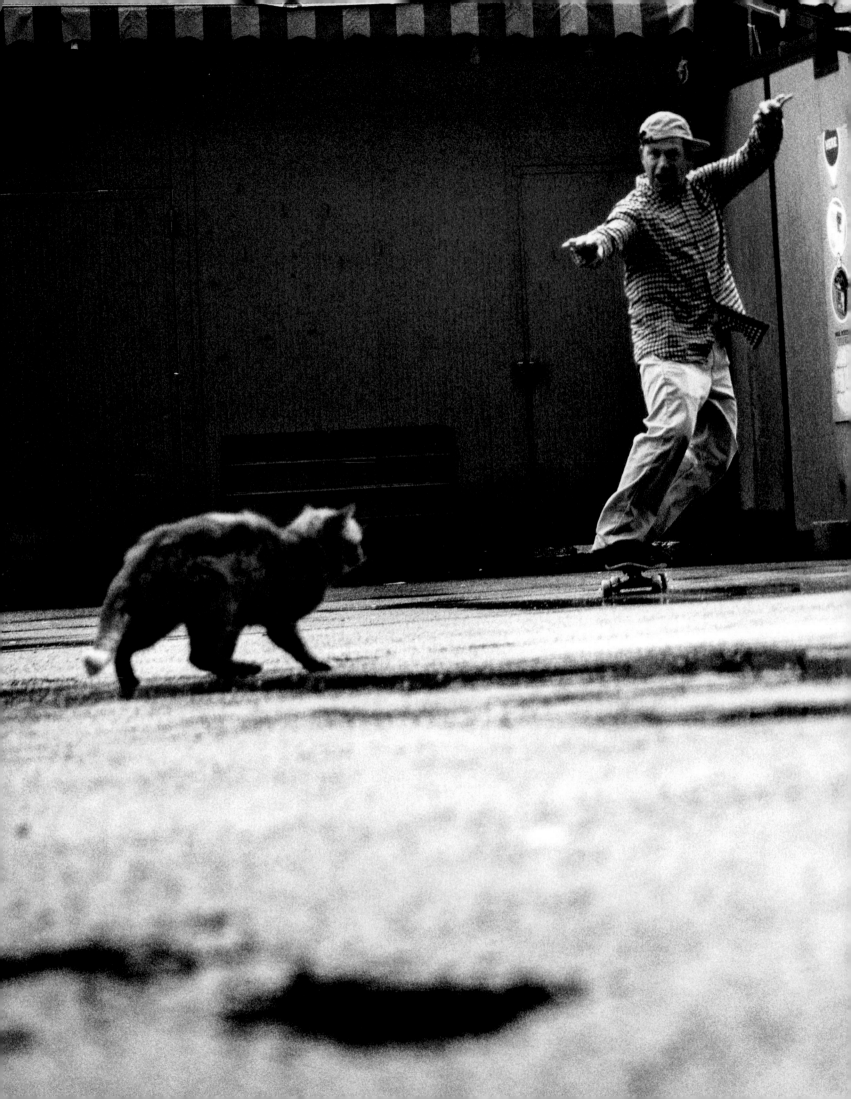

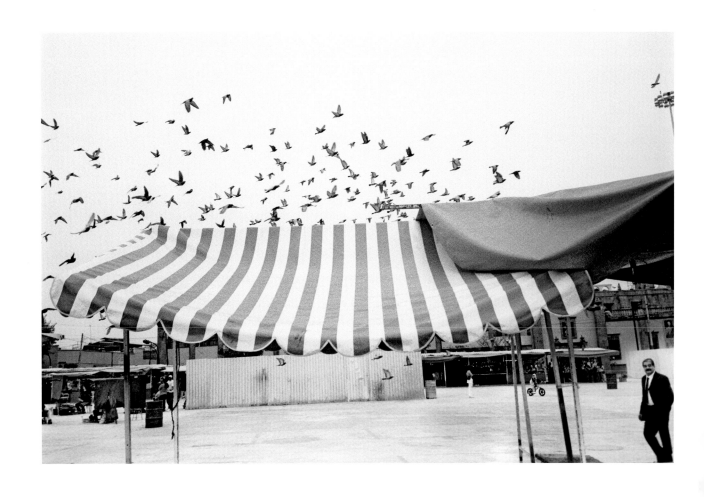

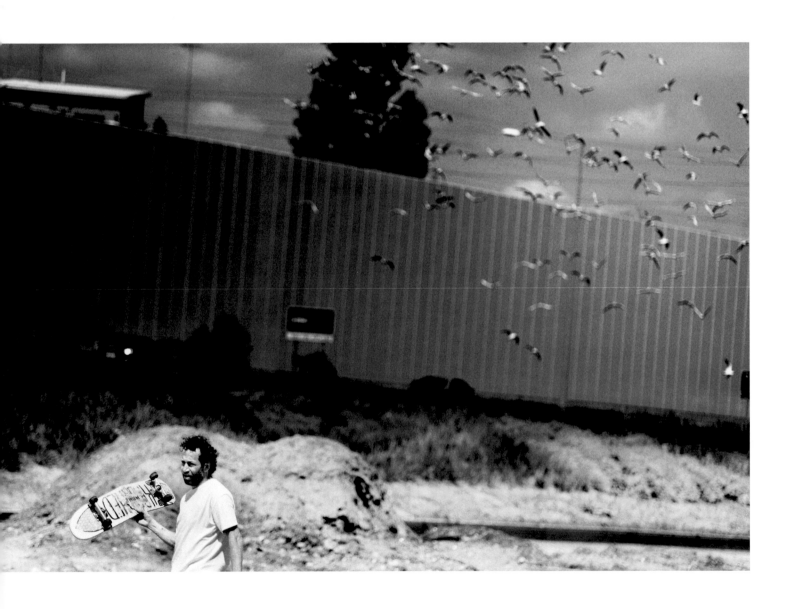

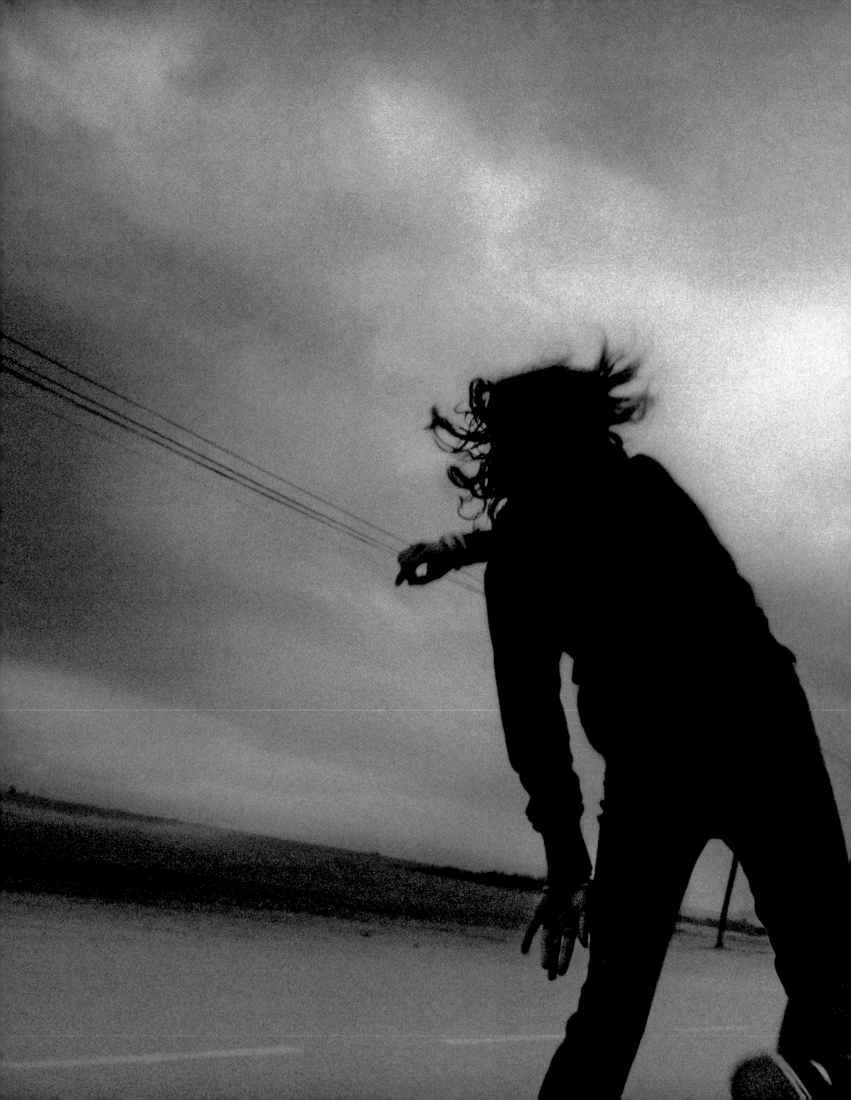

CURTIS KULIG

Kulig is a North Dakotan artist and designer who lives and works in New York City.

L — Curtis, when did you meet Mark?

C — It was my life in the 90s. That's all we wanted to do was skate. So Mark was a huge influence on me in that capacity. It was pretty weird to come to New York, it was just a thing. I had originally met Mark in San Francisco through a girlfriend, he was living in LA at the time. But I'd known of Mark forever, through skating—when I was very young I used to steal my mother's credit card to order skateboards and things. There was a 1-800 number that you could call, CCS it was called, then there was another one called Skull Skates, and I would steal my mom's card and order skateboards. I would figure out when UPS would come, and whether she'd be at work. She didn't notice for years, and the one time that she intercepted the box, I had ordered an ATM Click and there was a Mark board. I think I just liked the imagery on it. And then the catalogue! The boards were so small, you couldn't actually see what was going on: "Ah, that looks cool?"

This deck had 2 characters talking to each other, one was saying, "Fuck you, something-something", and the other one was like, "Eat shit! Something-something." I was young, in 6th or 7th grade, and my mother was more tripping about the curses than the credit card. I think that might be it, my first introduction to Mark as an entity in my life.

L — What do you think the thing is with America and parents and swear words?

C — Yeah, it's interesting. Is it not something that goes on in Europe? I still feel like my mother is like: "Stop cursing Curtis."

L — Yeah, especially when it's in writing, or in any form of culture—music, movies, whatever.

C — Yeah. If you're cursing directly at someone, that's one thing. But it's not OK to be using it as verb/adjective in a sentence....

L — Or even seeing it can be humorous.

C — I actually think that it might have been a bit more next-level, maybe one character was a priest. Not that my parents are religious, but.... There might have been something more derogatory too, a little bit more than "fuck you, eat shit." But I don't remember exactly now.

L — When was the last time you saw Mark? What did you guys do?

C — I saw Mark about 2 weeks ago. He came over, he needed to make a painting. He does this sometimes. He knows where to find me. At this point in my career in NY I don't leave the studio so often, I'll be in the neighborhood but I'm not trying to go on any wild adventures. I'm here to work and he knows that he can come regular. It was for one of his friend's kids, for their birthday, he needed a little canvas and I had it. So he came over and painted and we ended up making a painting together as well.

L — Does he like collaborating with his art as well as his skating?

C — I don't know, I feel like he really enjoys going skating but he likes to direct it still, he likes to have a bit of control over it. But he's very interested in other people and their tricks and how they do them and, you know, their aesthetic. I think he feeds off that, I think he feeds off it more in skateboarding than art. I think in art he likes to be a little bit more inward and make it a little bit more fantasy, or it's more about him. I don't think he collaborates with that many people in the art realm necessarily.

L — Because he could, easily, right?

C — Yeah, absolutely. I think one of the things that keeps me OK about so many people coming over is that I have this system where I am shooting pictures of whoever comes over, and the time it is. It gets put in an archive: the UPS man, FedEx, friends, everyone—it's

been 3 years of it. I don't know what I'm gonna do with it yet but it would be an amazing book. To be honest, I mean it's over 20 people a day. If the UPS man comes 3 times, he has 3 pictures, and all 3 times are on the database. Which makes me feel, when the bell is ringing, "Well, at least the project's getting bigger", rather than: "I'm gonna fucking....!" Because it's a lot, it really is a lot. This place is so central, there's a lot of people who wanna charge their phones, or get internet. Like the young skaters hanging out. I have the rooftop so I usually just send people upstairs, especially in the summer.

L — That sounds very "godfather of the neighborhood."

C — Definitely, not that they look up to me, but the mediator. They come to me with their problems and things and I try to talk them through things. You know, I try my best.

L — What kind of problems?

C — You know, just whatever's going on. You know, the youth in New York, they're so motivated and great. The only comparison I have is when I go to Los Angeles, I feel like the kids are so lost and, you know, a little bit more disturbed weirdly. Like New York kids are motivated and excited, and making videos and shooting photographs yet still partying and going out, where the LA kids are getting more influenced by the drug culture, but not even necessarily going out and letting loose. I don't know, here it gets dreary, but the kids all seem very healthy and motivated, it's nice to see. I see both. I have friends with kids and I watch, and the LA ones are like heady and crazy, and carrying guns and weird shit—and I'm talking about normal, like, kids who go to good schools and shit.

L — It sounds like they don't know who they are, maybe like some pretty deep identity issues.

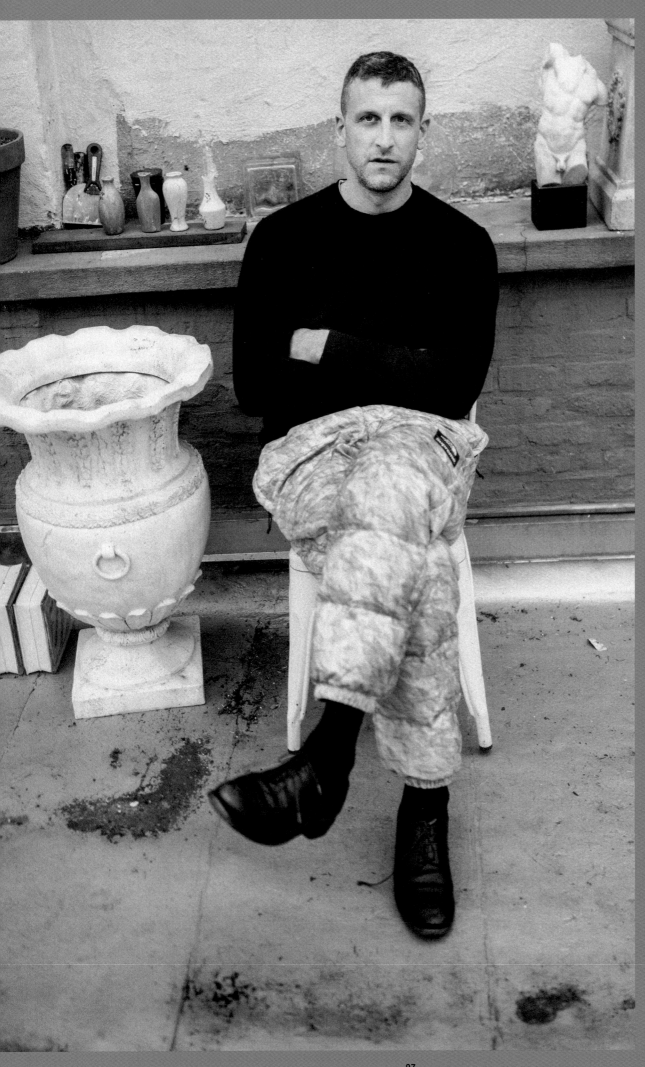

C — Absolutely. Which LA can push for sure. And New York is more down to earth, "We're all on the same level, and we're trying to survive, and we all work," you know? I assume that's where it all stems from mainly.

L — There is an obsession with work in New York, where in LA it can be more like, how can you get by through knowing people, to not have to work, or to be hooked up into something easy.

C — Totally. And you sit around and wait for that. With Mark, we've worked together in an art capacity for years. I mean even that first time we hung out in San Francisco we made a body of 8 paintings or something, together in a hotel room. That was the first real time I spent with Mark, and so we made paintings from the start and throughout our friendship we've continued. But I don't feel that he works with too many artists, and he does have the option to have access. I feel like the very upper echelon blue-chip art crowd really respects him. They know who Mark is and they respect Mark for what he is, for sure. I don't think that he's painting childlike or so simplistic because he can't paint the right way. I mean, I don't think he's a traditional oil-painter, but his aesthetic, his compositions—his perspective on things is crazy. It's one thing to be able to draw still-life or draw what you're looking at, but he can translate. He'll be describing to me a girl he saw: "I saw a girl, she was walking across the street and she had this red hair, and she had this nose like this actress...", and then he will draw an image of a woman and you'll see all of the minuscule details. I mean, it really is special. Going back to this idea of him blocking that out a little bit, I don't know if you are referencing him not bringing in these European techniques or hyper-realistic ways of painting but I think that really minimizes it. He's also very impatient so I think he needs that direct satisfaction, he wants to have it now.

L — It's interesting, as a creative or an artist in general it's your job to define your world—this can come in, but this is gonna bug me or throw me off course—you know, filtering.

C — Which I think most art is made that way in general. But his is very personal.

L — When you read his short poems, his text, do you feel like you have extra insight into them?

C — I do, I do feel that way, yeah. I think that goes for any art. Art is such a subjective thing, so often I feel paintings—but once you personally know somebody it becomes more about that person than you, so it changes your take a little bit. His poems, I know what he goes through.

L — Do you hear his voice?

C — Yeah, totally.

L — Can you tell me about his way of skating? What connection do you feel to it?

C — There're 2 ways I feel about it. There's a more innocent way, when I didn't know him. And now that I feel personal with him there's a different way I look at everything he does, whether it's skating or drawing.

L — What touched you? 'Cause you look at some people skate, or move, and you think "whatever." And with some people you connect emotionally.

C — Sure. He just has that thing. I mean his style's crazy. I should have done a Mark brainstorm before, I almost have so much information in my head that it's hard for me to translate it. So often you're just like, "Wow, Mark." He really is one of those entities that you know, you can't make that up. He's constantly going. You can get him to focus though. If you get him to focus on something, it's fun to watch him. It's nice to see his perspective on that, on art—to go to a museum with him—you should bring him to a museum. You can't make that up either, he's so much more informed than one would think. He knows what's up in art history, Renaissance paintings, every aspect of it. He knows the life stories of these people, he knows where people came from. He's deeply versed, he always has some tidbit of information. Sometimes I think he's a late-night YouTube watcher of every history from cavemen, to the stonemen, to the Egyptians, 'cause he has so much information. But not only that, he like, breaks it down and takes these little aspects that are just Mark, and just holds onto those. And it's always very factual too. It's factual information. It's the same as when I was talking about his drawings and perspectives of people, the intricacies of these things are factual, and it's trippy.

L — The way I've heard him described so far makes me think "OK, so he's a psychic." He's somehow connected.

C — Yeah. It's real.

L — What would be a soundtrack for him? What would be a song?

C — Jesus, and there's music too. I mean you cannot make it up. I know you're asking me what the soundtrack would be, but I go straight to his taste in music, and how he puts it in context with his videos that he's making. I think that he does these obscure songs because I think YouTube doesn't accept the real things, and he doesn't want to break the boundaries of YouTube's rules. He's also very particular about rules, that's an interesting thing to talk about Mark. When it comes to the law or something, he reminds me of my mother. My mother has always been like, "Well you stop at the Stop sign because it says stop," you know? Because that's the law. I feel like nothing stops him from what he is going to do, nothing. It does matter. But when it comes to actual law and actual authority he is like, beyond. Like he wants to stay as far away from any sort of police interaction or anything that becomes real real, like with law.

L — Maybe he's had bad experiences.

C — Yeah, I think that's what it is. To tell you the truth as I'm talking right now I think that he's had a few really wild ones. I think one in Tokyo that really tripped him out. That's definitely what it is. He's such a beast about everything, but when something like that comes into play, or anything illegal, it's like—out.

L — I think most people who actually brushed up against a system and realized that when it comes down to it they can be nothing, you don't keep fucking around with it if you know how bad it can get.

C — Absolutely, it's true. It's one of the only things that can really stop everything. I think that he has had a bit of a taster so he's like "No." So it's like this intuition in his head and he just cuts off the second that anything illegal starts to happen. But then at the same time he'll like trip out and drag something into the middle

of it, you know what I mean? It's a weird balance of the both. A soundtrack for Mark, I really don't know.

L — So what about Mark's relationship to skateboarding, the freedom, interactions with people, and how that influences his art?

C — Yeah, through skateboarding, and his being on the streets, movement and energy, and interaction with society and doing tricks on the board—I feel like that has no boundaries. I feel like he truly has no boundaries, like that's his open field to play, whereas in paintings—which is usually kind of opposite for most people—it's like he's almost more constrained because it's much more cerebral. The physical part of him moving around is an important aspect of him. I think he feels more freedom in the streets, interacting and running around, doing that. I dunno, the studio seems more like there's boundaries for him and he has to be a little bit more contained. But at the same time I feel like he is doing what he wants through his work and his poetry.

L — Painting is hard.

C — Painting can be a nightmare, yeah.

J — Would you say that his skating is as important as his painting as a whole?

C — Yeah. I mean, skating is such a huge aspect of him. Most people would probably think of him as a skateboarder, I guess, but I would think of it as one of his wings. And I even think that he's doing it in such a more artful, more performance-based way. It's like a performance piece every single time. But also involved are the technicalities of what needs to happen to get that trick in the first place. So it is also strategically planned out. Man, he is a trip. You can give the guy a jump rope and he'll make something out of that, he can't just jump rope like a normal person. It's just constant progression, it's like a little bit more and then a little bit more, and then adding his own style to it, it just becomes this whole package. I don't really know anybody who really does it like that.

J — When he rides a bike, it's a performance as well. It's not that all skateboarders are doing art when they skate, but somehow because of Mark's point of view and interactions, it becomes this canvas.

C — You can't make it up, it just doesn't end. Even him bringing Gemma to school in the morning, I just wonder what goes on on their walks. They definitely don't just walk to school. There's gotta be so much going on throughout the journey.

J — And then him coming home.

C — Yeah, alone! His silly moves in Spike's film [How they got there, 1997], too. And that was so long ago. And hands opening the milk. He's always commenting on my hands, taking note of them. And his are just, like wizard hands almost. And then his pinky is an exaggerated part of this wizard hand. In this film he opens the milk, and his pinky, it still looks the same. It's like this dirty fucking little nail. So Mark.

L — Can you tell me in which ways you feel more free than when you were younger?

C — Wow, I guess when I was younger...it's a great question. I can only really think about when I was losing my freedom, which was around 13 years old. When I first started feeling held back from

"TO ME,
HOCKNEY'S
IPAD
DRAWINGS
CAN EAT IT
COMPARED
TO MARK'S"

things, whereas before, everything felt really light—until probably 12, 13 years old. Once I got into my teen years there started to be barriers or walls that would bother me. Before, I remember being joyous and happy to get up. I mean life is not—I am very grateful for what I have, and I do what I wanna do every day and I have fun doing it, but I don't wake up like [bright Broadway smile]. And that was consistent for a long time as a child. I don't know what the fuck happened. I guess real life starts to come into play and you start to have to answer to things and have responsibility. I think as time goes on I've lost the freedom a little bit, but I think you kind of work toward that freedom again as you age. I'm 38, and I'm starting to feel more of that freedom than through my 20s and early 30s, where I felt like I was definitely held back. I think that starting to know yourself and feeling comfortable enough, understanding your -isms and things. Maybe it just becomes more comfortable, but that comfort feels like a freedom of sorts.

L — The comfort of knowing yourself?

C — Yeah. I don't know if you ever reach the freedom of that true innocent youth of just going with the flow.

L — Do you feel that when you're hanging out with Mark maybe?

C — Yes, Mark is an aspect of my life that I definitely put a lot of the bullshit behind and let go a bit. If Mark wants to hang out.... Listen, it's not like, "Drop everything!," but it's Mark's rules. If Mark says, "I'll be at Cafe Select in 15 minutes" you kind of have to get there. And if you don't—like it's all good if you don't—but you miss a Mark hangout, and a Mark hangout is more than likely gonna be a special hangout, you know what I mean?

I've had days when I've had some stuff to catch up on, work-related stuff, and Mark wants to go get food or go to the Met and I'm like—you know what, let's do this, it's fun. It's also nice 'cause he's very present when you're one-on-one with him. Looking at him from an outside perspective, he wouldn't be someone you'd necessarily go to for advice on life, but Mark's definitely broke me through a lot of different moods, or a breakup with a girl, or depression, where he'll hit you with factual statements sort of thing, and I think it's just refreshing because I don't think many people do see that aspect of him. Also him being in the present. There was a period where he had his iPad for like a year and a half and he was carrying it around. It's so wild, I swear he must have made 100,000 drawings in a year and a half, maybe the only ones that exist are the ones that he's emailed off. It's gonna be funny seeing people trying to collect those because they are just so good too, so wild.

L — How are they different?

C — They're digital. He was doing them before I think Hockney showed iPad drawings. To me Hockney's iPad drawings can fuckin' eat it compared to Mark's. His are so next-level. He brings it into this stop-motion thing, where it's this eyebrows-up/eyebrows-down vibe, it just goes and goes. And then he's making full stop-motion videos and it's so complex, really. But his drawings. I mean his finger had sores on it because he was dragging his goddamn finger across the screen so much. He would do these drawings and then push the button in the corner that says *Send To* and whoever was in his head, he would send it to—some skater guys—and then ditch the thing and then start a new one. And then he would email that too. I definitely have years of emails, some of them are in a group email, some of them are direct to me. Just iPad drawings. But none saved. I can't even

imagine what Deluxe has as far as archives of Mark's scribbles, he doesn't stop. But I feel that there's gonna be like a year and a half gap: "Wait, what happened to paper and pen!?" And it's gonna be the iPad! It was so real, and he really couldn't get off it.

J — And this is like 5 years ago?

C — Yeah, probably like 5 years ago. I mean if he's at the gym he'll set it up and then he'll go do his routine and then he'll film it from the selfie camera. I think he's still doing that. I'm telling you, *those*—if you look deeper into them, those videos are mind-blowing as well. All of his YouTube videos. He says, "You can follow me on YouTube!," and it's like, "Ha ha, Mark on YouTube." But those things need to be getting archived at the highest resolution. I feel like once they're gone, they're gone. He makes one of those every couple of days, and he puts a good chunk of his energy into those videos. They get long and drawn out, but they all have a reason. It comes back to this idea that there's a way to do this in an abstract way. He finds the right balance. He's showing the repeat of his foot touching the ground like 40 times over 'cause he's dissecting the way his arm is positioned. If he's filming people in Chinatown and there's an old man, he'll do a repeat of that on the video. I feel like it's a process of studying; those videos are another entity. As far as a historical standpoint on Mark, I've never even seen it enter his mind: "Be sure to get a picture of that before it leaves the studio." No. It's just out there, and it is was it is. The last people to make this book on his zines, chasing down all the different zines he had done.

L — Emma [Reeves]?

C — Emma too. I felt he was the least helpful, he just couldn't be bothered.

L — Brian said that he works out, he's so strong.

C — Even if he's not working out. It's like he has an inner strength. Every time he works out he films it. He makes it into a performance and he knows it. He exercises for his heart too. But it's like he has an inner soul strength, that's just like retard strength. Like when somebody freaks out and is able to lift a car or something.

L — Mama-bear strength.

C — It's like all the time. Also, as far as acting, he could be—his acting skills—once he hones in on that.... I know people have attempted to put him in things.

L — He's not down with it?

C — I think he is. It would take a certain director to make it happen. He's also very infatuated with the stars. You'd think he wouldn't know so much about models and New York socialites and the social system and actors and even the older actors, but he'll say weird factual things about people like that. Not only is he talking about the Egyptians from whenever, he's talking about Gigi eating at Robertson in LA. Somebody will walk in a restaurant, some obscure character from like a movie, from like the 80s, and he'll know her.

L — That's very New York too. Being here you know so much random stuff like that by symbiosis.

C — Which is the magic of the city. It's perfect for him.

L — We were talking before about feeling free, and I want to ask you what still drives you crazy now?

C — I feel I've worked on myself and tried to talk through things enough, to where I'm finally becoming comfortable, but things that eat me away...the "Love Me" thing, it's become more just a logo or like a brand, in all these entities. But I like people to grasp it for what it is to them; for me it really isn't anymore what it once was. I had no intentions of anything other than a very vulnerable splurge. I really was feeling that way. And I was hanging around graffiti artists and I put it on something. It was interesting too, people's response. That it was so digestible, and so many people had something to say about it, just made me propel it further and further. I think about it now and I think, Oh, it can sound so "feel sorry for me." Part of it is great because it's so universal and so digestible, and people have this emotional attachment in some capacity, not everybody sees it like that, where it's being needy, or self-fulfilling. It's a very powerful word and statement, it's interesting to watch it grow, but for me, looking at it in this day and age it's more of a logo or graphic almost. It just doesn't contain that heavy pressure that it did once, and I think that's age and the freedom of getting older, more comfortable. It's just lighter and not so heavy. And it's intense to have that. And it's part of growing too, you have to experience that.

L — What I'm hearing is like a mix of growing out of the neediness of it, at the same time needing love is universal. Everybody has felt this way, everybody relates to it. Whether from a place of "please," or a confident place of "this is me."

C — Right, both.

L — I can see how it's lasted this long. It's not gonna let go of you.

C — And I've come to terms with that as well. 'Cause there have been times when I'm like "Just git!..." But then it comes back around. "Love Me" became this thing that almost 100 percent of the time makes someone happy. It's a positive reaction. If I'm making even one person happy, let alone...well, that's a positive message to the general public.

L — Those always come from a place of vulnerability.

C — Every time. It's funny, I would never see that from the beginning. That's how the message formed, and that's what I'll be living with.

J — You must be happy to have such a successful one.

C — It's like a blessing and a curse. Yeah. It supports many different things. It's a weird transition too, and the art world is finicky like that. Last year I had 2 shows that I put my all into. It was other work I was focused on in the studio. I did that boxing series, these self-help pieces painting I did. Part digital, digital, oil paint. I actually put this Donald Trump piece to be sold at an auction. I normally stay away from political art. It didn't even get a bid. Nothing. And I was like, "That's why I don't make political art." Sometimes I just put touches of it to make a kind of transition. But it was always like, "No."

L — But you gotta give these things time.

C — Of course, a lot of people paint their whole lives, you know what I mean?

L — Well, for what it's worth I really like these.

C — Thank you. It was pushing. They're a little bit confusing with so much meaning, but I like that. It's obviously clowning on the idea of his self-help. My point was, I didn't even have a piece of press, and I did take the time to get it out there: "I'm having these shows". There's a conversation to be had. It's not like, "I'm making a T-shirt, can you do an article on my T-shirt so I can sell some T-shirts?" It's like, "I'm having a show and it's a new body of work and I think that it's an interesting conversation." But I don't even think there's one press thing out there that says I ever even did this. Meanwhile, I'll make an ice-cream machine in Midtown in some hotel, and it's like: *Wall Street Journal, New York Times*. It's like....

L —some conversations are easier to be had.

C — I mean people don't wanna think, necessarily.

Interview by Lou Andrea Savoir and Julian Dykmans

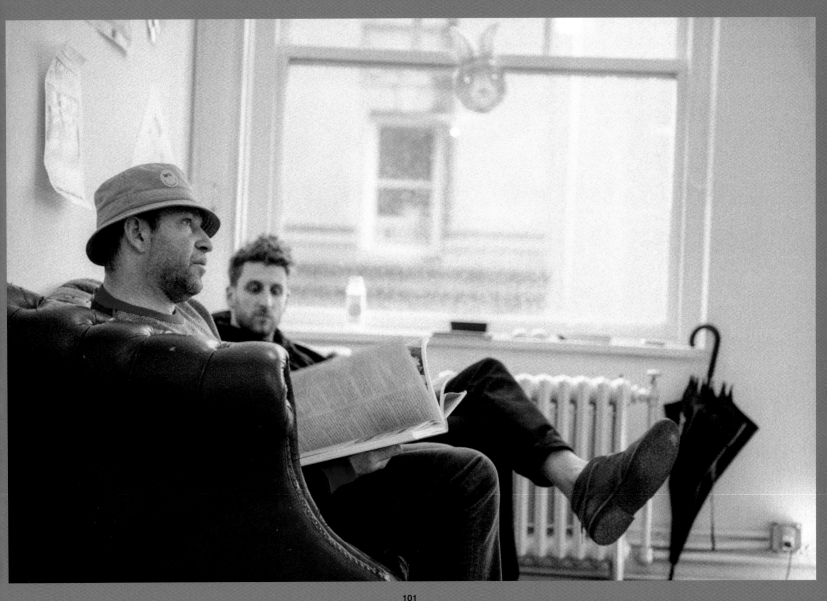

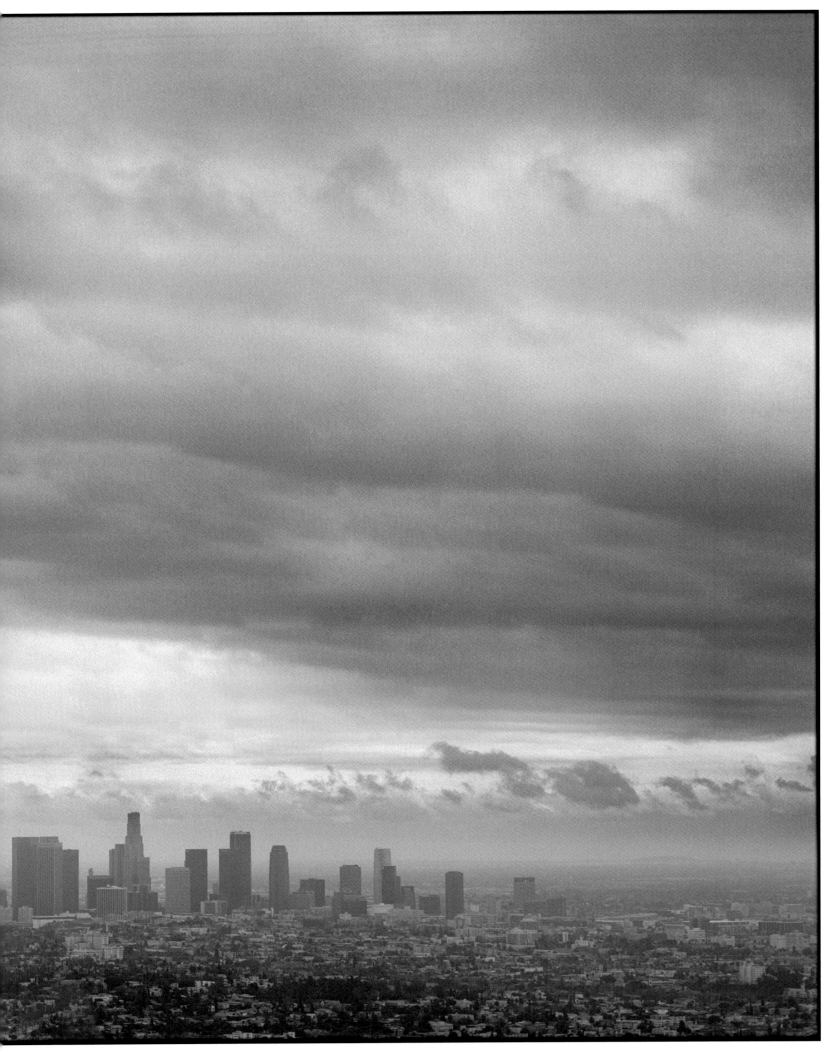

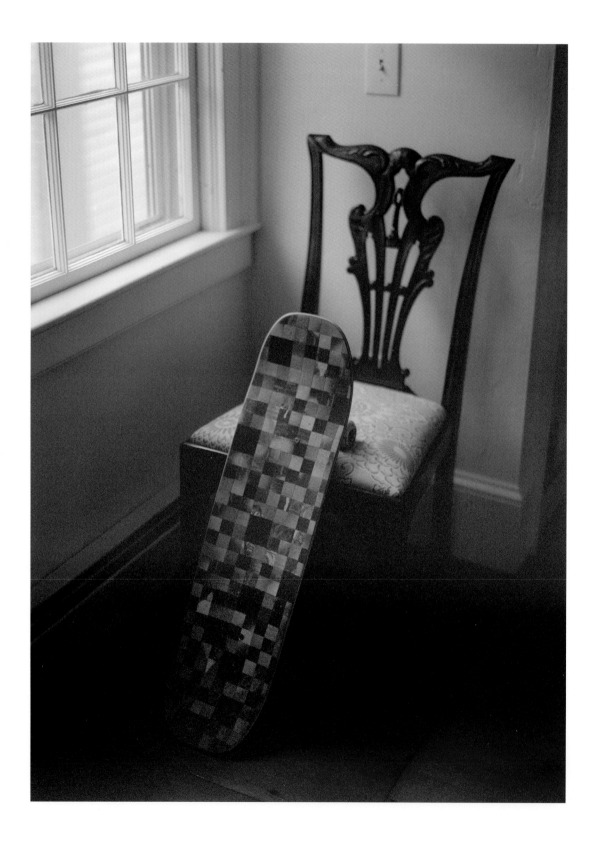

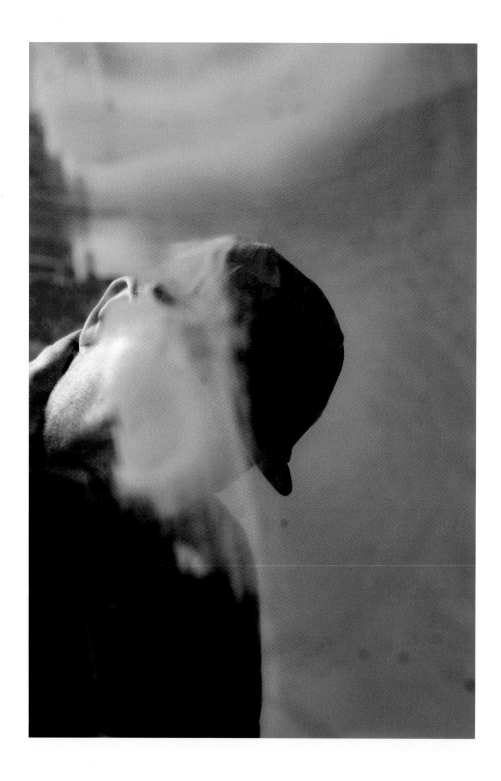

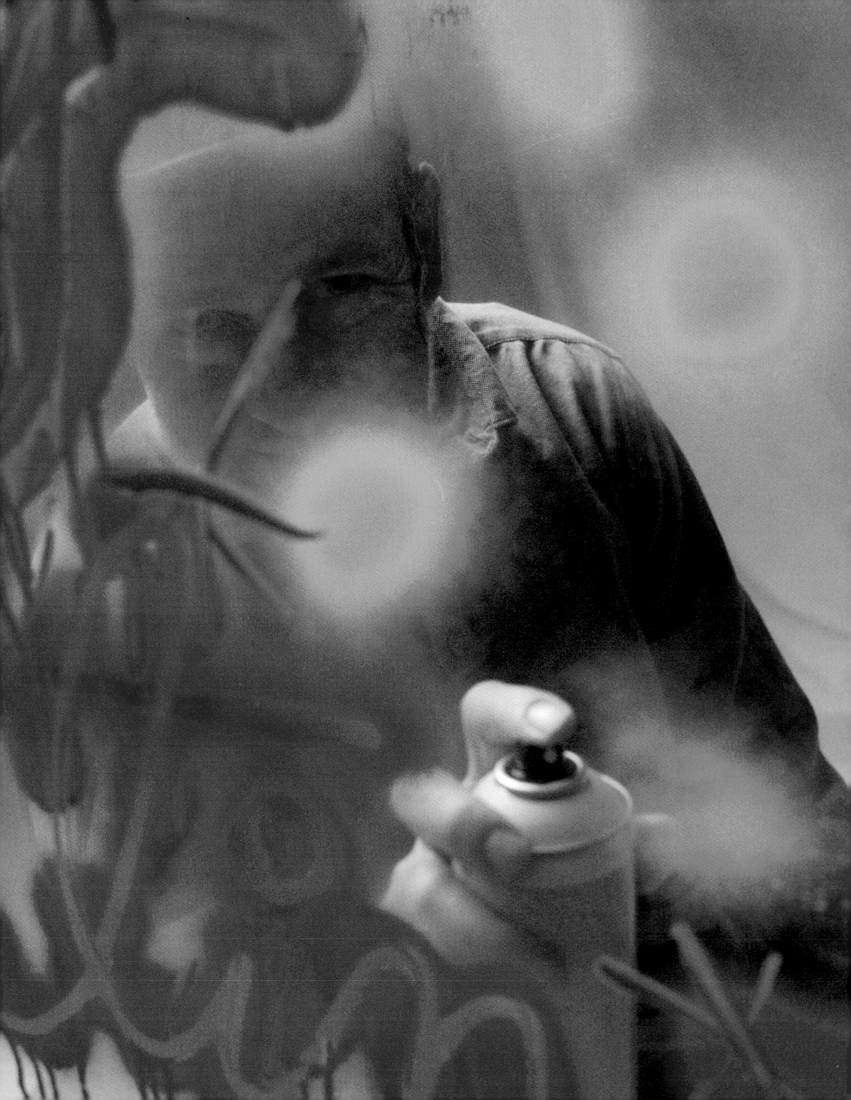

AND
A PARENT
WILL
SEE WITH
ADULT
EYES LIKE
A WARNING
SIGHN
AN UBUNDANCE

OF FUN
CAN TURN
THE
TABLES

LEAD YOU
RIGHT BACK
TO
NUNE. AND A
PARENT OUR
PARENTS CAN
SEE. JUST WHAT IT'S
LIKE 2 KNOW HOW IT USE TO BE!!

The Museum of Modern Art
11 West 53 Street, New York, NY 10019
MoMA.org

middle aged
white women
needed in japan
youth suicide
serious.
Condition not
no sighn of
supsideing

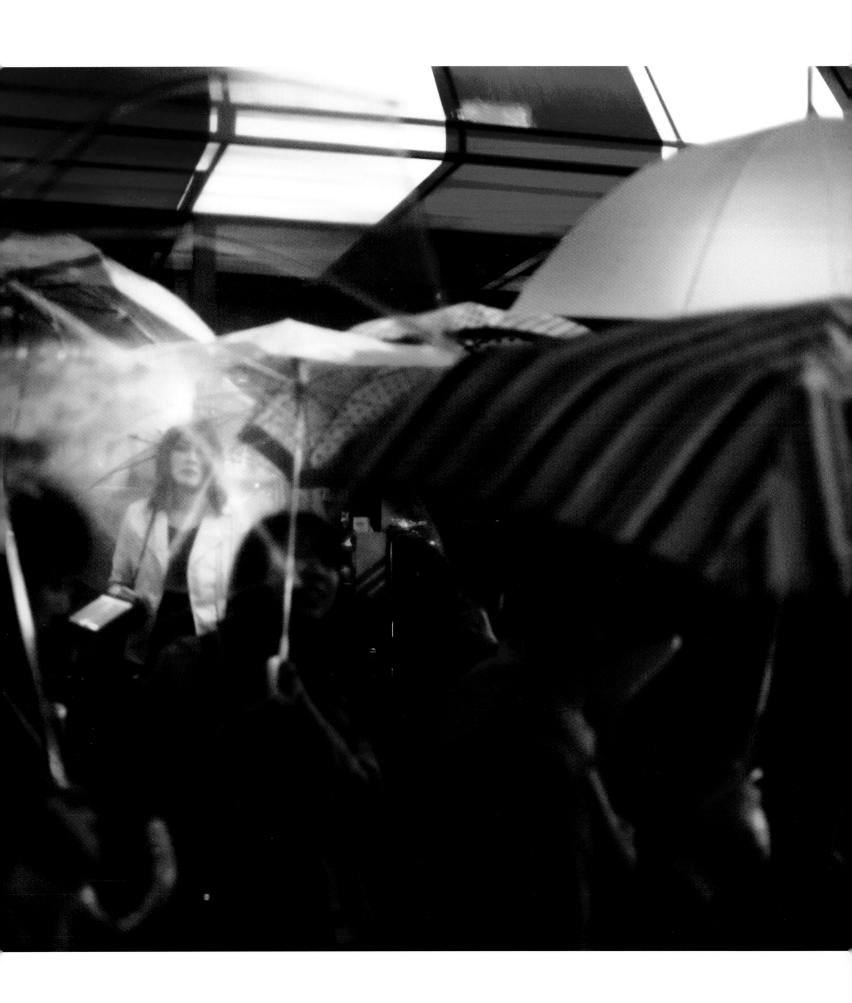

Hiroshi
Fujiwara

Fujiwara is a musician, producer, and designer living and
working in Tokyo.

Q — Can you describe Mark's skateboarding?
A — As fast as the wind, as quiet as the forest, as daring as fire,
and immovable as the mountain.
-

Q — You say you work solo but you collaborate a lot.
A — For me, solo does not mean alone, I work as solo with a
team, I play as solo with people. I don't like moving with many
groups of people.
-

Q — What's the last argument you are glad you had?
A — To not be in an argument.
-

Q — Do you feel more free now than when you were younger?
A — Now.
-

Q — What still drives you nuts?
A — Living.
-

There was an art supply store called PEARL on Canal Street. I
was buying something there, and Mark was there. Coincidence.
Perfect place to meet him.
-

Q — One song that makes you think of Mark?
A — *Traneing In* [by John Coltrane].
-

Q — Do you think the internet has changed the link between
geography and identity?
A — A little, but not so much.
-

Q — What advice would you give to a young artist?
A — Look at Mark Gonzales.

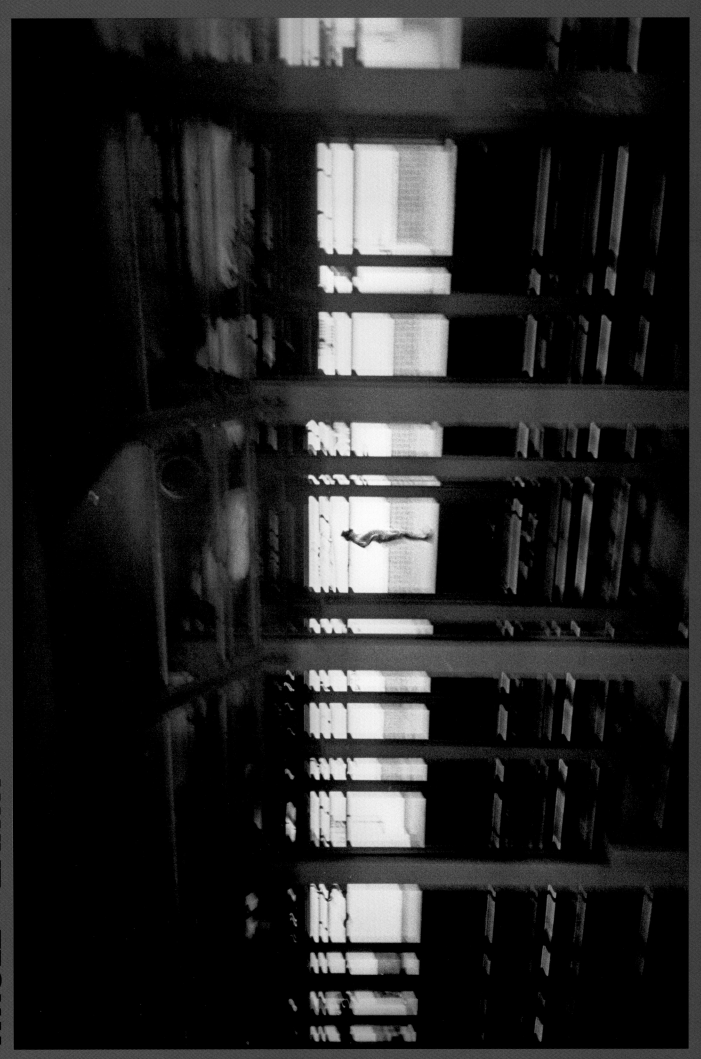

FRICTION – NON FICTION
FREEDOM – BONDAGE
WHOLE – EARTH

JOKEING
ABOUT
DEAD
HUNG
DIEING

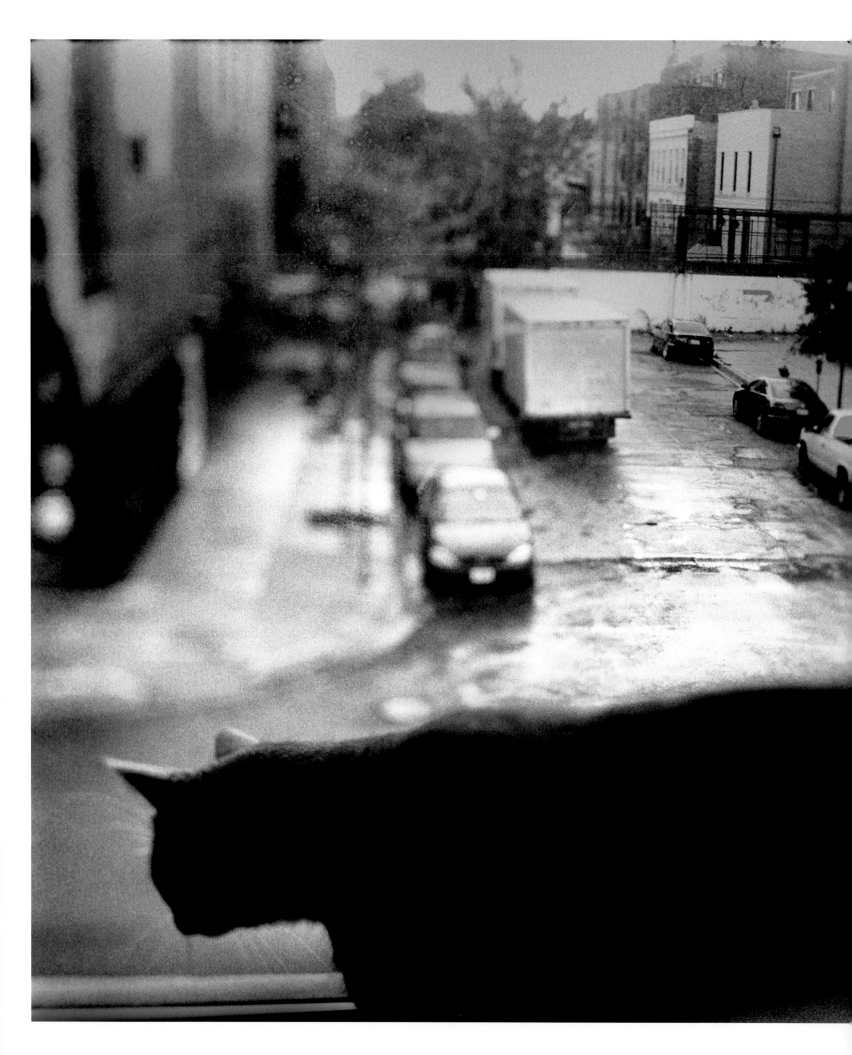

DAN FIELD

Field is an artist manager and a long-time collaborator with MG and Spike Jonze. He currently lives in Los Angeles.

L — So Dan, how old were you and Mark when you first met?

D — Good question, I think I was 23 and he was 20, 21? I had a skateboard shop in Chicago called Sessions that I started in 1990, it was right around the time when Mark stopped doing Blind. He kind of went into hiding, nobody knew where he was, and a girl that I knew was dating his roommate in New Jersey. So I started talking to Mark on the phone and he said that he was gonna really try and do artwork, and his hope was that he could do as well just with it as he did just skating, that he could skate for fun and artwork for real—instead of the other way round. Does that make sense? And I said, "Well, if that's what you wanna do, let me help you. I'll sell your artwork in my skate shop. Just send it to me and I'll hang it on the walls and sell it to the kids." And he's like, "Oh that's a great idea! I'd love to do that." So he just started sending me tons and tons of artwork. This was when he was doing a lot of his artwork on his grocery bags, he would open them up and tape wrappers and stuff on them. And of course the kids—wait, are you recording this or writing it down?

L — I'm recording it.

D — OK good. 'Cause I'm really funny and I don't want you to miss any of it. Where was I? Of course, all the kids that came into the shop, they freaked out and bought it all up, I just kept calling him saying, "Send more, send more," I just forwarded him all the money that came in from it. He was selling it super cheap but, you know, he was excited, as were we. And then I had this idea to do an art show of all the skaters who painted. There were so many of them and I was into all their artwork. From looking at the magazines and skateboard graphics and the way skateboarders were always pushing the envelope with music and fashion, I

thought it would be cool to do an art show. It was the first one, I got this really big art gallery, like the coolest art gallery. It was run by a big artist in Chicago, Tony Fitzpatrick, who let us do it there. It's in this really big loft downtown. So Mark came out for that show, as did tons and tons of people and it was super fun. From the art show, that's sort of when we really started hanging out and became really good friends. Then I moved to LA in 1995, and that's when Mark was living in Westwood, so we would hang out all the time. I had an apartment with extra bedrooms and we would call it "the doghouse" because whenever anyone was in a fight with their girlfriend, they would stay at my house, and Mark would come over at least once a month, so.... He stayed at my house a lot back then.

L — How was that opening night?

D — I didn't know how many people had agreed to be in the show at first, and I also didn't know how many people would come out, but it was crazy. I don't think anybody said no. And pretty much everybody who said yes also said, "Oh you gotta have this guy in it" or "You should see this guy's work." It was the first art show for Ed Templeton, for Thomas Campbell, for Mark, the first art show for Spike I think—you know, like, a lot of people's first art show. Everybody came and hung the artwork, hanging it was almost as fun as the opening. A band from LA drove out all the way for the opening, you know, that's how weird it was. I don't know how many people were there in total but I had this apartment near Wrigley Field. People were sleeping all over the floors and because there was no more room, people slept on the roof of the building. It was amazing. There was a big write-up in the *Chicago Tribune*. It was really fun.

L — Did it start a whole gallerist direction for you?

D — No, maybe I helped on some other stuff but that's the only one I ever did.

L — You sort of topped yourself on your first show, I guess.

D — [laughter] Yeah I guess, I've always encouraged and tried to help everyone I could, but I didn't expect it to become what it's become now, you know? So I moved to LA to manage bands because I always worked in music and was touring with bands. I was here for a couple of years and then went to work at Girl Skateboards.

L — I read that one article you wrote led to Adidas offering you a job...

D — Yeah, that's correct. And I helped do Mark's first contract with Adidas. I was friends with a sports agent and I was working at a management company for music that also had a sports division, so I had someone look at his deal, and he kind of got the best deal that Adidas would give an athlete, which is awesome. I think between my knowledge of what skaters were getting for their shoes and what they chimed in with, we got Mark a really good deal.

L — That's great. There are many stories about royalties, and even before royalty deals. Skaters just being happy to be able to make a living off of things, not realizing how much money was being made through them.

D — Yeah. I'm really proud that the DNA of the first deal is still going today, and that it's worked well enough that Mark's still on Adidas.

"THE ONE I
ALWAYS GO
BACK TO IS:
IF THERE IS
A GOD, HE'S
GONNA
GET IT."

L — So then you were at Girl.

D — I was managing bands, one I was super into called Phantom Planet that Jason Schwartzman was in, and they were really young, and it was taking a while to make real money. They eventually did do really well. But I was like, "I need to do something with a steady income" and I went to work at Girl. I love skateboarding and I loved everybody who worked at Girl, so it was a no-brainer. It was a smart choice. I was able to keep managing bands *and* do that. Work is a loose word, because we were having so much fun.

L — You were with a lot of people who you knew and loved, I guess.

D — Like right when I got there, not long after, we started 4 Star, and I helped put together that team. Mark was on that team, so I got to help with that. We had a lot of fun.

L — Always creating things. So, as far as Mark is concerned you guys are friends first and foremost?

D — Yeah. I mean, I would talk to you for 24 hours a day for months about Mark with no problem. And would like to talk about myself only for about as long as we just did.

L — Sure. Can you tell me a favorite story from long ago?

D — One thing that sticks in my head forever is right when I moved to LA, I became friends with Timothy Leary [Professor at Harvard and precursor in the fields of mind expansion and the therapeutic potential of LSD in the early 1960s]. He was always thirsty for knowledge—who was cool, what was going on in popular culture, what the new thing was. He always liked seeing what was coming next. He was at the forefront of a lot of stuff in terms of the internet and computer graphics and the combination of all that into mind control. I saw these VHS tapes he was making, he would use strobe lights and different effects to kind of hypnotize the viewer. I was doing lighting for bands at the time and that's how we started hanging out, I asked him if he would teach me how to do it so I could sort of hypnotize the crowd at rock concerts. I started bringing people up to his house to hang out because he had a sign nailed to his front door that said "Please come in" in scratchy purple marker. The door was never all the way closed. Mark and I went, and Timothy would read Mark's poetry books. He had such an amazing voice, such a cool voice, to hear him reading Mark's poetry books—amazing. And the conversations that those 2 had... Mark wrote this amazing short story about Timothy Leary stealing a Rolls-Royce and I was trying to get Timothy to do it.

L — Can you tell me when was the last time you saw Mark, and what you did together?

D — Good question, I'm really bad with stuff like this. Oh, I was in New York at the end of November, and me, Tia, Gemma, Enzo, and Mark went to the grocery store and hung out at his apartment. That's what we did.

L — It sounds lovely and homey.

D — Yeah, it was kind of chilly out, but it was fun. They tried to charge Tia like 90 dollars for an orange, but she busted them. When they looked at the receipt they figured out that instead of 90 cents for the orange they charged 90 dollars or something like that. You know everything in New York is crazy expensive, but even that was too expensive. One time, I remember Mark was wearing this bright pink overcoat, and bright pink pants and pink shoes. Gemma had one of those Razors, these little scooters that have 3 wheels. He was pulling her on that really fast—you know you see photos of Gemma on Mark's shoulders and all that stuff, and it's clear that she's gonna be fearless like him.

L — Yeah, Brian was telling me he plays a lot with the kids, and he's kind of teaching them how to fall without hurting themselves.

D — That's great. The most important thing about skateboarding is knowing how to fall. I love hanging out with his kids and playing with his kids, just recently Tia and Mark asked me to be Enzo's godfather. I've never been a godfather before so it's awesome.

L — It's a cool title.

D — Yeah, that is a cool title.

L — So what would be the first thing that you do as a godfather when they show up at your door as, you know, 14-year-olds who are curious about the world?

D — That's it, right? When I was about 16, I had a guy who taught me to play bass, he was 27 or something, so he was right in between my age and my parents' age and it was so cool to have somebody that was an adult, but cool. Someone that I could talk to about stuff that I couldn't talk to my parents about. So my goal is to be like that valve for Enzo and Gemma, to be like this adult that they know has their back and that they can reach out to at any time. You know, Mark—to me—one of my favorite parts of him is he hasn't forgotten what it's like to be a child. All the best parts of children, I think he's held onto. I've talked to a bunch of different artists in different types of art, especially musicians. They all say the key to making great art is remembering what it's like to be a child. I don't know how to say this without it being name-droppy, but I was with Spike [Jonze] in Australia, he was shooting *Where the Wild Things Are*. We went to see U2 and we were talking with Bono and he explained that their second record, Boy, was about being a young kid, and that nobody had whole records about being a young kid. That's what people were most impressed by. He also said that that's what Bob Dylan said to him. I don't know how to tell that story without dropping all those names in there, but there you go. Remembering what it's like to be a child is the key to all of it. But I don't want that in there, it'll sound horrible.

L — Maybe what's really interesting in that story is how it goes back generations, older and older men talking about the value in being a child.

D — Yeah. That's interesting and I think maybe some of that didn't happen to Mark 'cause he sort of stayed away from school a lot.

L — It may be legitimate to want to stay outside of a society that's trying to cut off half of you, whether you're taught to be either "a boy" or "a girl."

D — Yeah, I think he just wasn't into school for a bunch of different reasons. He'd go hide in the library or church because he knew that they wouldn't look for a kid skipping school there.

Mark is my favorite artist, he's my favorite skateboarder, he's my favorite poet, he's my favorite human. You know, one of my favorite humans, for sure.

L — A favorite Mark detail, something he did?

D — One time Mark was at my house and he was getting ready to leave. He said, "I'm gonna go get my hair corn-rowed." There was an Ethiopian neighborhood a few miles away. He knew of a place there, and I had to figure out where it was. I found it in the phone book or something and Mark had just gotten a new MacBook laptop. I found the number and he was like, "Hold on, hold on, let me write the number down on my computer." He got his computer, and as I read out the number, he pulled out a big Sharpie. And wrote the number on the back of his computer.

L — Did Mark ever give you any advice in love or life or business or anything that sticks with you still?

D — The most recent one that comes to mind is when I texted him: "Mark, should I get a new car?" And he just texted back "No. Less is more." And you know that doghouse apartment that I had? He painted the inside of it, the whole inside of it, and when you walked in, it was the coolest thing 'cause it felt like you were walking inside a Mark Gonzales painting. When he came over he would just write poetry on the walls, there were Sharpies all over the place, so it was like you were in this poetry book. There were a lot of good lines on the wall, but the one I always go back to is:
"If there is a God, he's gonna get it."

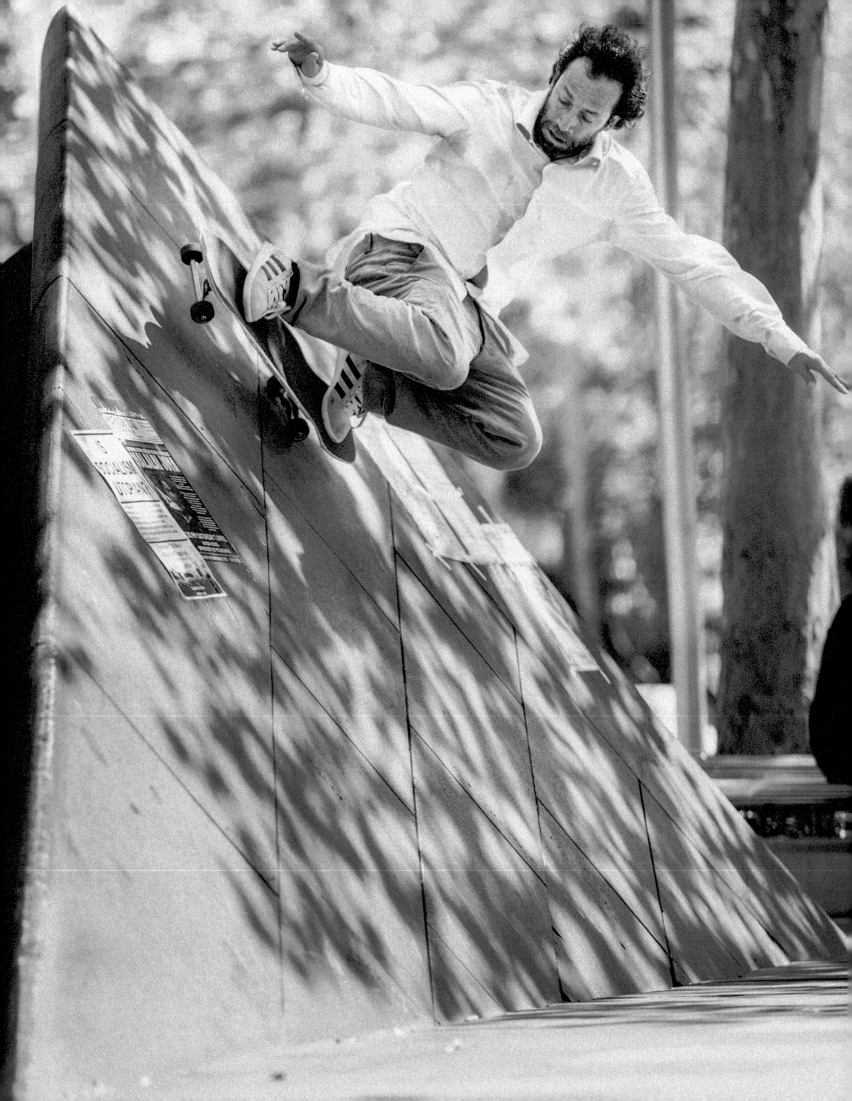

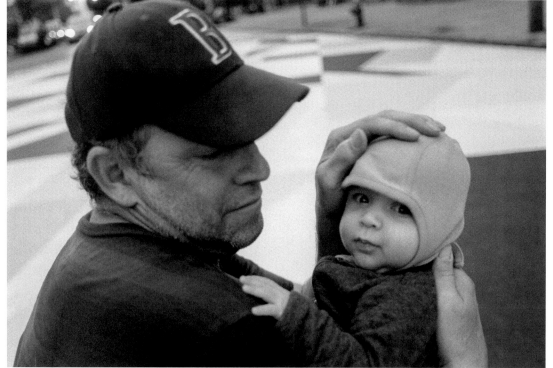

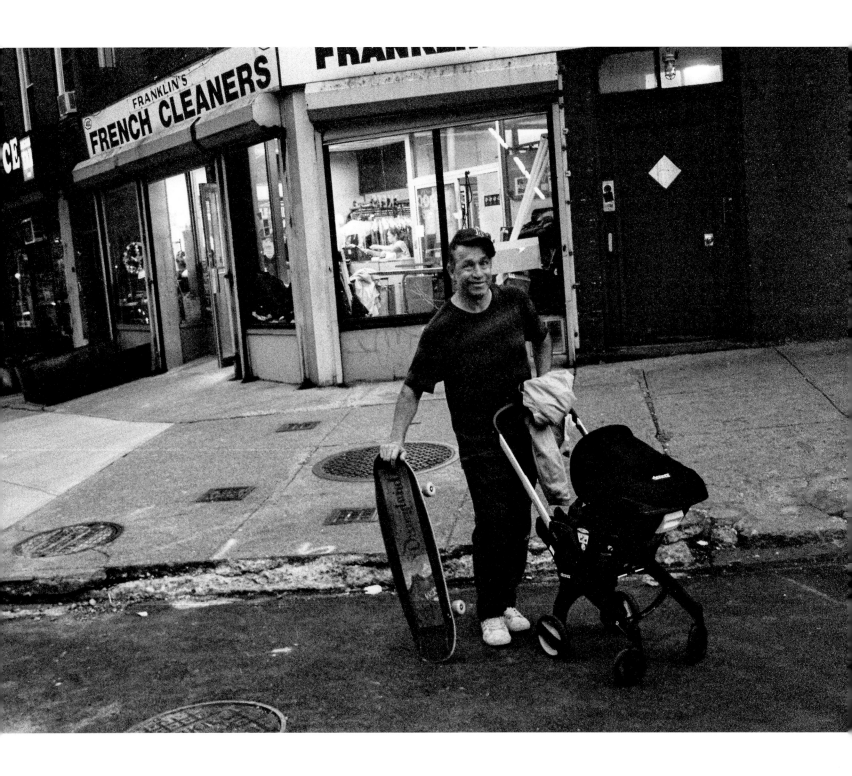

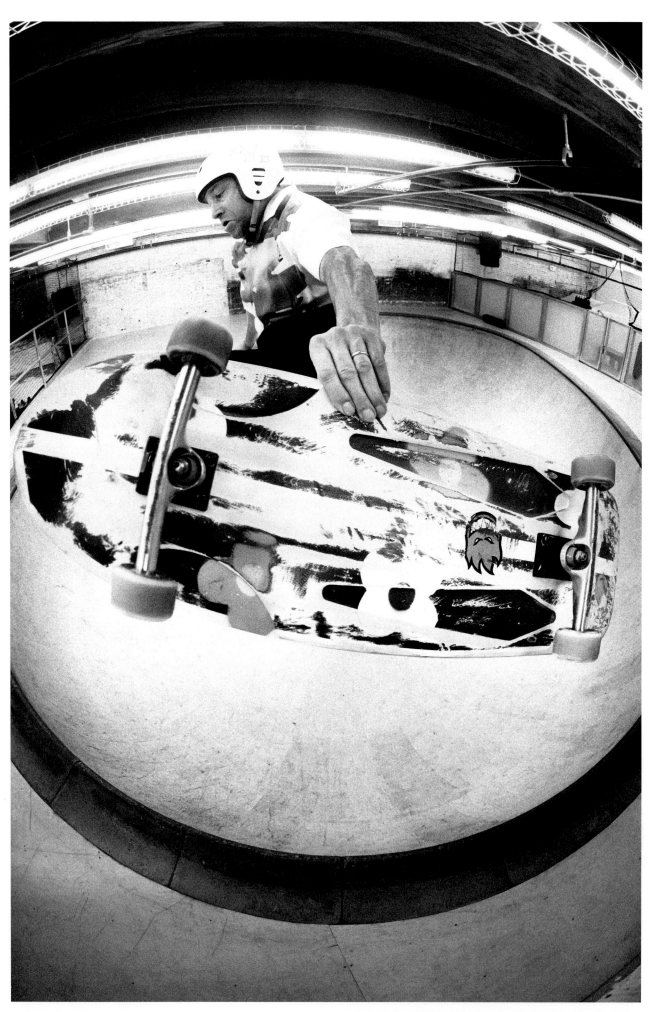

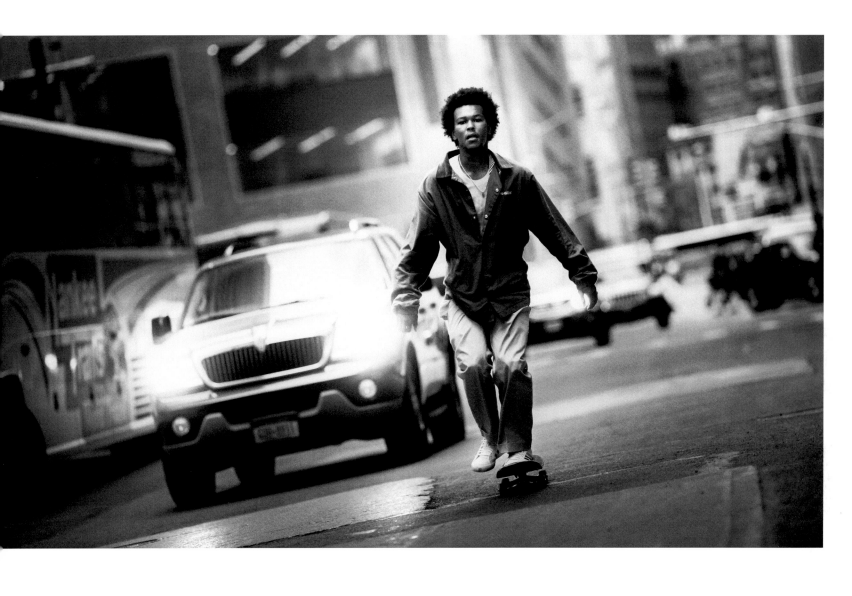

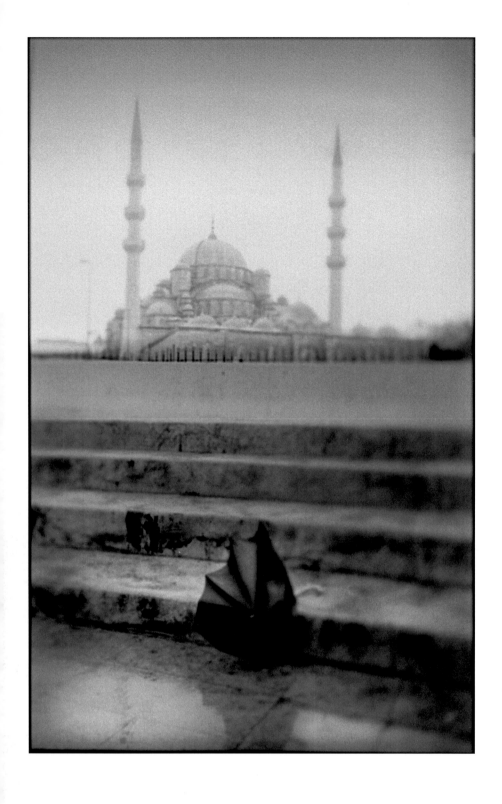

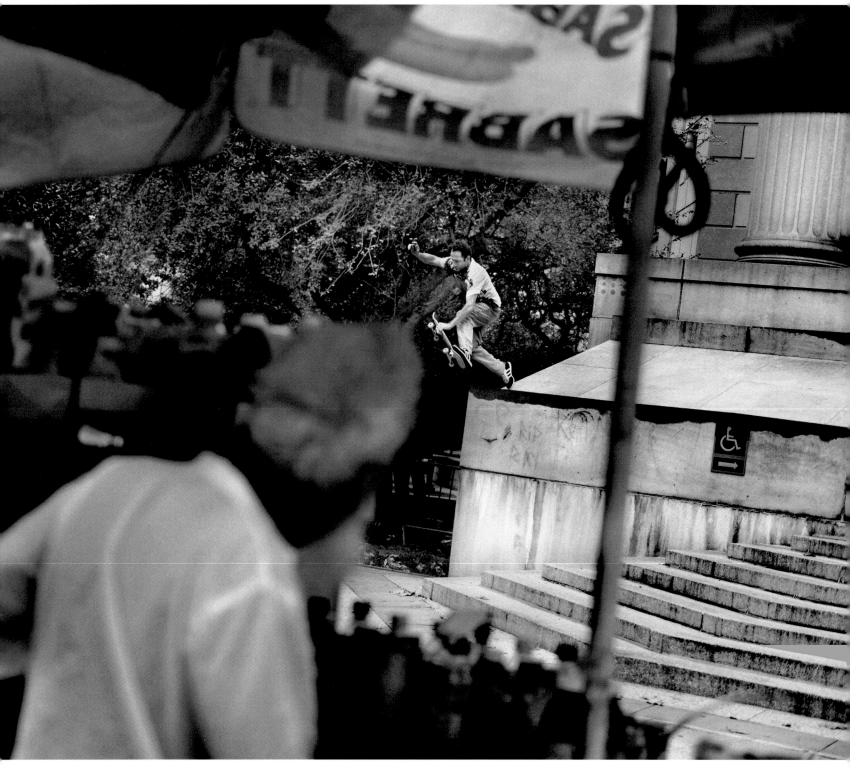

Bill Strobeck

Strobeck is a filmmaker, director, and videographer based out of New York City.

Q — Something Mark once told you and that sticks with you?
A — I dunno but ADIDAS stands for Average Dudes In Dope Ass Shoes!
-
There have been so many stories.... One real moment tho' was when I was chasing Mark toward Midtown from Downtown, me on a skate and him on rollerskates, and I wanted to follow him with the camera and document it.... We took a left off 1st Avenue on like 42nd Street and an 18-wheeler was waiting to turn the corner but was stopped, so I was like, "Go under it and I'll follow you." Little did I know my bag was to get hooked on a bolt and I was stuck under the truck and was super scared. My bag got stuck 'cause I was frantic and was moving around so much. It was the most scary thing because I was by the back 6 wheels. I think Mark was scared too—"Hurry up hurry up!"—because all the driver woulda had to have done, was press the gas.... Thankfully he didn't and I got out from underneath...and live to tell the story today.
-
Youthful spirit is the only thing worth capturing...if you can capture it correctly it'll last forever.... Also skateboarders just have such interesting lives.... Mark is an example of being yourself. I learned a lot from him.
-
Q— Who is the most successful person alive in your eyes these days, and why?
A— Depending on what success is...if fame...possibly Donald Trump.

In skateboarding you are an individual amongst a crew of other individuals...like just 'cause you roll and love your crew you're your own person in it.... It's like a self-indulgent selfish hobby I guess.... It's also a way of escape too.
-
Q — Are you more of a follow-the-flow or an instigator type person?
A — I do what I feel is comfortable.... It's different as time changes.... I'd say I'm a bit of both, 50/50.
-
I'm easy-going, my last argument was probably stupid.... Since I don't remember it, I think, ya, it was.
-
Dennis Hopper is my favorite Director.
-
Q — In which ways do you feel more free now, than when you were younger?
A — I feel secure, which is nice.... I do miss feeling carelessness... but I'll leave that to the newer generation.
-
Q — What still drives you nuts?
A — When someone has an umbrella up under a scaffolding...like, dude someone without an umbrella should stand there, not you.... And people that repeat themselves over and over.

FRICTION – CHANGES IN TECHNOLOGY
FREEDOM – GEORGE MICHAELS' SONG
FAILURE – DROPPED OUTTA SCHOOL

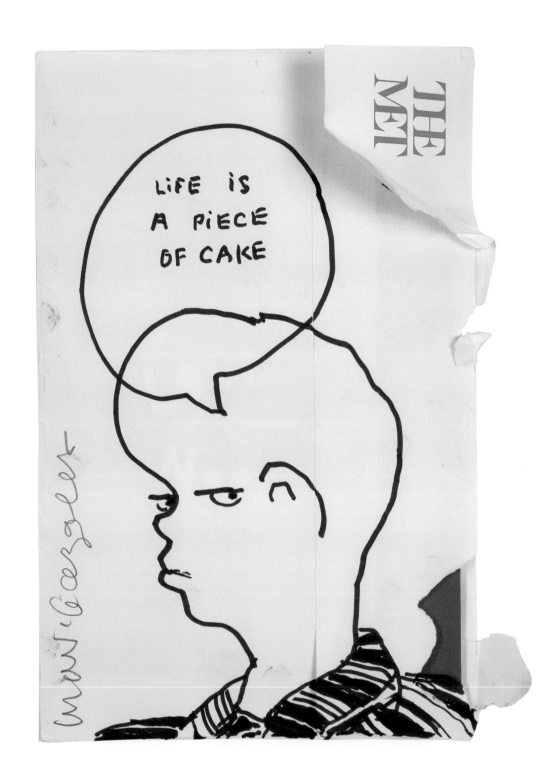

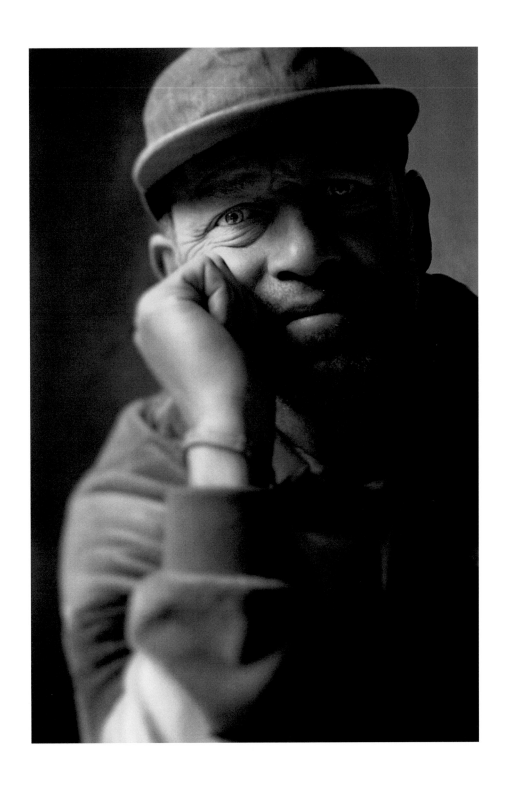

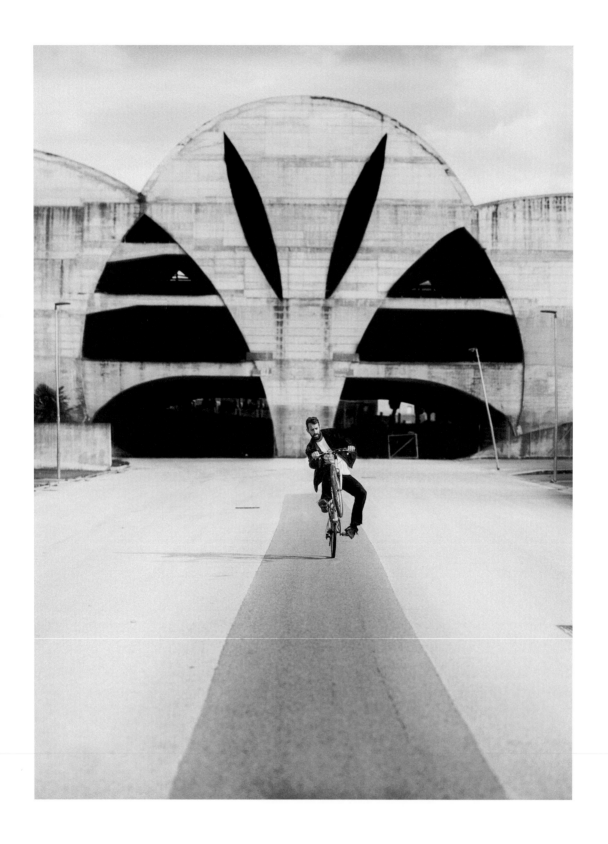

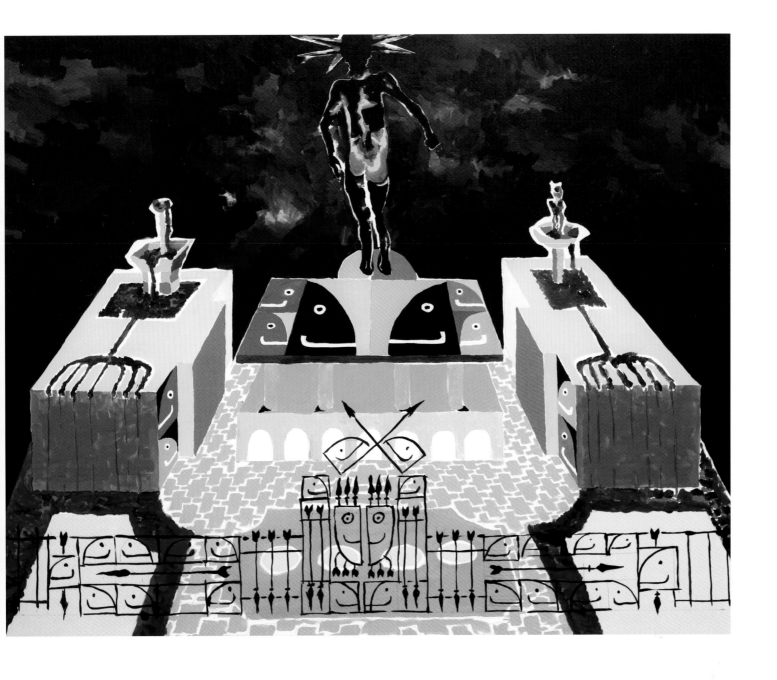

JASON DILL

Dill is a professional skateboarder and Founder of Fucking Awesome, with Anthony Van Engelen, and Hockey.

J — Thank you for taking the time to call me. My day changes with the drop of a hat these days.

L — Where are you at? 212 used to be a NY number but maybe that's not a fact anymore?

J — 212 is still a NY number. This phone number is so old it's when you *could* get 212 cell phone numbers. I have an iPhone and I have a shitty phone, I'm talking to you on my shitty phone. 'Cause I'm not good with telephones and bullshit. I mean all the technical mumbo-jumbo, I hate it. But I do like to Uber.

L — You know Uber became illegal here.

J — Are you in Berlin? I lived there for a little bit. It's a very eclectic place. People walk up to you on the street and give you drugs, it's a fuckin' crazy place. So where do I come into this? I mean I represent so much of what Mark did to my generation, you know what I mean, look at everything I do. I paint, I make clothes, I fuckin' do all this shit, and I fuckin' moved to New York when I was young like he did, I followed so much of Mark except for the really wacky crazy shit that that fuckin' idiot would do sometimes. It's very strange too, it's like you like John Coltrane *so much*, so much, he seems like he's from a nether universe, and then you see him at the grocery store, and then you learn from him! Get the fuck *outta* here! That's what happened to me and Mark and it's insane. Mark's a fuckin' genius. He really is, Mark is the genius at, I'd say, *consistent* happiness—he likes to bring happiness to you. He doesn't care what form you want, he's gonna give whatever the fuckin' form *he* wants of *that* moment. 'Cause Mark comes in and he dominates moments; it's not *all* he's doing, but that's what Mark does. He comes in: Hey! How're you doing? Oh good!" and

then all of a sudden you're fuckin' playing basketball with him and he's wearing like 4 of your hats. I mean I've known this man since I was fuckin' 9 years old. It's unusual to be really close with your childhood hero.

L — You think it comes natural to him?

J — No! No, no, like he's putting it on? No, people know I'm close to Mark, they ask "Is Mark's whole thing an act?" I mean it's an act as much as OCD is an act, get the fuck out of here, that's *him*. Like he grew up in South Gate, he saw weird parts of life and escaped it to go around the world, and make a new brain, you know what I mean? I did the same thing, I was a fuckin' *kid!* 9-year-old through 13-, 14-, 15 year-old, 'til I found I was actually kinda cool—I was a nervous wreck, I was so scared. Family moved me fuckin' 22 times before I even moved out on my own at 17, and I don't want that! I don't want *that* fuckin' kid in my head anymore, so—that's what you do, you kick him out, you make a whole new fuckin' lexicon of a life.

L — You rewire yourself.

J — Beyond that. Very good, very good, apparently that's what the masons are all about. But when you're fuckin' 8 years old, or 9 years old, and you see this dude who has influenced you from magazines—I'm not *bumping* into him and like, "Hey! How you doin'?" I was *hiding* from him, "Oh my gosh I don't want to be seen with my *mom*—fuckin' hell, that's not cool." But then a few nights later I'm skating in the same parking lot with him, and then another fuckin' 2 weeks go by, I see him leaving a pizza place and I make sure he don't see me, and I watch him get into a car. Mark was like a, like a myth, it was crazy! Ah, I hate that I say the word

like so much, I'm 43 fuckin' years old! *Stop it.* So. You would *hear* shit about Mark. People would say, "Hey, Mark was here and he did this and this," and you missed it. And you were bummed, and then you'd be on Main Street in Huntington Beach and you'd look in the stores and there'd be a T-shirt with fuckin' Mark on it. You know? It was crazy, it was a crazy time. Being part of that then must have been fuckin' insane. Things were just different you know, the world's way different now. Mark for me, I kept *seeing* him. And then all of a sudden—he's my friend, I can't even say when that happened.

L — Isn't that what skating does?

J — Sure! And boxing and music and jazz and all that stuff, where the age gap really doesn't matter. I don't think John Coltrane was *too* bothered by Miles Davis's age when he first brought him into his *thing*. But then everyone then was just chasing Bird, they all wanted to sound like Charlie Parker and Bird, but that age shit is incredible. I'm out to dinner last night and I have Aiden Mackey in front of me, and he skates for me and he's 22 years old. And he's such a *man*, I don't know. I saw 9/11 with my own eyes when I was Aiden's age. Time and Space is magnificent and incredible and sad. But yeah, being the generation right after Mark was *really* incredible. It really was, 'cause he taught us so much shit, he really did. And all the smoke Mark gets blown up his ass he fuckin' deserves, unfortunately. [grins] He invented shit, he did shit different, he lived different, he showed how you could live different.... Who turns that much dyslexia into that much of an impactful thing?

L — Yeah. I was looking at this video of you with the FA Kids and I was thinking about how everybody refers to their skate family. And

you were talking about how everything sort of came together for you with FA, which made me wonder if it also came together for you as a kind of caretaker, or father figure in a way?

J — Is this an interview about me or fuckin' Mark Gonzales? OK no! I was just being funny. It's all Obi-Wan Kenobi/Luke Skywalker you know? It's: here's what I did with *my* talent, and here's what you could do. And then they say, "OK. Yeah. I get it." And then they do better than I ever did. Tyshawn Jones has had like 2 of my careers by the age of 20.

L — At 20 they're like, "Yeah man, we love each other and we care for each other," they say it out loud, it's cool.

J — Look. They're young people. They squabble. I get the middle. OK. So.... We're all hunky-dory, but just like any other family, we have our moments. But I hate perfection. Perfection is fuckin' *stupid.* So. You know.

L — Yeah. Perfection is death.

J — Whoever invented perfection sucks. Ha*ha!*

L — It's a really tender feeling, seeing them all together, it was super sweet.

J — Thank you, I *really* appreciate that. Me, Bill—William Strobeck—and me really appreciate that. I had dinner with Bill last night as well. I didn't start traveling for skateboarding until I was about 14...

L — That's still super young.

J — No for sure, but I wasn't pro. Mark was pro. This is 1994, I find myself in Europe, and I'm walking down the street with Jason Lee and Ed Templeton. I'm in the pro contest with them, I'm in the big league. It was crazy. Jason was walking down the street and by a fire hydrant, but he made it go through his legs, and I thought it was the coolest fuckin' thing in the world. And then we saw a dude get stabbed in the neck, that happened. Jason–eldest, Ed Templeton–middle, me–youngest, all of about 17 in '94. We were all part of Mark Gonzales, do you understand? That's really what was up. I never thought about that, but that moment in time, walking down the street with them—besides that guy getting stabbed and shit—us 3 were students of the Mark Gonzales fuckin' form of karate. And then—time's funny—at one point, I'm 15 and I see Mark at spots in LA, Lockwood and stuff. I was there when he broke his *ankle,* which is crazy 'cause Mark doesn't get hurt, you know what I mean? He just doesn't. That's another whole conversation, that he's the strength of a chimpanzee.

L — I heard that he's super physically strong, like insanely strong.

J — A freak! Freakishly. Strong. Person.

L — How did he react when he broke his ankle then, he must have been surprised?

J — I do what I always do when someone gets hurt. I jump the fence. And go to 7/11. And pretend that shit didn't happen. Skateboarding man, tough work—toughs you up. But anyways that was Mark's big injury, whatever—I don't want to talk about it. As Mark would say, "That's negative! Don't talk negative!" Getting into the development of the relationship, I think it turned around when I was like twenty-four, twenty-five, and Mark was

at my house a lot in New York. So I'm really hung over from maybe doing speed and drinking and stuff and whatever, and this is 10 a.m.: Ding! Ding! Ding! He's ringing my buzzer. "Hey! Come down, I got coffee!" and I just think "Oh, man." Of course I gotta go, like that's my fuckin' childhood hero, and then all of a sudden I'm riding a bike with him to the fuckin' Guggenheim. You know? That's just what you get. If you spend 24 hours with Mark you're gonna see a lot of shit. One time we were *so* uptown, at the end of Central Park looking at the turtles and shit. We didn't have bikes, we didn't have skateboards, we were walking. He wanted to buy.... I *believe* he wanted to buy chocolate for Puff Daddy because his girlfriend at the time worked in that field of people who sets up photographs and shit. And he did! He met Puff Daddy and he gave him a box of chocolates. So we were at Godiva, but then we went way past that. The whole crux of the story is that he sees one of those dudes who rides the bike with the carriage in the back? He hails him: "We need to go to Prince Street". We're *way* the fuck up there! Probably 86th street. Mark paid the dude like 250 dollars—it's just so *long*. But you know what I mean? Now I wish had that whole thing on film. 'Cause so much funny shit happened, him interacting with the driver and shit. Making the guy go faster. Trying to get the guy to do tricks. "*Off the curb!*" I wonder if Mark's hiding...—not hiding. I wonder if Mark's whole drive, everything that comes with it.... I hope it doesn't come from a place of pain. With *me*, you know, no one touched me when I was a kid or nothin' weird, but you grow up fuckin' slap-in-the-face broke and just everything was fucked, trailer parks and motels, and roaches and bullshit and fighting and psycho-ness and jails and, fuck! Undercover cops looking at our house, dude. As fuckin'-fuckin' bullshit white-trash dumb as you can get. And much of what I do is attempting to make all that OK. You know what I mean? And I do it with my business. Everything that I make with FA is what scares me, and what I love.

L — What scares you?

J — Everything! Spirituality scares me, the books I read *scare* me. Life everyday scares me. *Humankind* scares me. The bible being *so* written by a fuckin' penis scares me. The unacceptance of the penile gland and the vagina and all that stuff being the real Whole Thing. My Indian friends—which are the Native Americans I'm talking about—the Lakota Sioux—I'm part of a anti-suicide thing with the kids out there, in South Dakota. They think a big giant horse is running in the middle of the world. Uh, you know, I dunno—maybe? Everything with FA, you walk into the store—I'm not tryna plug my store but—you look around the store and there's a lot of happiness and a lot of scariness. Cops, I don't like cops. Cops end up on the ceiling. Upside down. Why? 'Cause anything's possible. And we got the cops, they don't got us. You know. This is very all topical because you're talking to a person that was so influenced by Mark.

L — Yeah. He doesn't seem scared.

J — No, he's not. He's not. I'm saying that *big* energy and happiness, or attempt at happiness, can come from a bad childhood. You know what I mean?

L — Yes. And I definitely, in a lot of skateboarders.

J — I met Mark's mom and shit. Let me tell you this. This is a lot of Mark. It's not everything but this says a lot about him. One time we were having coffee up on Prince Street 'cause I live there, and this is the year 2004? Mark turns to me and he says, "Erm,

Dill? I'm sad. I'm down." And I said, "What's wrong with you? What do you mean?" And he said, "My grandma's dead." And I said, "Oh my God, Mark, fuck, I'm sorry." And I went into this thing like, "Older people, it's natural, everybody does it, etc. When did it happen?" He goes: "I don't know." So: "What do you mean, you don't know?" He goes "I'm no good with *years*, I don't know." So, this doesn't explain a lot about Mark, but it describes a bit of who he is. You might have that conversation. It's the fact that I just accepted what he said to me, with any other friend, you'd be like, "What the fuck are you talking about?" With Mark, you just accept. Because he's not lying to me, he doesn't remember. So Mark's vastly interesting in a whole lot of ways. For anyone's who doesn't get Mark's art, or doesn't get Mark as person or anyone who thinks he's overly celebrated—which I don't hear much of that, but you know what I mean, any big artist, Basquiat or whatever, got raked over the coals.... But it's the genuine article. He's the fuckin' real deal man. It's Mark. He takes chances and he's crazy and he doesn't hurt himself apart from that one time when I was there. Just seeing him skateboard at this age, it comes from a magical place. It can't not. He's like Muhammed Ali and a whole lot of other things combined into some miraculous Chicano magician skateboarder.

L — He's still alive, he's doing all of it still. It's pretty nuts.

J — Well I fuckin' hope so, don't scare me God dammit! [laughs] Imagine: you build me all up to this point, and then: "Well, we just got some sad news, Dill." Jesus! Ha ha! That. Fucker. Will. Out. Live. Us. All. He'll be at *your* funeral, jumping over the car on his way home. (laughs) I've seen him jump over a car. He might be getting a little older now, but that's another thing with Mark. If you were gonna hang out with him, or skate with him or whatever, be prepared for him, he'll give you...he'll put you in a situation where either he'll be killed, or you'll be killed. Like, just a little bit. Just a *little* bit. You know? But anyways, whatever I'm getting at is the real gnarly influence. Mark has locations, skateboard spots named after him. No one's like: that Dill thing. That shit don't exist, I don't got no trick with my name on it. I'm just fuckin' dumbass Dill. But, Mark can do anything. Do you know his whole career?! Mark could ride for anything and it didn't matter, it didn't fuckin' matter. Mark would protest this, and that...not that it's uncool, but no one else would do it. And he did.

L — Yeah, different phases in life. When you've been alive for 50 years and you've had ups and downs in skateboarding, had money and no money.... Anybody who judges either hasn't tried, or is maybe too young to get it.

J — Oh trust me, Mark had that influence on me big time. I just recently started to get a grasp on not spending money like I do. That dude.... One time he woke me up on Prince Street and took me to this little Japanese North Face-y outwear brand place called something like R 55-9, and all this shit was cool, I didn't even know it existed, it was right down the street from my house. Mark takes me in there and I'm on the phone talking to a girlfriend or some shit like that, Mark is pointing out flannels to me and they're cool flannels, and he says, "You want one? I'll get you one. You'd look good in this one." And I say, "No no no. I'm on the phone, no no no." He's like, "He'll take this one, and I'm gonna get these." He knows the guys, "Hey Teto!"—the Japanese guy, he knows his name—when Mark walked in, the dude bowed, so stoked. "Hey Teto we need 3 of these, and I'm gonna take this belt!" so I get to the register and close my phone, and say, "How much are these flannels?" "Don't worry, it's cool." There's four, mind you, four flannels on the counter. They're fuckin' like,

159 dollars apiece. I said: "Put that back." Don't just get these flannels! Also, it's summer time. I dunno what it is. He would come in the summer with a hooded sweatshirt with a jacket over that, and a jacket over that. But well, this has been fun talking about Mark. He's a wild, wild, *extremely* big influence on this person that you're talking to. And it's the icing on the cake that people come to me and ask about him, that's been happening to me for a long time, and it really makes me happy. I wrote to him the other day, we email. Everybody probably just emails with Mark. But I watched one of his YouTube videos. His YouTube videos are so *fuckin'* annoying, I wish he would just show the footage, but he shows one thing over and over and over and you have to fast forward. He was doing these high airs, and he looked smooth, and an invert, it was beautiful. I wrote to him: "Hey man, God your airs are clean man, they're big, they're top!" He answered, "That's nothing! I'm *so* much better now!" You know, and then I'll get an email from him, "What kind of tricks you been doing lately?" [laughter]

L — Yeah, he's progressing all the time, always pushing something where it wasn't before.

J — If Mark doesn't want to, then don't put this in there. But one of our recent conversations over email was—how did he put it? He said, "Dill, I miss being the innovator." He's saying I miss being young and doing it the way I used to do it. That was like the crux of the email. And I really thought about it for the day, 'cause it hit me. You do miss the time when you could throw tricks away all day, it didn't matter. Shit that would kill me now, you know what I mean. You know that aspect is gone. That battery doesn't exist anymore. But I said, "Mark, you know you really can't be the first to break ground, and stay in that realm. You're a lot of the reason that people can do what they do now on these things." I don't think he answered me back. Which I love. That's another thing about Mark too. You might ask him a question and he'll just blank you. I had a taxi driver not too long ago in Los Angeles and the guy started talking to me about acting and I was like, "Yeah, I own a skateboard company." He goes: "So, do you know who Mark Gonzales is?" I was like, "Bro, do I!?" It turns out this dude grew up with Mark. He was telling me about this band he was in, and how Mark used to come to the shows and all this stuff, he's all, "Tell Mark I say Hi!" I even took a picture of the guy and sent it to Mark and he just blanked me. With any other friend you'd be more inquisitive, but with Mark, he just gives you whatever he gives you.

L — He gives a lot in certain ways, but he doesn't give away what he doesn't want to, for sure.

J — Yeah, I really like that. I think I admire that most about him 'cause I'm just a blabbermouth, I can tell you about fuckin' everything.

"COPS, I DON'T LIKE COPS. COPS END UP ON THE CEILING. UPSIDE DOWN. WHY? 'CAUSE ANYTHING'S POSSIBLE. "

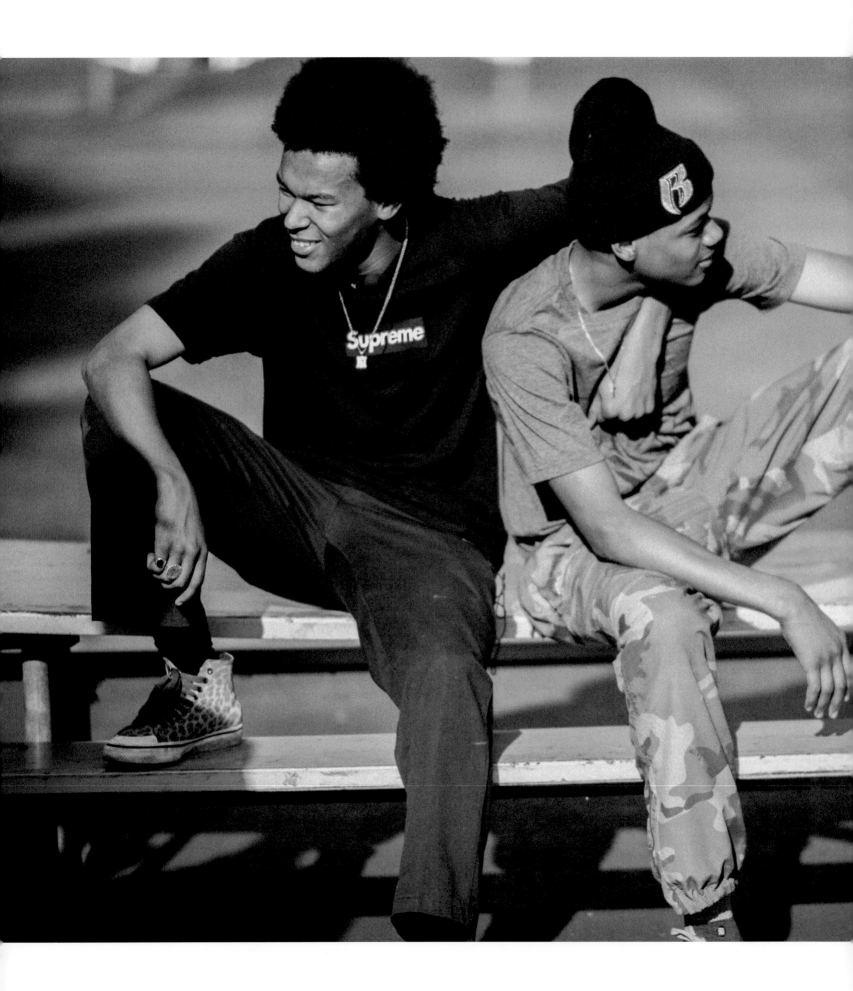

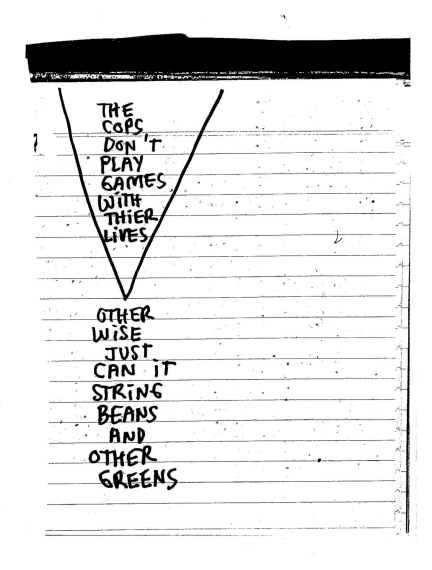

THE
COPS
DON'T
PLAY
GAMES
WITH
THIER
LIVES

OTHER
WISE
JUST
CAN IT
STRING
BEANS
AND
OTHER
GREENS

Joe Roberts

Roberts is an American artist and psychonaut who lives and works in San Francisco.

I like the look in Mark's eyes when he's sketching. I like the part in the Real video *Non-Fiction* where he waves to the guys filming him from the car to catch up with him so he can go faster.

-

Is Mark easy to talk to?
YES
Is he boundless?
YES

-

If Mark were a song, he would be Max Roach's *Parisian Sketche*s.

-

The last argument I was in that I liked was probably one where someone changed my mind about something. I don't really argue tho so I'm not sure.

-

Q — What do you tell someone who feels lost?
A — You are not lost, you are here on earth, living. There are many paths to take, they all end in the same place. Take the path that looks to be the most fun.

-

I already knew about free will before psychedelics.

-

Q — In which ways do you feel more free now, than when you were younger?
A — I don't have a curfew.

-

No bosses please.

FRICTION – HEAT, LIFE, ENERGY
FREEDOM – TAKE A DEEP BREATH, THINK ABOUT
WHATEVER YOU WANT AS YOU BREATHE, REPEAT
UNTIL YOU DIE AND BECOME ACTUALLY FREE
EMPTINESS – MONEY, FAME, LIKES

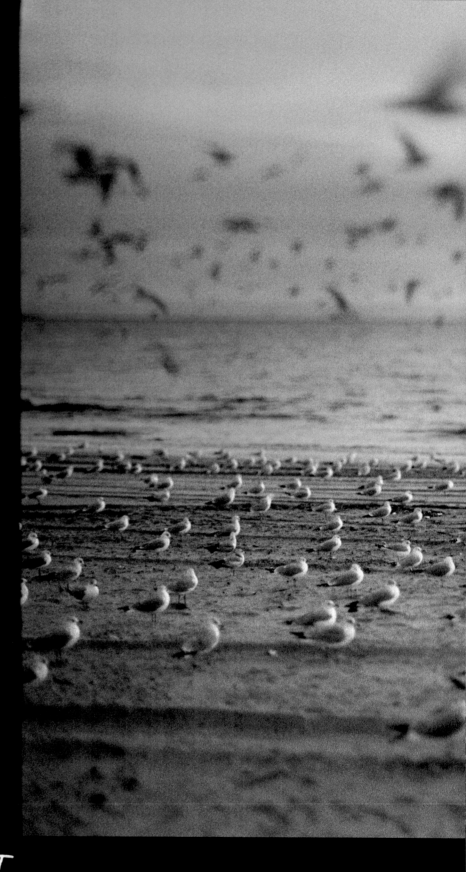

ROCKET
POWERE
 SUNSHINE
 BEAT UP
DAY AND NIGHT
BEACH RENTALS
 RIO
THE RINGING IN
MY EARS
IS THE SUN
SHINE IN YOUR
STRIDE
WHEIN ~~YOU~~ IT'S
~~SHIE AND~~ BRIGHT
~~AND SHINE~~
AND YOU CAN'T FIND ~~█~~ NO PLACE TO
 HIDE

JIM THIEBAUD

Thiebaud is a skateboarder, activist, and Vice-President of DLX Distribution. DLX produces and distributes Krooked Skateboards (in partnership with Mark Gonzales), Real Skateboards, Anti Hero Skateboards, Thunder Trucks, Venture Trucks, and Spitfire Wheels.

I first saw Mark at a street contest in Southern California. I had taken the red-eye Greyhound Oakland-LA, it was $30. I didn't know anyone at that contest other than a few of my friends who were there. I was way, way, way out of my league at the contest. There was this one young kid, and he was unbelievable. Everything he did looked so good. He was light years ahead of all of us. It was the first time I had ever seen a Kickflip. I know that sounds unbelievable, but, before then, I had never seen anyone flip their board that way. It defied logic. When I returned home, I tried to explain to my friends what I had seen. "No, no, he didn't use his hands or do an Underflip....he ollied and then flipped the board...." It was like magic. We spent nights spraining our ankles, trying to learn.

Fast-forward a few years. Mark had been in the magazines, was becoming known as one at the forefront of street skating. I was such a fan of everything he was doing: his skating, his art, his approach to all of it. One day I was in Concrete Jungle, a small skate shop in SF, and Mark walked in. Completely out of the blue, Mark, alone, walks into the shop. I fanned out. "You're Mark Gonzales," I said to him. Without missing a beat, he says: "....and your name is Jim." I had no idea how he knew me, probably through my friendship with TG [Tommy Guerrero], but he knew me and that blew my mind.

We went skating that day, all around SF, just Mark and I. It was great. He did Frontside Boardslides to back lip transfers into the deep side at the Sears curbs—never saw that done there, and I had skated that spot with the best... I tried not to just sit and watch the madness of what he was doing, just to soak it all in, but I knew that would ruin the moment. I skated along with him, trying not to let him see me following his every move, trying not to miss anything he did, and trying not to squeal with disbelief at what I was witnessing. We have been friends ever since that day. I'm still the biggest fan of his and always try not to stare when I see him skate.

I'm a fan of Mark's art. There's not one specific deck that stands out as my favorite, but when Mark surprised me with a rendition of my first deck on REAL, that was a special moment for me. It's cool to see how excited Mark gets when he does art for others. Seeing him pour himself into doing art for skaters that he respects and likes, and knowing how much it means to them to have him do it. I'm happy they get to experience what I did when he did it for me. There are very few "awards" in skateboarding—but being able to say Mark did a board for you...That's about as good as it gets.

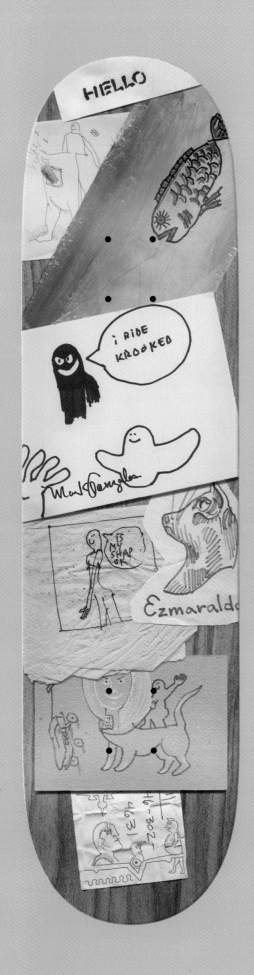

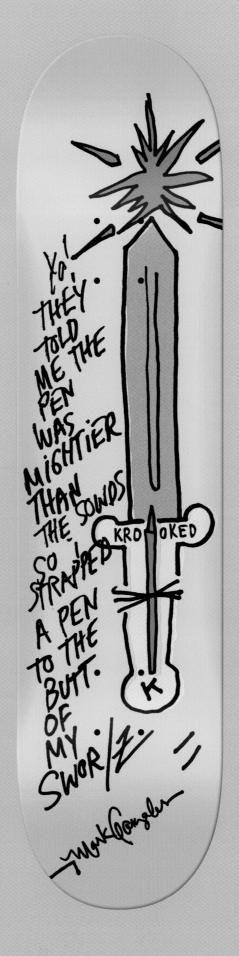

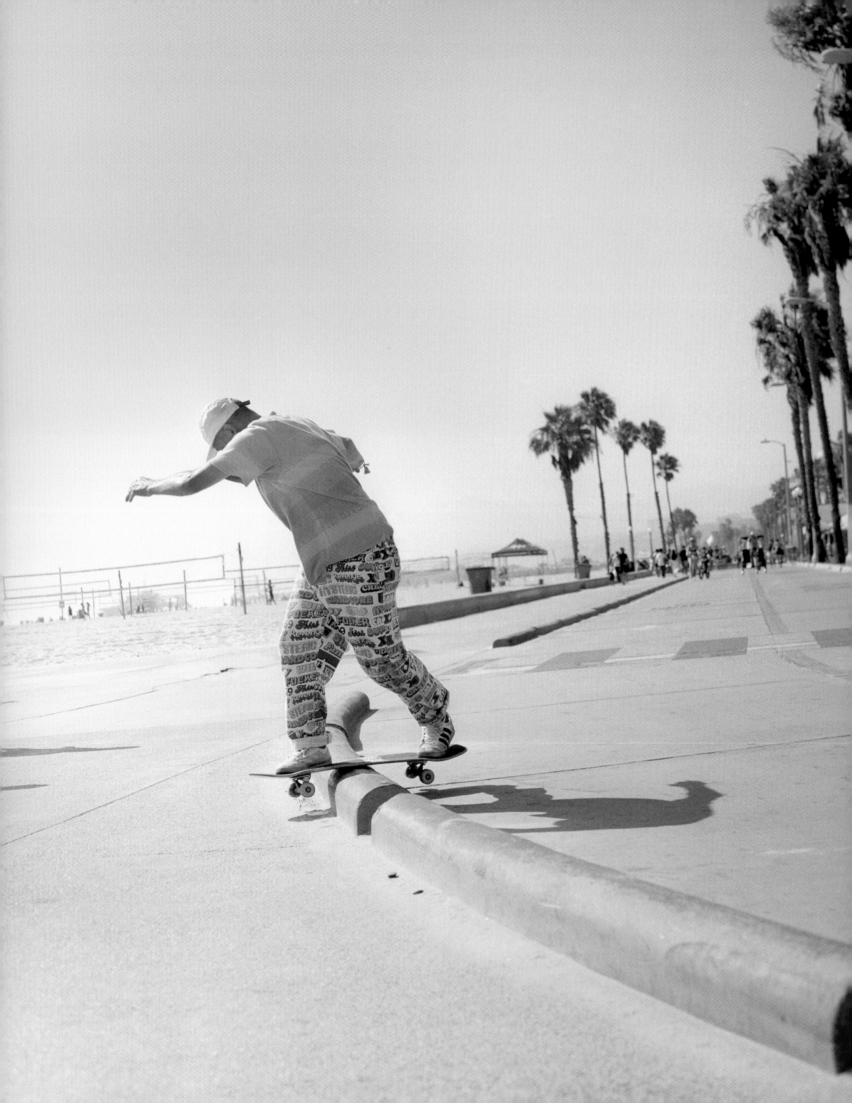

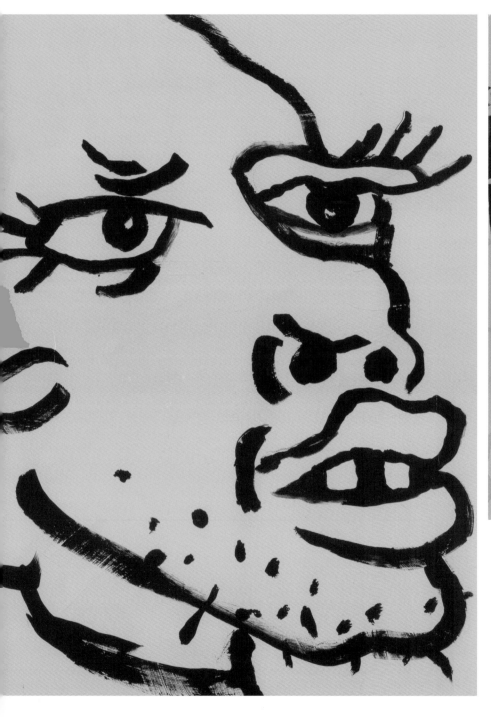

Liz Goldwyn

Goldwyn is a filmmaker, artist, writer, and activist. She is the creator of The Sex Ed, a digital platform dedicated to sex, health and consciousness.

I have appreciated and been fascinated by skateboard culture since I was a teenager—collecting *Big Brother* magazine, pasting Fuct stickers on my schoolbooks and hanging out with the Menace Skateboards crew as a high-schooler. I first met Mark not as a skater but as an artist through my friends Harmony Korine and Aaron Rose/Alleged Gallery when he had his first show at Alleged in the late 90s. I still have a Calvin Klein nude camisole he drew on from that show and the zines he and Harmony made. A line that sticks out from one of them is "Jean Harlow's pussy glowed," but I could be paraphrasing.

-

Mark used to send me the most beautiful care packages in the mail—letters and drawings. I still have them all saved. He used to send my nephews boxes of decks and clothes.

-

It's probably not little known that he is a sensitive troublemaker!

-

Mark's eccentric, effortless style is timeless.

-

I push boundaries every day. My job as founder of The Sex Ed is to discuss topics that make most of the world uncomfortable yet are essential to the human experience—Sex and Consciousness.

-

I play a long game in business, always prefer strategic alignment over fast cash and loose ethics.

-

Q — What's the last argument you are glad you got into?
A — I prefer to use diplomacy whenever possible.

Q — What helps you think clearly?
A — Meditation, orgasms, kundalini yoga, therapy, sound baths, hula-hooping, music, laughter, great sex.

-

I don't have as much trouble saying no, setting boundaries and my bullshit detector has gotten stronger. All of which frees up space immensely.

-

It drives me nuts when people and companies hide their intentions. We are in a new landscape where social good and feminism is used to sell product. I'm all for capitalism but call it what it is! That said, people can do good and "make a buck" as long as it is not merely performative.

-

We need to feel as humans, less alone. We all walk around wondering if we are normal, and have so much shame, fear, and taboos tied up with sexual identity and self-love. If The Sex Ed makes one person better understand themselves and unlock their pleasure potential, I've done my job.

-

Q — What is the bravest decision you took regarding this space?
A — Being ok that not everyone will understand my path or accept it.

-

I love traveling and doing public talks. We spend a lot of time on analytics but it's always better to hear firsthand what people are curious about, struggling with, seeking.

FRICTION – CHEMISTRY
FREEDOM – CONSCIOUSNESS
PASSION – SEX

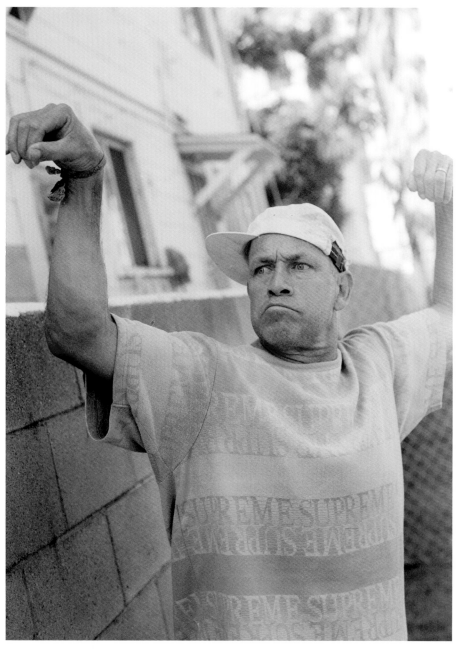
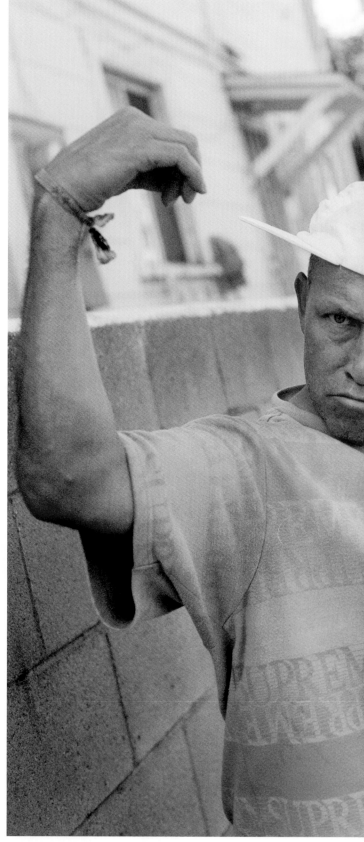

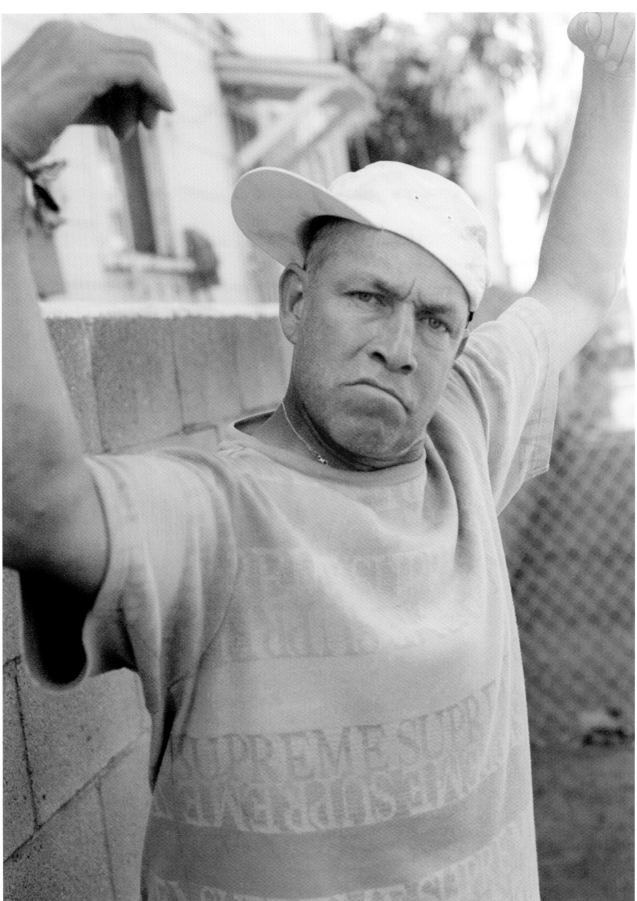

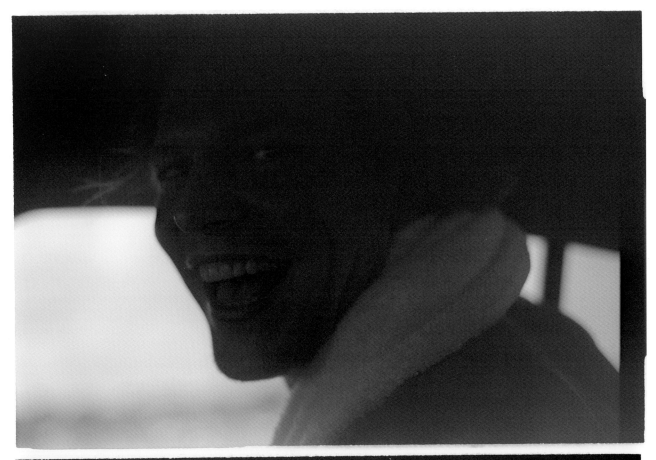

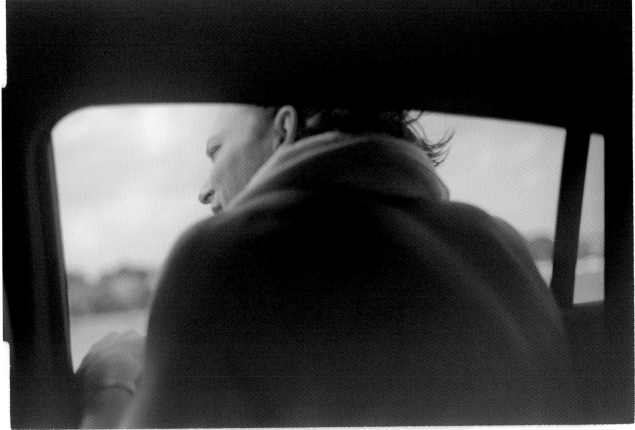

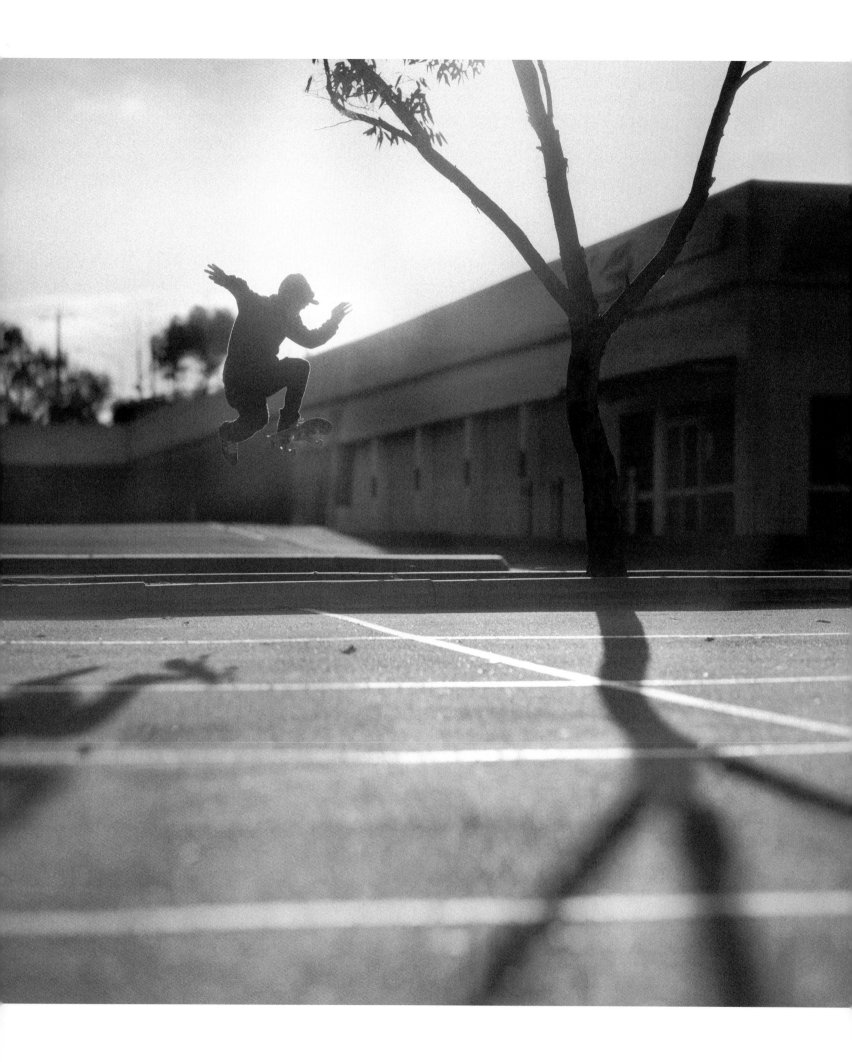

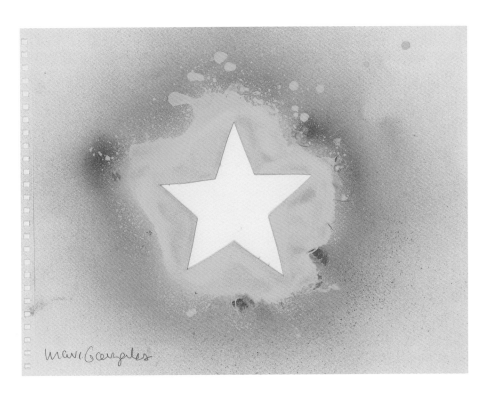

JOHANNES WOHNSEIFER

Wohnseifer is a German artist based in Cologne who worked with Mark Gonzales on a seminal performance piece at the Städtisches Museum Abteiberg in Mönchengladbach in 1998.

J — OK, I speak English, but sometimes I have the feeling that I sound simplistic because I lack certain words or expressions. Maybe I will switch into German if I have the feeling that I am not precise enough.

L — No problem, but in my experience, Germans say that and then speak perfect English. [Wohnseifer laughs] So were you a skater? Are you a skater?

J — I started skating when I was 10 years old, which was a long time ago [1977]. This was actually one of the first summers when skateboards came over officially from the US to Germany. There were also many American soldiers around at that time who were importing all kinds of stuff. I was very much into skating, but my friends were so much better at it from the very beginning that I focused on other things very early. But I was always interested in it, and always had a lot of skater friends. At the time nobody thought about tricks, it was all very simple slalom contests and things like that. When I was 15 or 16, still at school, I was developing my first ideas as an artist and I was very much interested in graffiti. I had the idea to work like a graffiti artist, but with sculpture, so I was building very simple, basic ramps with what I found in construction sites or in the streets, mostly at skate spots. It was the thrill of working at night, at that age it's the first times you're able to go out a bit longer. And also working illegally, stealing materials from construction sites and so on.

L — Where was this?

J — This was here, in Cologne. There was a very vital and active skater scene. Many skaters were artists, and vice versa, you know? I never was a good skater, but I always liked the thinking behind it, there are a lot of parallels between my work and skating, like needing to do things very often, and repeating them over and over again, to become good at it. I lack this endurance with skating, but not with drawing, painting, and making objects. This was easier for me, and so I did it instead of skating.

L — That was where your talents took you.

J — Yes, but this strong affinity to skating was in me, since my childhood, you know. Cologne had one of the first shops in Europe that was exclusively for skaters. Blue Diamond. This was the first shop where you could buy Stüssy clothes, the end of the 80s, the beginning of the 90s.

L — That's early.

J — It was.... I still have one of the really first series of Stüssy sweatshirts and T-shirts. And, especially in Cologne, if you were moving with certain people, there were always connections with skateboarding or skaters.

L — So when did you see Mark for the first time? Did you see him skate or did you meet him in person first?

J — No, of course I knew about him. But one of my best friends, Michael Zöllner, founded a small publishing house called Tropen Verlag, and initially he had the idea of publishing scripts of Raymond Pettibon's videos.

L — Wow. Niche.

J — So he met with Raymond and they talked, but Raymond wasn't in the mood for publishing. He did some longer videos, like home movies about the life of Charles Manson, and Michael was very much interested in publishing the script, but Raymond had no interest and he said: "You know what, I know someone who is a really good artist and a really good writer. His name is Mark Gonzales. You should publish *his* stories." So Michael got in touch with Mark and they concluded to make the book *Broken Poems*, it's a collection of short stories by Mark which appeared in special magazines over the years.

L — I didn't know that Pettibon made the connection.

J — Yeah, initially it was with Pettibon. At the same time, I was invited by the museum in Mönchengladbach, and when I visited it for the very first time I was really struck by the architecture. It's quite interesting because it was the very first postmodernist museum architecture, and it had these different levels and this smooth surface. It looked like a skatepark with a roof. And so this was my very first idea when I came in there. It would be perfect for skating. I talked with Michael, and I didn't specifically think about Mark. It came up that it would be perfect for him, and I had different ideas, and then I think Michael asked Mark if he would be interested. It was very good timing because Mark was flown in for the release of the book, and he had 2 or 3 *Buchvorstellungen*, you know, book release parties, so this would be perfect to promote the book as well. I proposed this information to the museum director and I said, "I would like to have someone skating through the museum." He said it's not possible because of insurance and so on. I said, "But it's Mark Gonzales." "Mark Gonzales? Who is it?" So I said, "He's a two-time world champion, and one of the best skaters in the world." "Ah OK, he's World Champion, then we can do it, *ja*, no problem."

"THE MUSEUM CONSERVATOR QUIT WHEN WE STARTED OUR PRACTICE RUNS."

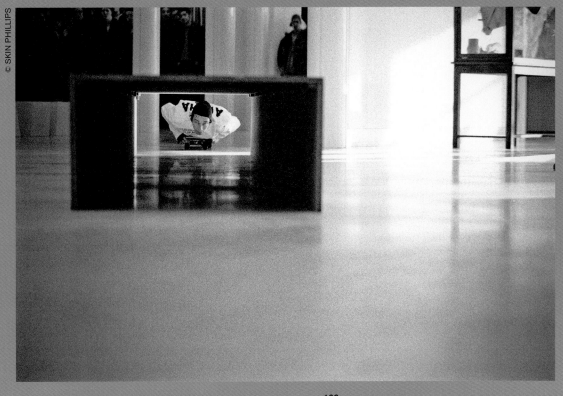

It was really a bit crazy you know?

L — Was he world champion or did you just make that up?

J — I think he was world champion, at least that was the information I got from Michael. I never verified it. But it worked, you know. Because this term broke the ice.

L — Yeah. I mean I'm tempted to say that's so German, but I think it would have been the same anywhere in the world.

J — Ja, in a way actually I think it wasn't very German because also looking in retrospect, it was just crazy. Mark was skating through the permanent collection, and actually it's incredible because the museum Conservator quit when we started doing our practice runs inside of the museum. She said, "No! Are you serious? No, you must be kidding!" And the director was shouting back at her. "No-no, this guy is a world champion. He knows what he does!" There was a big tension between the director, who was always yelling at all the other museum employees, and everybody hated him. But he was on our side, you know, and so she said, "No. I'm protesting and I'm going."

L — No!

J — She took off for the rest of the week.

L — Do you think it was for the principle? Or do you think she was nervous something would happen?

J — She was absolutely nervous. And in retrospect I can understand, it was potentially very dangerous for the artwork around. Sometimes you can see it even in the footage, because Mark bailed many times, we tried lots. And you know sometimes it was just me and Mark in the museum and the board was maybe crashing against a Beuys piece, and so on.

L — Wait, did you say it went crashing against a Beuys?

J — Ja.

L — Actually Beuys maybe would have loved that.

J — Yes...but on the other hand, Mark was very precise. There were these casts made out of plaster, really fragile, by Bruce Nauman, called *False Perspective*. And Mark was always going like a millimeter besides them, it was crazy. And then he was using a prop, a Richard Serra! You know, that's an iron or steel plate that weighs hundreds of kilograms, and it is just balanced on a metal pole. Mark thought it was welded, that it was fixed, and he skated through it, under it. I have some proof, I have the photograph! He could've been hurt if he'd touched the pole and the big steel plate had fallen, he would have been badly injured.

L — Richard Serra talks about weight, it's all about the weight for him.

J — Exactly. But Mark made it appear very light.

L — So what was the idea?

J — I need to go back in time now. Some weeks before we met in Cologne, we were talking on the phone, sending faxes back and forth, communicating and developing the performance. Mark had this idea: "You know all my bones are broken at least

one time, and I'm feeling like an old man, and I won't be skating anymore, and now I want to become an artist."

L — How old was he? Do you remember?

J — He is from '68, so he was 30. I was 31, I'm one year older. He was 30, it was more than 21 years ago!

L — So he wanted to evolve beyond street skating, he needed to protect his body.

J — Ja, exactly. But also he didn't like this public perception as a street-style skater. At that time it was a lot about toughness, being crass, things like that. It was not what he was interested in. He was more interested in something like ballet, or choreography, you know? And he wanted to bring it back to something very elegant, that's why he chose to wear a fencing suit. Because fencing is like one of the most elegant sports you know? This was the idea. Then on the back of the fencing suit, he had "Aloha." He was interested in the origins of skating, which are lying in surfing—at least that's how he told it to me. He said in former or ancient times, surfing was very elitist and it was exclusively for the members of the royal family of Hawaii. He wanted to stress these origins and the idea of it being very elitist. But also with a lot of consciousness about all the conditions you're dealing with as a surfer or a skater, because he also had a Hawaiian term written on the back which people in Hawaii use to apologize to the forest for taking a new tree when they made a new surfboard. And so it says, "Excuse me forest," translated roughly.

L — That's beautiful. He's really got this talent of paying homage to things but at the same time questioning them and rebelling against them.

J — Absolutely. Yeah exactly. And what's also funny is that his initials, MG, are corresponding with the license plate for Mönchengladbach. This was another lucky coincidence.

L — Cool, so you guys invited I guess everybody linked to the book or its release. How many people came to this performance?

J — Ja, you know the performance was on Sunday morning at 11:00. Maybe it was around 80, 100 people. Not so many. I would say 20 percent from the art world and 80 percent skaters, and most of them brought their skateboards. There was a big misunderstanding, they thought they could all start skating inside of the museum. You know Mark was also doing a soundtrack for the whole performance. He did it with a friend of mine who's a musician. He made it here, in Cologne, and included the bells of the Cologne Cathedral, and old songs from the soldiers of Fiji, and then it was morphing into classical music by Robert Schumann.

L — So it was very spiritual, or romantic?

J — Ja, it was, and very unexpected for many of the visitors. The track is roughly 12 minutes and this marked the beginning and end of his performance. We placed the visitors, we made little islands for them with tape markings on the floor. We placed them so you would always have groups of 10 to 12 people, they were not allowed to move during the performance, and Mark used them like a parkour, you know? It worked so good because you could hear him on one side of the museum, and then he would suddenly appear on the other side. All these levels of the museum, Mark really used the whole space. This was really great.

L — We use a lot of skateboards for traveling shots on shoots.

J — It's good. That's something Mark taught me. Skating has a very specific speed. It's really different to seeing something when you are walking or on a bike or when you are going on a board. It's a specific speed and you can make use of it. And for sure for shooting things that's the perfect dolly. It's in between, it has this kind of hybrid aspect that makes it very different from other forms of moving and perceiving at the same time. We had the luck that Mark was accompanied by Aaron Rose, his gallerist at the time, and Aaron was commissioned to make a documentary of the whole thing. You may know a video from the performance, which is now super popular on YouTube. I think it has more than 60,000 views. Mark gave the video footage by Cheryl Dunn to Jason Schwartzman to use for the Coconut Records song, which fits perfectly, like it was made for that song—or the other way around. But the video that was done by Cheryl Dunn. Unfortunately there was no happy ending. She was filming on video, on super 8 in black and white, and mixing it all together, which was not common at that time. It was the first time I saw that style of shooting.

L — Still very popular today.

J — Exactly, exactly. But I think she was never really paid by Aaron, she never got her money. And so the video was never officially released. But now through YouTube...at the beginning maybe 8,200 people saw it, and now it has so many.

L — It has become a cult object or artifact for sure. So what did you think about them re-doing it at Milk Studio?

J — I liked it. It's 20 years later, of course it's something else, but I don't see any competition there. Actually I'm a fan of redoing things, reenactment, and I like the inversion, he's now wearing a black fencing suit, I like it a lot. Actually I did a Japanese version of it in Tokyo with Shin Okada. He was in a video called *RAMP*, which stands for Roppongi After Midnight Performance. I had a residency in Tokyo, I was living there for almost half a year and people talked me into doing it. I said maybe I'll do something else, but then everything was already prepared. [laughter] So I was like "OK." It's like having a Japanese version of a vinyl record, having the Japanese pressing, which is very exotic and valuable. I kind of liked to make a Japanese version of it. Like "how does it look like in a parallel world" in a way.

L — What do you think of actual skateboards as a support for artwork?

J — I like it. Actually I collect them, or try to collect them—sometimes they are immediately sold out.

L — Which ones do you go for these days?

J — I am absolutely sympathetic to it, not about every deck design and collaboration, but especially the Supreme boards work really well. Before I even started in the art world, in 1992, I worked on a show with Larry Clark. At that time, Larry Clark was not very well because he just came to Cologne after rehab and he was sober and not in a good mood and I was the one installing his work. I was wearing a skate shirt, and he asked me about it. And I told him about the skate scene in Cologne. He asked, "Where can I see it?," and I told him it was a 10-minute walk to the Dom plaza, the spot in front of the cathedral. He went there, and he turned around 180 degrees. You know, this

was 1992, this was 2 years before *Kids* came out. And it was really strange, I knew Larry Clark as an artist and a photographer but I would have never connected him with skateboarding.

L — Wait, are you saying you turned him onto skateboarding?

J — Oh no. He was already totally into it, but you know this was before internet, you couldn't know that people were into certain things. Today it is unthinkable but at that time I didn't know the connection. Very soon he talked to the skate kids of Cologne, and he knew every board, he knew the wheels, he knew the skateboards, he knew the whatever, every detail. I was really impressed. And then the whole week we went all around Cologne, to the skatepark, again to the cathedral, and he really liked it.

L — Do you know if it was Mark's first time in Germany?

J — I think he came here before but always to Münster for the big contest but it was his first time in Cologne.

L — Oh of course. But Cologne is much more artsy, a very different scene for sure.

J — Yes exactly. Mark and me stayed together all week because he didn't like Michael's style of driving, so I had to drive all the time. We always went to the museum on Mondays or after 5 o'clock when it was closed to prepare everything, and I took him to my friend Tomas who had a home recording studio, and they made the soundtrack, so we did everything together. I think he enjoyed it. You can see some of the footage in the beginning of the video when he's skating through the streets of Cologne, through the cars.

L — I wish I could translate the tone of your voice because when you talk about this, it's like you're a kid again.

J — [Laughter] That's nice! Ja, it's like that. You know, I became a father very late, I was 42. My kid is now 9 years old and it can sound so pathetic you know, but in certain ways it *is* like that. I can have fun like a kid. I can still feel this.

L — I think this is a great quality that a lot of skaters have in common, you know, this capacity to still feel joy like a child.

J — Ja, because it's a childlike sensation, you can feel again and again, you can see it with Mark. I mean at that time, more than 20 years ago he thought about retiring from skateboarding, now look at him today. And it's still fun.

Again I can see the analogy to my work as an artist in the studio, because actually you are right, you are doing the same stuff you did as a 10-year-old. When I was 10 years old I was drawing and making objects. Of course I'm romanticizing now, there is a lot about it which has nothing to do with a 10-year-old. But the very basic skills and the physical experience and this sensation you feel, if a trick is working, or painting is working, and you discover something—that's a childlike sensation, it's true. Today we know that motion is crucial for the development of children. And you know Mark is a motoric genius, you know? He does things you wouldn't believe. And then he has a 6th sense—it happened twice, walking with him through Cologne, and he could foresee dangerous situations between bicycle and car. He said "Ah, look." And I looked and nothing, but in the next moment the bike nearly crashed into the car, it was a really close call. But

Mark saw it like 5 seconds before. I never met a person like Mark again. He has senses, and probably he needs them in traffic in New York—or wherever, in the world. Yeah, he needs them, it's a survival technique.

L — You could call it magic, you could call it psychic...

J — Ja, it has elements of both. As if the person next to you is living in the future. And maybe the future is just 10 seconds ahead of you, but still it's the future.

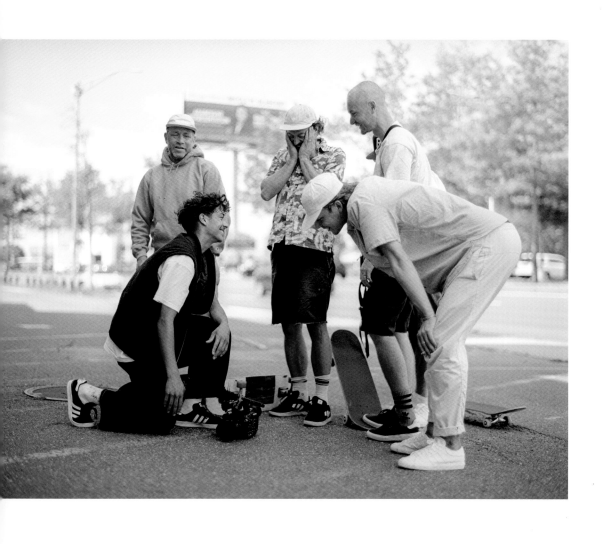

THEIR'S
~~ISNT~~
NUTHING
SO ~~MUCH~~ TACKY
AS A POOR

PERSONE

WITH LOTS

OF ~~~~ CAPITAL

~~MEAN~~
~~MONEY~~

ALL I HAVE IS REGRET

FOR NOT BEING

BORN INTO AN ARISTA.CRAT

FAMILY

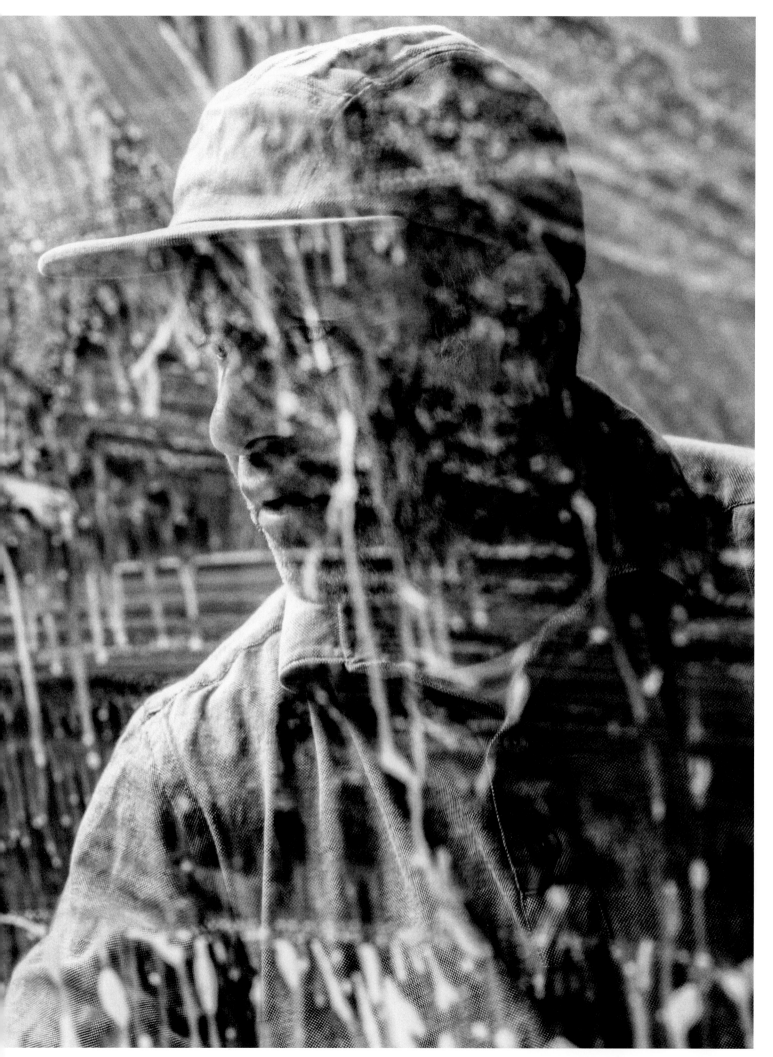

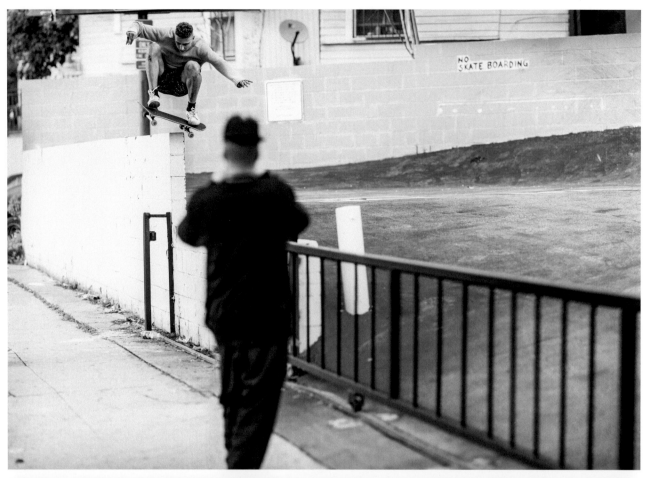

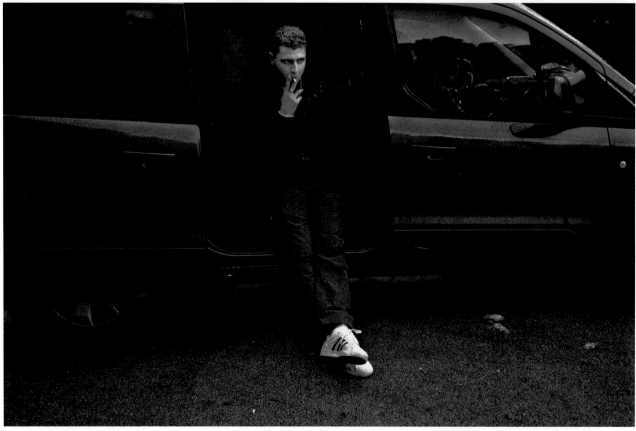

Blondey McCoy

Blondey McCoy is a professsional skateboarder, fashion designer, and model. He is also the Founder of Thames.

Hi,

apologies if this is too late but it only hit me this morning that I have a quote for the Gonz book. Please see below, and you're welcome to include or not.

Best, Blondey

"When I think of the spirit of skateboarding, I picture Mark Gonzales on a mountain bike."

Sent from my iPhone

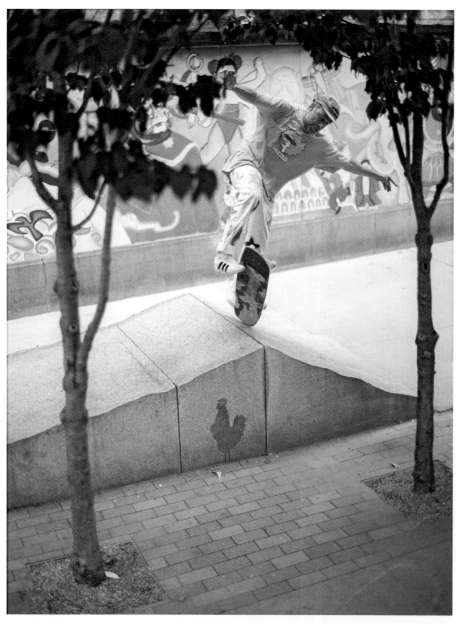

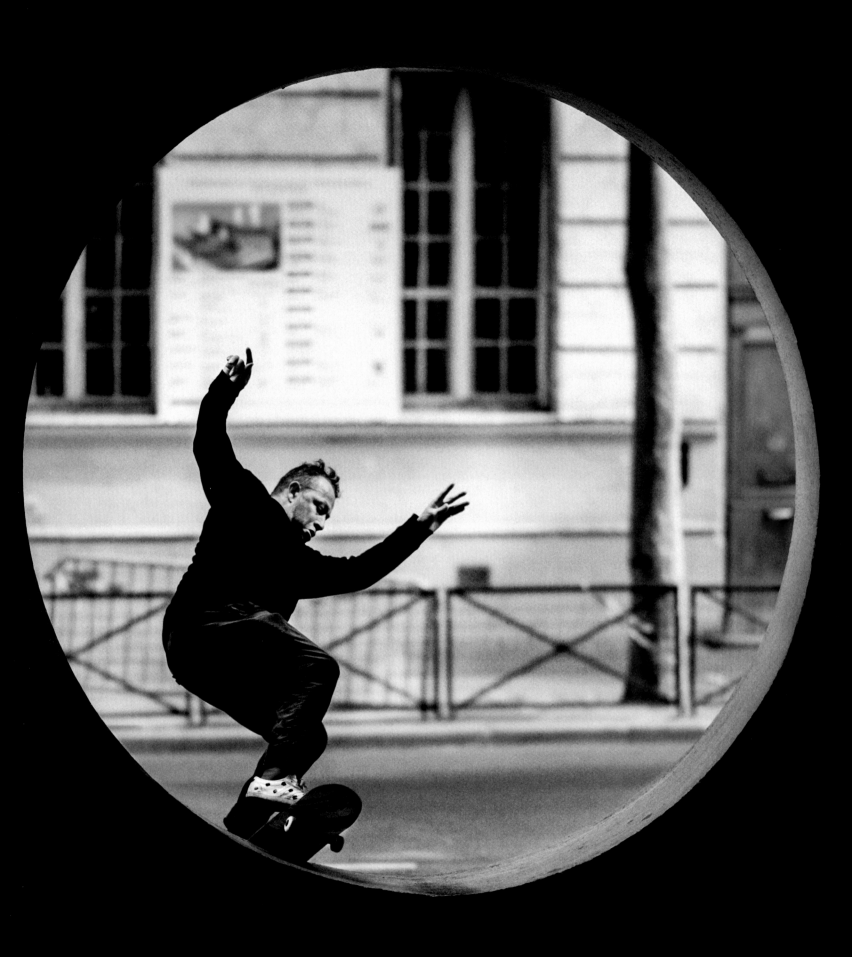

ÉTUDES

Aurélien Arbet is Co-Founder of Études, a brand based between Paris and New York that operates across platforms ranging from menswear to publishing.

Mark and I met through a mutual friend, and our first meeting was in our Études New York studio. He already knew about the project, and he came with ideas and proposals, which was amazing. It really showed how creative and generous he is. It was summer 2015.

-

At the time, we were working on our Spring Summer 2016 collection (Études N°8). The theme was "Up and Down Town," and the idea of a mix between the bohemian Parisian artist and the New York skater wandering through the city. We instinctively thought of Mark Gonzales and we knew we wanted to work with him. We deliberately focused on the poetry part of his work, less known than his drawings and his skating career.

-

There is a striking sentence in the video we made with the American video artist Peter Sutherland around the collaboration that goes: "This is not poetry, or even photography. It's time passing us by like a wise kid that pees on everything."

-

The craziest part was when we asked him to send us clips of his voice to use in the collaboration video. He sent us 3 videos taken from his laptop, where you could kind of see him in his New York apartment, but you could mostly see his ceiling. The videos weren't usable, but we kept them as archives.

-

Besides the capsule collection, the collaboration lived through many mediums. During the show, we used snippets of Mark's voice in *Kindness'* soundtrack. We also produced a dozen of our Horizon Bomber jackets and had them hand-painted by him, and we released a micro-edition box set of postcards (50 units). This collaboration was the first we did with an internationally renowned artist, and had a strong visibility. It took Études to a worldwide audience, and it gave us the chance to work with someone who had inspired us since our childhood.

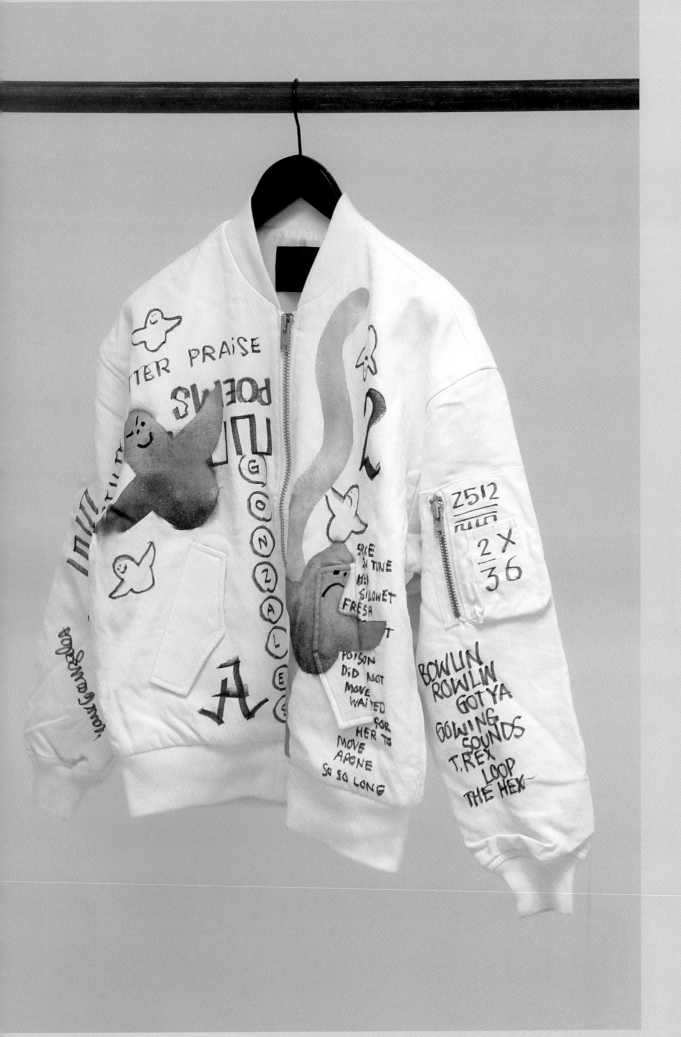

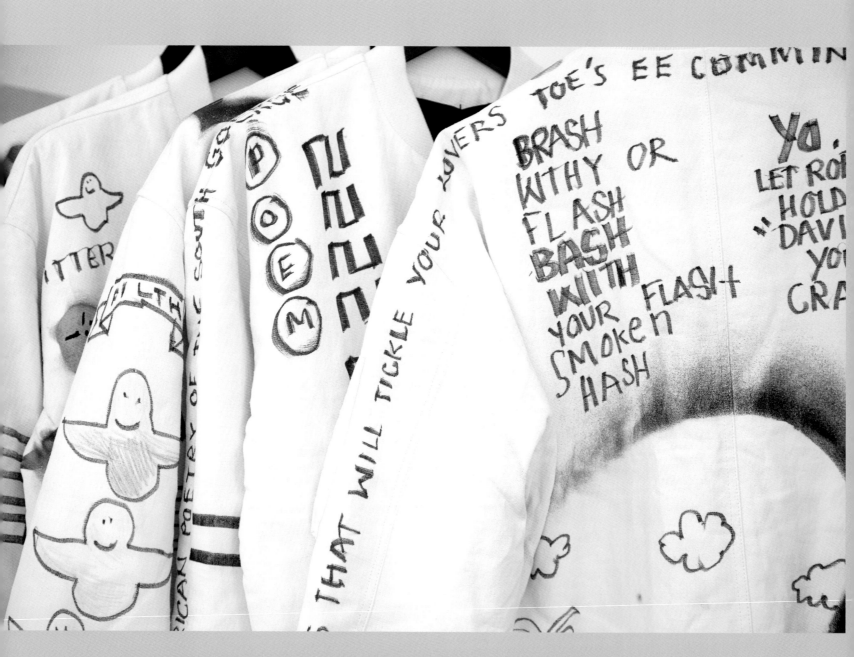

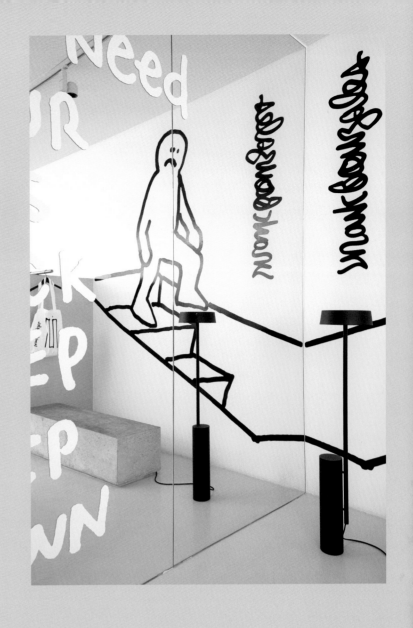

Études with Mark Gonzales

Mark Gonzales, often referred to as "The Gonz", is an American skateboarder, poet and artist. Shredding in New York by way of California, Mark is known around the world for his innovations in skateboarding and is highly regarded amongst the global skate community as one of the most influential skateboarders of all time. In addition to his skateboarding career, Mark is a working artist and poet, whom is known for his poetry zines and distinct illustration style

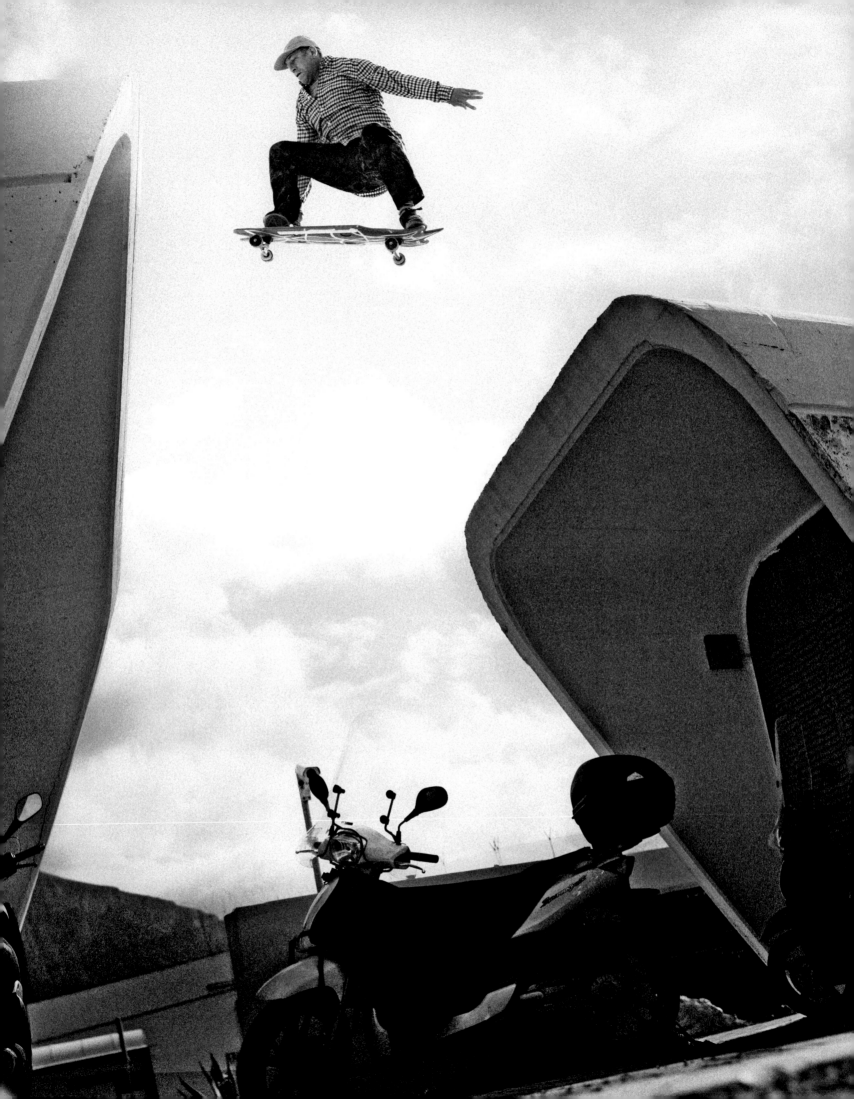

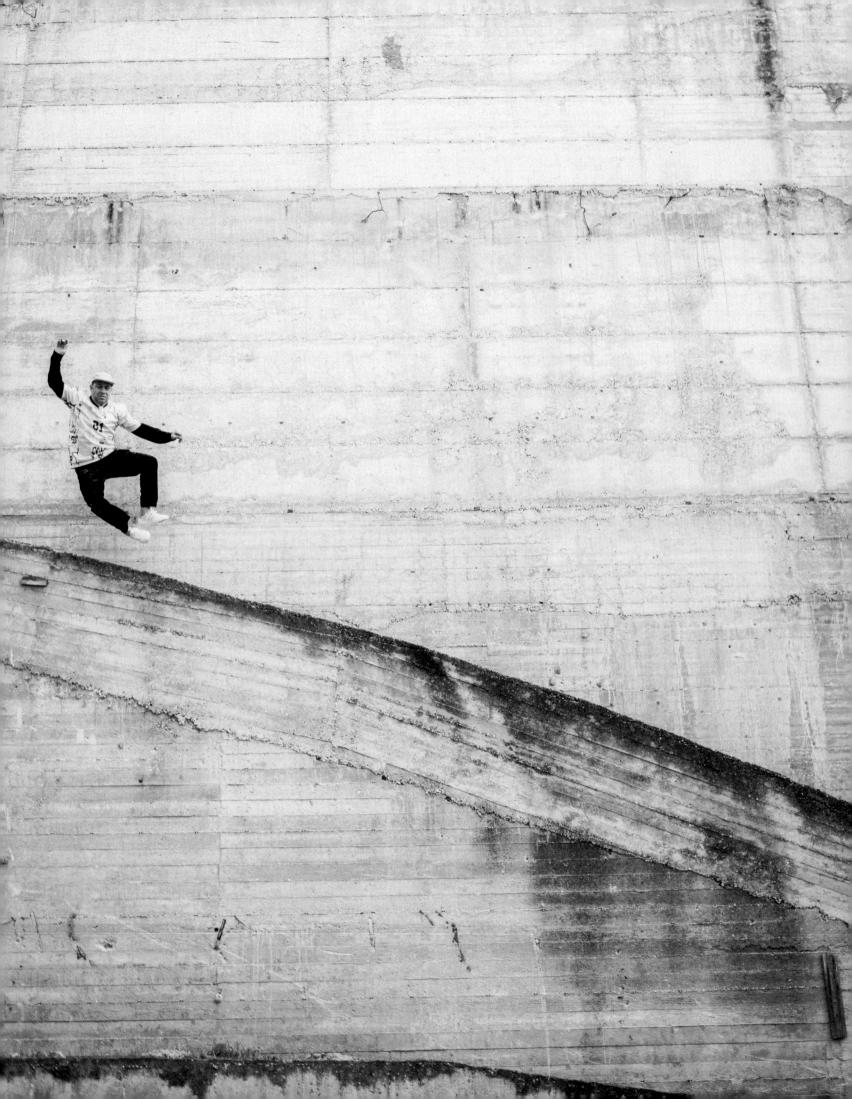

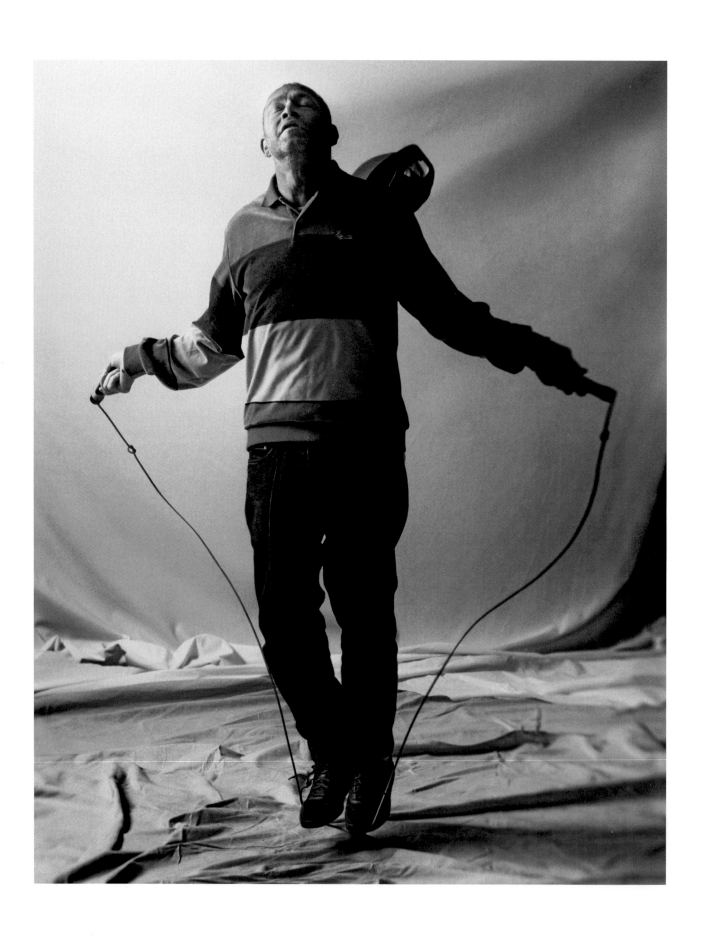

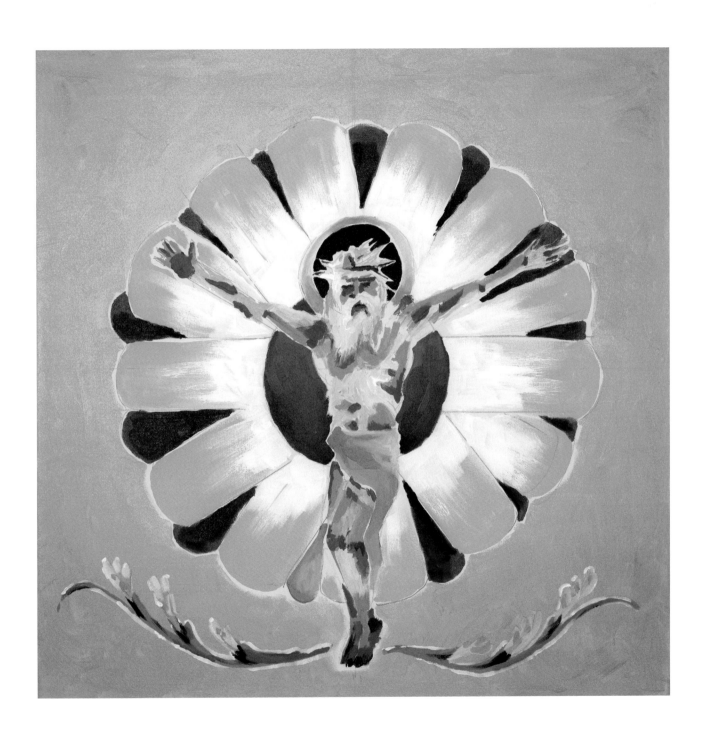

Jason Lee

Jason Lee is an actor, photographer, producer, and writer. He and Chris Pastras are Co-Founders of Stereo skateboards.

I would bottle the first time I skateboarded with Mark, and every time after that. I was 18, Mark 20. It was like not only meeting but also playing music with Bob Dylan. The way we see Donovan's obvious delight in [the documentary] *Don't Look Back* when he's hanging out with Dylan in London, that was much like me that first night skating with Mark. A night that would change my life. His energy is infectious, and his spontaneity a constant and necessary reminder to always be open to all things. He's taught us all the importance of creating your own path. That first night we skated together solidified in me a desire to not only have fun skateboarding but to never take it too seriously.

-

Q — Was there ever a mission he refused to follow you on?
A — No.

-

If we were a classic movie duo I'd say The Bandit and Cledus from *Smokey and the Bandit*, Mark being The Bandit and me being his sidekick Cledus.

-

Sitting in his garage in Huntington Beach one night, chatting, Mark was talking very seriously about the importance of art in life, and in skateboarding. He was being really insightful and spoke in a uniquely articulate, very relaxed manner. His thoughts and approach were, and still are, ahead of the curve. The conversation and his passion behind what he was saying had a big impact on me.

-

I think it's safe to say that most know a lot about Mark, but 2 things that impressed me in particular when we lived together

was his love of music and films. He listened to everything from Beethoven to old country to Public Enemy, and watched films like *Paris, Texas,* which at the time would never have been on my radar. I hadn't known skaters that were so tapped into such a diverse blend of music and films. Especially at the young age he was. And it was those things that inspired so many of us. He was undoubtedly the bar.

-

Finding myself came later, in a more complete way, anyway. But it was certainly Mark who opened my mind up to things that I may not otherwise have been exposed to, which would help direct my future skateboarding and creative endeavors.

-

I think Mark found himself before I met him, when he was 20. But with Blind and his *Video Days,* I could see in him a big push to want to define something perhaps a bit bigger, more fulfilled creatively. Before Blind, while still very much having his finger on a creative pulse, he was skating for someone else's company. But with Blind, it was his own creation. And he pushed to make it really mean something, I think.

-

Regardless of age, there's always some degree or another of struggle, and we contend with insecurities and uncertainties at every age. But as you get older you tend to let things go, which allows for more focus, which ultimately allows for more freedom; a more purposeful freedom.

-

Q — What still drives you nuts?
A — Not much does.

FRICTION – A GOOD THING
FREEDOM – A GOOD THING
FUTURE – A GOOD THING

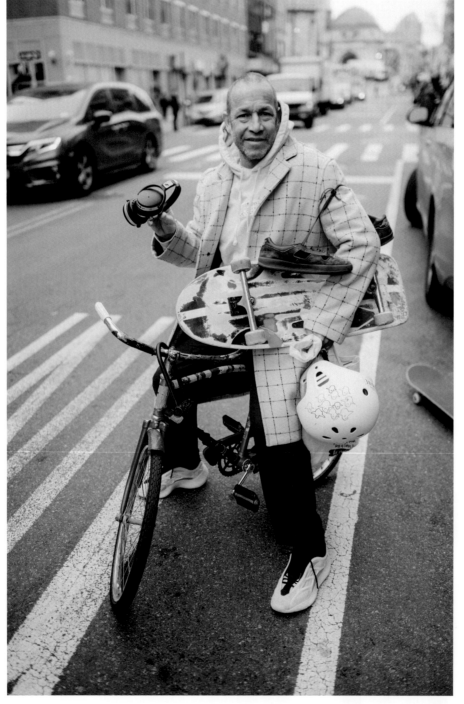

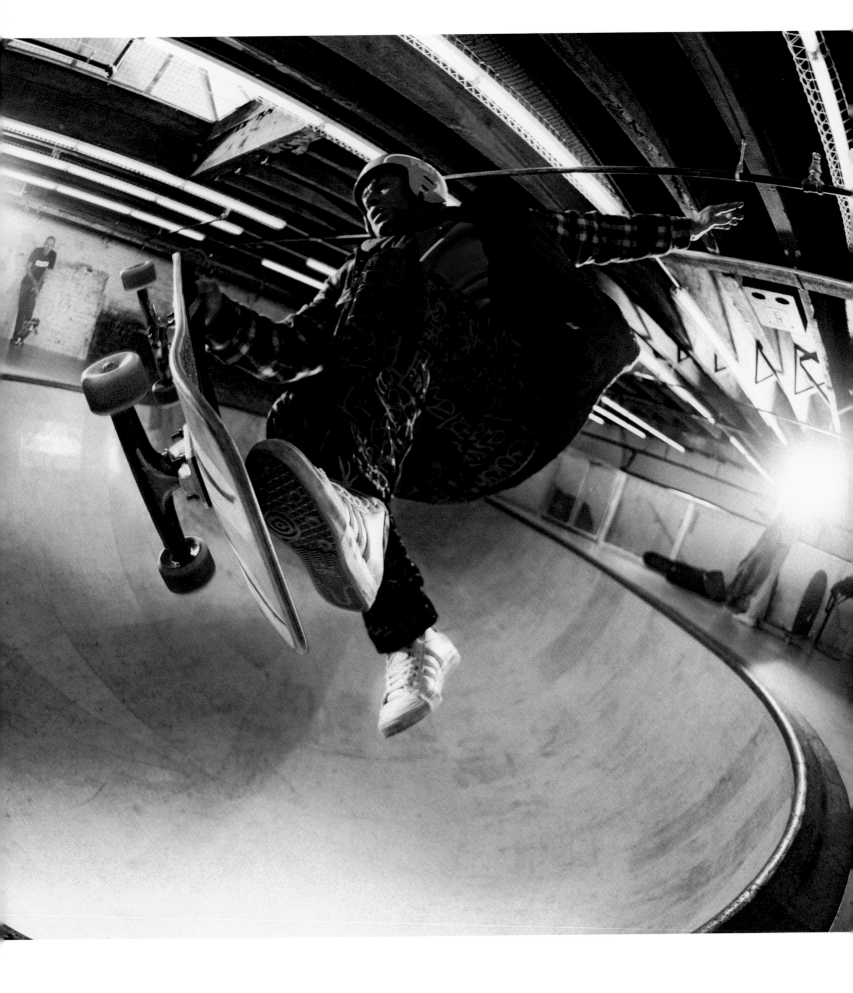

KATHERINE OVERGAARD

Overgaard is Gallery Director at Franklin Parrasch. Mr. Parrasch has been working with Mark Gonzales for almost 2 decades.

L — Do you remember the first time you met Mark?

K — I'm sure it was in a flash on 57th Street where this gallery [Franklin Parrasch] used to be located, and it would have been in 2010, maybe 2011. For a period of time he would ride his roller skates—I don't even think they were rollerblades, they were actual roller skates. Ride them from his place Downtown, on Chrystie Street I believe, to Uptown, and go to the Met or the Whitney when it was on Madison Avenue. He walked in here wearing just socks, his skates thrown over his shoulder, he sat down and visited with us for like 6 minutes. Then I think he put his skates on in the middle of the gallery, and skated backward to the elevator bank. And that was it.

L — Did he seem approachable because of this?

K — To me, the time when he feels the most approachable is when I'm in his space, if I go to his studio. That's the moment where I feel I can communicate the most clearly with him, when he lets me do that. But he can be a complicated person to communicate with.

L — In what way?

K — To call it a childlike instinct is not totally accurate but it's almost like the need to be businesslike, or the ability to address businesslike things can be difficult with him, maybe he doesn't really wanna give those things that much space. It's not really part of the world that he is building for himself. He can be very serious and very business-like for sure.

L — So you were saying that Mark isn't afraid of creating some friction.

K — Yes, working here I've read his artistic practice as an extension of his practice as a skateboarder, it's all part of the same production for him, I think. And some of the challenging language that he uses or the challenging imagery he works with has everything to do with this concept you brought, that there is no freedom without friction, and it can be very provocative and it can be offensive. But it's true to Mark, I think. He is very layered, and if you can get to the point where you're engaging with him and vibing with one another, there's a lot more to be seen and learned about his perspective than he necessarily allows. But I think in his skating he can be very transparent about himself, and sometimes in his art as well. His self is clearly laid out for us to see. There's a reality to what he's creating that maybe some people would shy away from.

L — Yes. Also in layers like the spelling?

K — It's totally on purpose I think. But if you accustom yourself to approach language in a way where the line between intentional and unintentional is a blurry one, and you've been writing that way through so many years of zines, paintings, poems, and other types of text-based work.... It's always hard to find that line between artifice and reality. Mark also pushes these types of boundaries in relationship with street skating and thinking about urban architecture as a skatepark. He shifts that utility to what he wants to get out of it, and I think that's what he does with language too.

L — New York is a stage. And I can imagine if you're skating in public, that line becomes blurred too.

K — I think so, and I get the sense from hearing stories about how he acts on any given day at the skatepark, that sometimes he would want to emphasize one element of his personality or his persona.

L — He's poking the bear.

K — Right, part of the nature of it all. But this is where the dichotomy becomes really blurred and complicated to follow. But Mark is super checked-in.

L — I was thinking about how much he travels and exactly how many people he encounters, just constantly.

K — Right, at the airport, like anywhere.

L — From different cultures, in all the languages, all walks of life, all the time. And, he seems like he must have a hyper-bank of subliminal information in his brain that he just measures things up against.

K — Yeah, I think he plays a lot. Thinking about a scene, and the poetry in that scene. Seeing the poetry. You'll feel like you're following one narrative, and it just clicks onto another track very quickly. "Wow." It is very easy to take a glance at Mark at the surface, see how he approaches life and just call it ADD or whatever and, who knows, clinically that may be true, I don't know. But I think it's all connected and it's all part of his way of being, processing, and creating a narrative for himself, which he then implicates other people in—with or without their permission, it's very interesting. The community within skate culture is not really replicated elsewhere. People end up connecting really genuinely and quickly through this mutual passion and understanding of, ultimately, movement. But I get the sense that Mark likes to play with that a little.

L — With that immediate connection?

K — Yeah.

L — It's like, you have this intimacy right away so I can mess with you a little bit. Or play with your expectations.

K — Exactly. And you see that in the language also. You know it's this interactive thing that he's doing physically on his board, bumping into this guy on his wheelchair or brushing past security. It's what he's doing when he's writing poems, or making portraits, or whatever it is that he's doing.

L — So what about this show opening tomorrow in Beacon? It's a two person show with Ray Johnson.

K — Yes, Franklin is also a partner in Parts & Labor in Beacon where this show is happening. He and Nicelle Beauchene run that space together, the concept is multi-generational shows. Typically two artists are paired or counterposed, and this show was Franklin's idea, he felt there's a kinship in the bold and straightforwardness of Mark's practice and some of the work that Ray Johnson was doing while he was alive. Johnson was one of the main forces behind what is now called "Mail Art"—the idea of sending packages or letters or postcards to somebody, and there being an ongoing exchange of objects, something he kind of posited as a post-Dada gesture. Mark has been known to make fax art, of course he mails and sends drawings, zines.... There's a direct dialogue between the two, a sense of appropriation which I think reveals itself in an unusual way. There's a mutual spirit of occasionally dark humor between the two also. I think anybody in Mark's sphere should expect the unexpected.

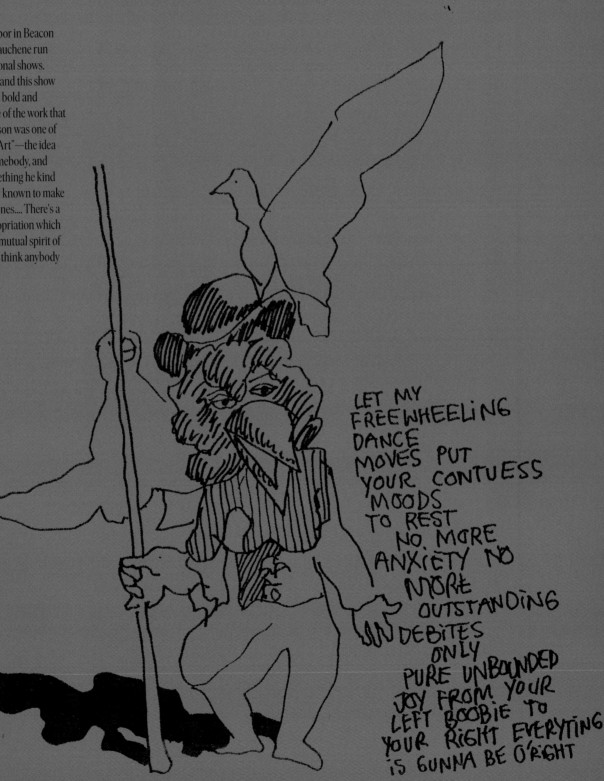

LET MY
FREEWHEELING
DANCE
MOVES PUT
YOUR CONTUESS
MOODS
TO REST
NO MORE
ANXIETY NO
MORE
OUTSTANDING
DEBITES
ONLY
PURE UNBOUNDED
JOY FROM YOUR
LEFT BOOBIE TO
YOUR RIGHT EVERYTING
IS GUNNA BE O'RIGHT

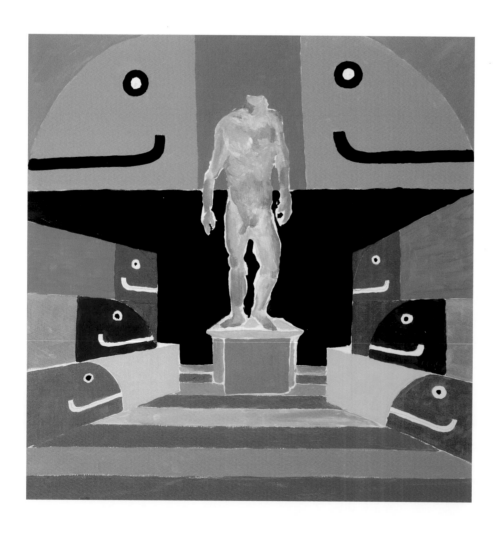

Spike Jonze

Jonze is a filmmaker and photographer based in LA. He also directs skate, music videos and commercials.

L— If you could choose one Mark moment to send in that compilation we've put into space for aliens, which one would it be?

S— One day sometime before Christmas, in New York, I was with Mark and we were about to cross Broadway. The streets were filled with thousands of Christmas shoppers, and we were standing at a crosswalk, waiting for a light to change with probably 30 other people on the curb with us. It was freezing out, and the cars were crawling by in gridlock holiday traffic. I, like everyone else, was zoned out in my own world, thinking about something. Mark slid off the heel of his shoe with one foot, and then flicked the shoe into the street, right under a taxi cab, and the taxi cab slowly ran over his shoe. All these New York City busy people, isolated and separate from each other, laughed at the exact same time at the dry comic absurdity and timing of Mark's strange joke. And suddenly, there was community amongst these 30 people, for this moment. Then the light changed. This is my best description of Mark, probably. I could spend paragraphs trying to describe him, but this moment captures him better than anything else I could write.

L— What was your first meeting, or first significant moment together?

S— I think it was a bowl of spinach stew, Viking-style, that he made us at the Inn by the Carlsbad Skate Park during a blackout. I'd known of him forever, since I was a kid, had always loved him, and he more than exceeded my hopes. He's a great dancer.

L— Most people I speak to have Mark's actual voice imprinted in their minds, when they quote him they often do it in his voice. What's one Mark quote or exchange you had with him, that's stuck with you over the years?

S— One of many Mark lines I remember was when I was doing a commercial for a car company. It was the first time I'd done a big commercial with, like, a real ad agency, and they were probably giving us a million dollars, which was crazy. I thought it would be fun to cast Mark in it, just because I like filming him, and you can kind of film him doing anything, and he's interesting. He was basically supposed to be asleep in a chair during the entire commercial, right up until the end when he wakes up and is supposed to look at this truck like it's cool. So, we get to that part, the camera's all set up, and the people from the car company, and the ad agency, and the production company are all behind the monitors watching what we're shooting. I think they were all already a little skeptical, thinking, "Okay, this kid wants to hire his friend to star in our big-time commercial? I guess we'll trust him." And then, as soon as we roll the camera, Mark opens his eyes. And instead of looking at the car, looks right at me and says: "Spike, I don't want to do this anymore."

L— People like to say "make or break," but life usually isn't that clear. How can you tell what's a risk worth taking, and what isn't?

S— If it's scary, embarrassing and exciting, all at the same time, it's probably worth taking.

L— How strong is Mark Gonzales?

S— Funny you should ask, he is incredibly strong. You can't tell, 'cause he's so wiry, but I've seen him lift a Toyota Corolla.

L— Can you describe what we are looking at here?

S— This is a photo Mark included in one of the many letters he wrote to my Mom.

FRICTION— I DON'T WANNA TALK ABOUT THAT. FREEDOM — I'M A LITTLE SENSITIVE ABOUT THAT. FILM — IT BRINGS ME BACK TO THE 1940S, WHICH IS A VERY PAINFUL TIME FOR ME. I DON'T WANT TO TALK ABOUT THAT ONE, EITHER.

WITH OUT A SKATEBOARD MENTALY i TEACH A KID IN JAPAN TO OLLIE

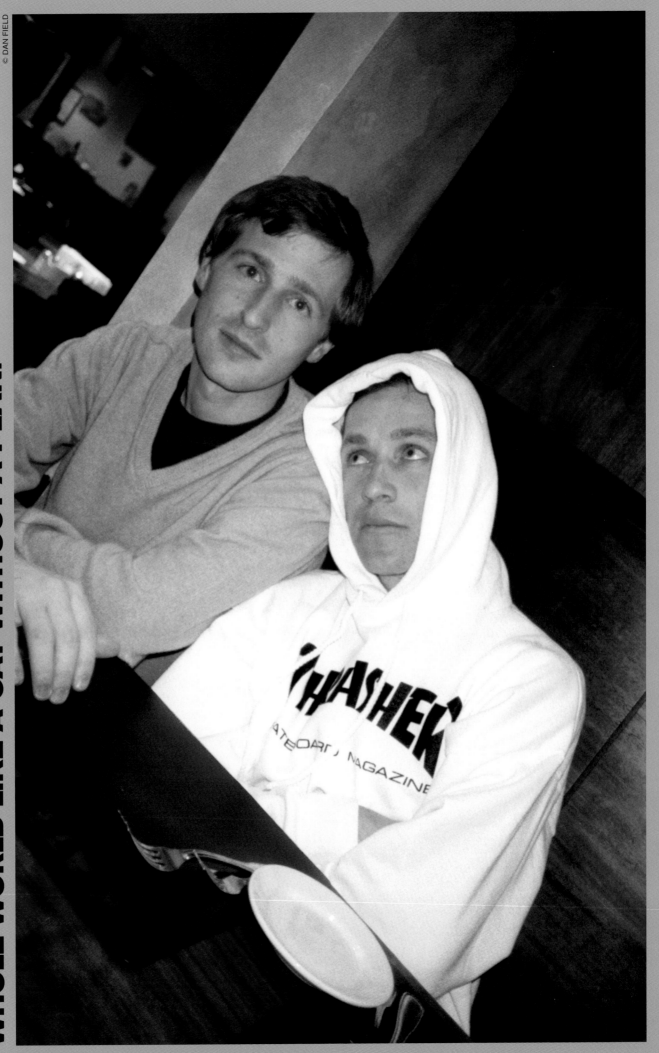

© DAN FIELD

MARK CAUGHT THE KID TOO, MID-AIR. NOT SURE HOW. HE'S QUICK BUT HE'S ALSO STRONG. HE TOOK A FOOT TO HIS FACE BECAUSE THE WAY THE KID WAS COMING DOWN. MARK NEVER PLANNED ANYTHING BUT WHATEVER SITUATION HE GOT INTO, HE WOULD FIND A WAY OUT OF AND LAND ON HIS FEET. WANDERING THE WHOLE WORLD LIKE A CAT WITHOUT A PLAN.

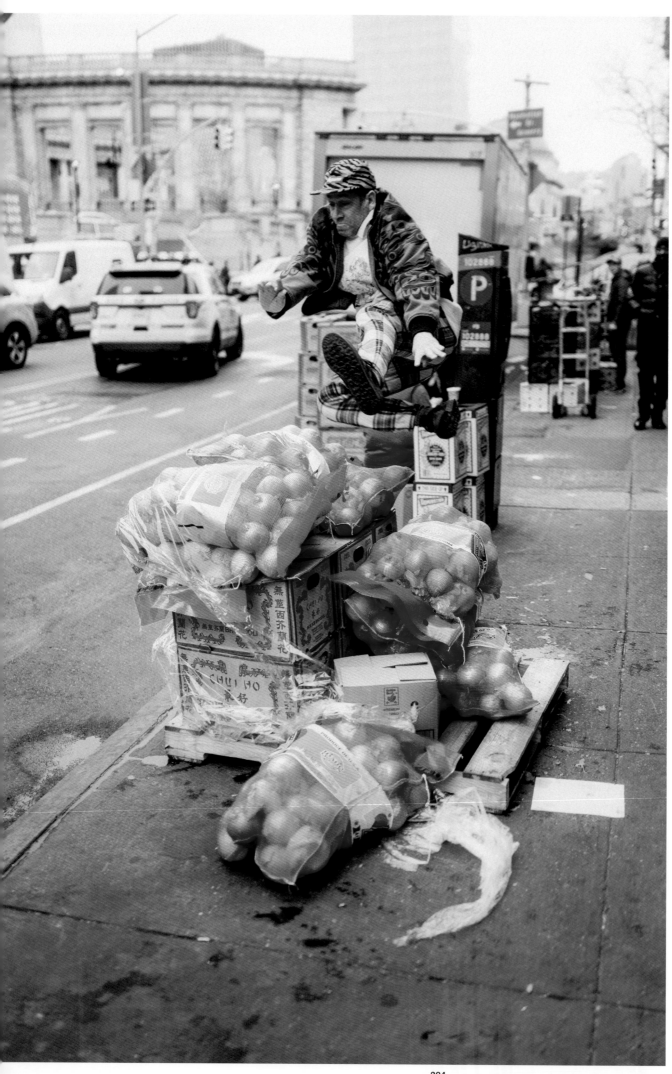

Tommy Guerrero

Tommy Guerrero is a professional skateboarder, musician, and Co-Founder of Real Skateboards with Jim Thiebaud.

Q — You and Mark were innovators together. Would you say you were activists?
A — No, but skating at the time was inherently anti-authority. Skaters have always pushed or railed against the status quo and antiquated rules. I hope this continues.
-

Q — If you are a detail-oriented improviser, Mark is...
A — In the moment.
-

Q — Mark as a musical instrument would be...
A — It hasn't been invented yet.
-

We all fight little battles daily. Often they are quiet and unsung.
-

I found myself when skateboarding found me.
Mark found himself probably the first time he rolled on a board.
-

Freedom of the mind. Letting go of all the trivial BS that might have been of concern in the past.

What still drives me nuts? Greed and willful ignorance. Hateful and violent people.

FRICTION – HEAT, TENSION, DISCOMFORT
FREEDOM – DELUSION, FIGHT, POLITICAL
HERITAGE – CHILDREN, CELEBRATE, HISTORY

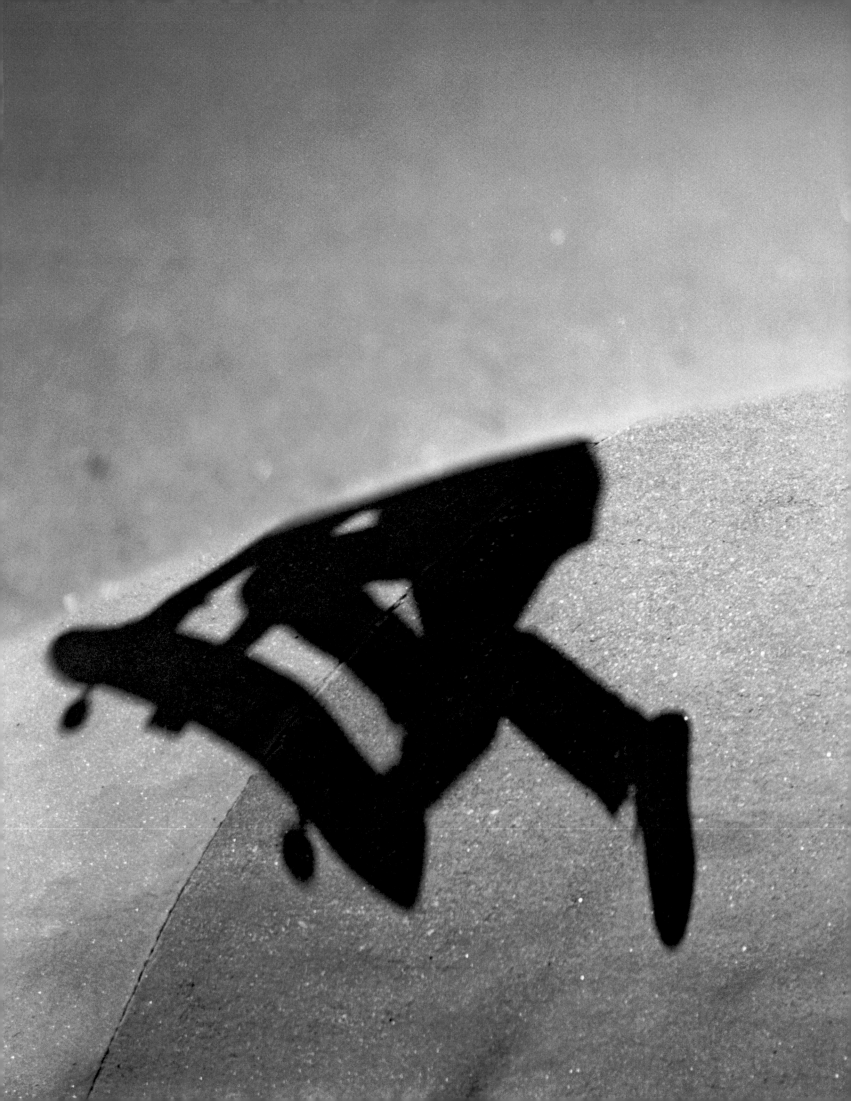

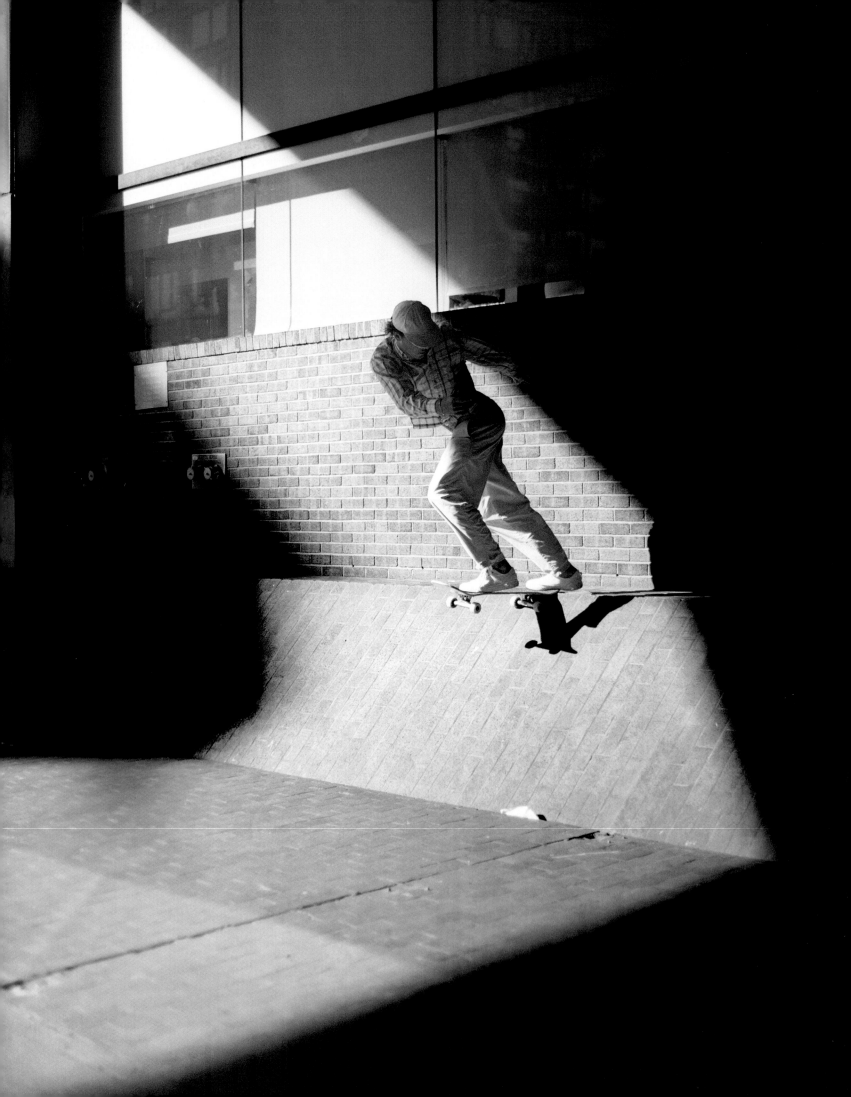

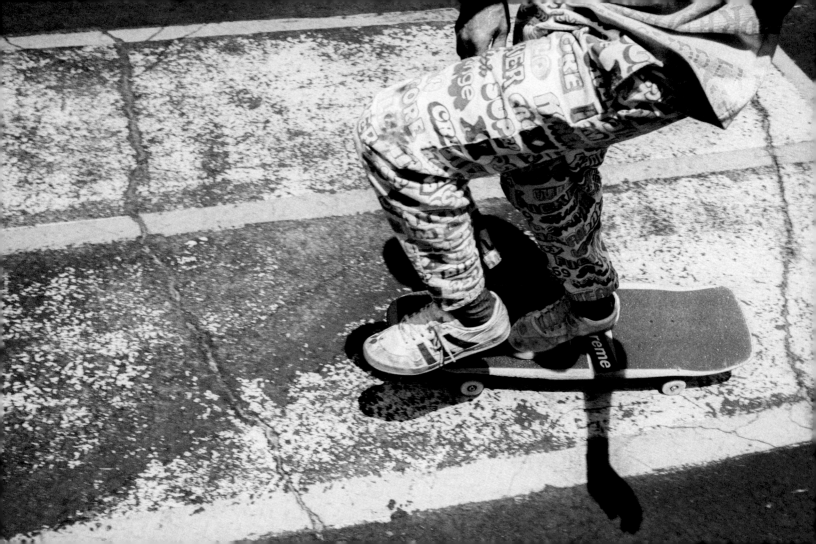

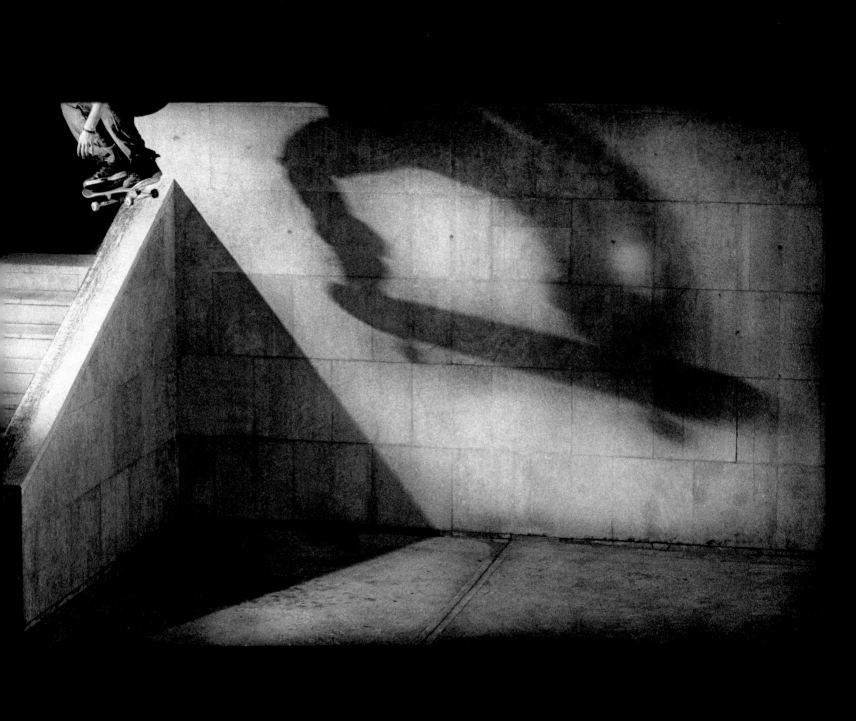

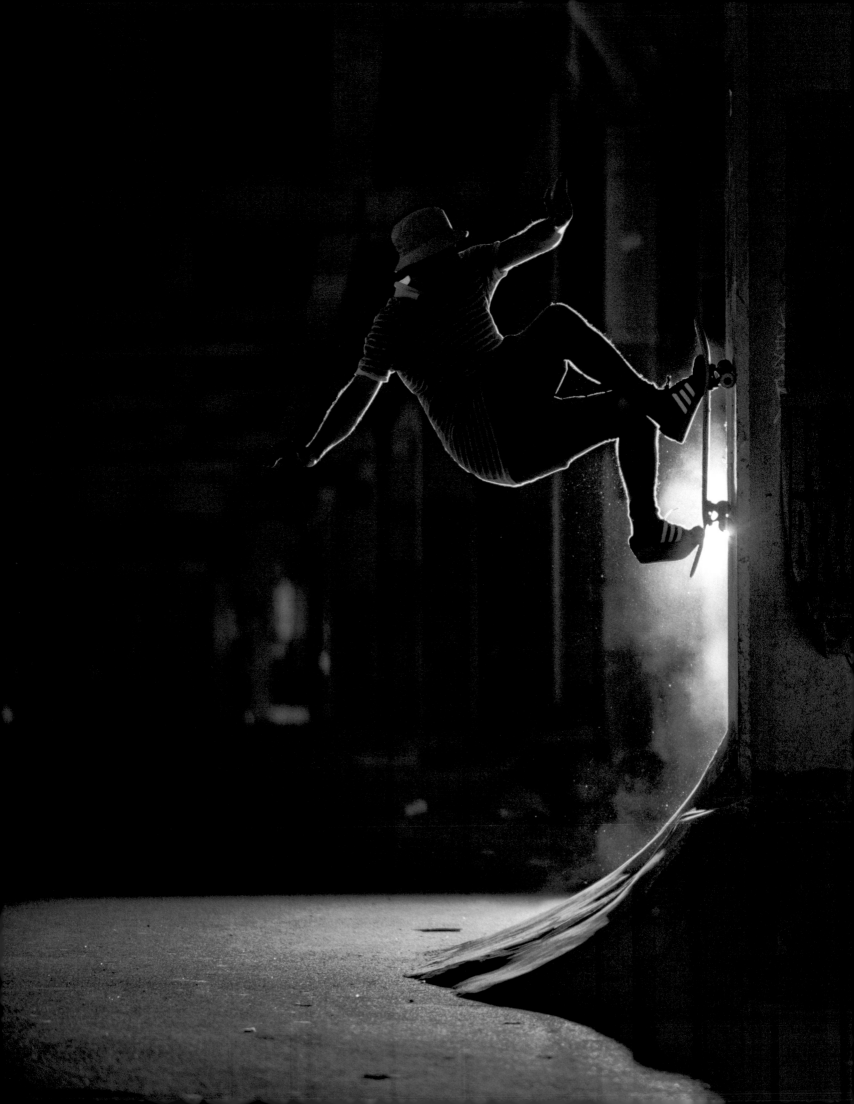

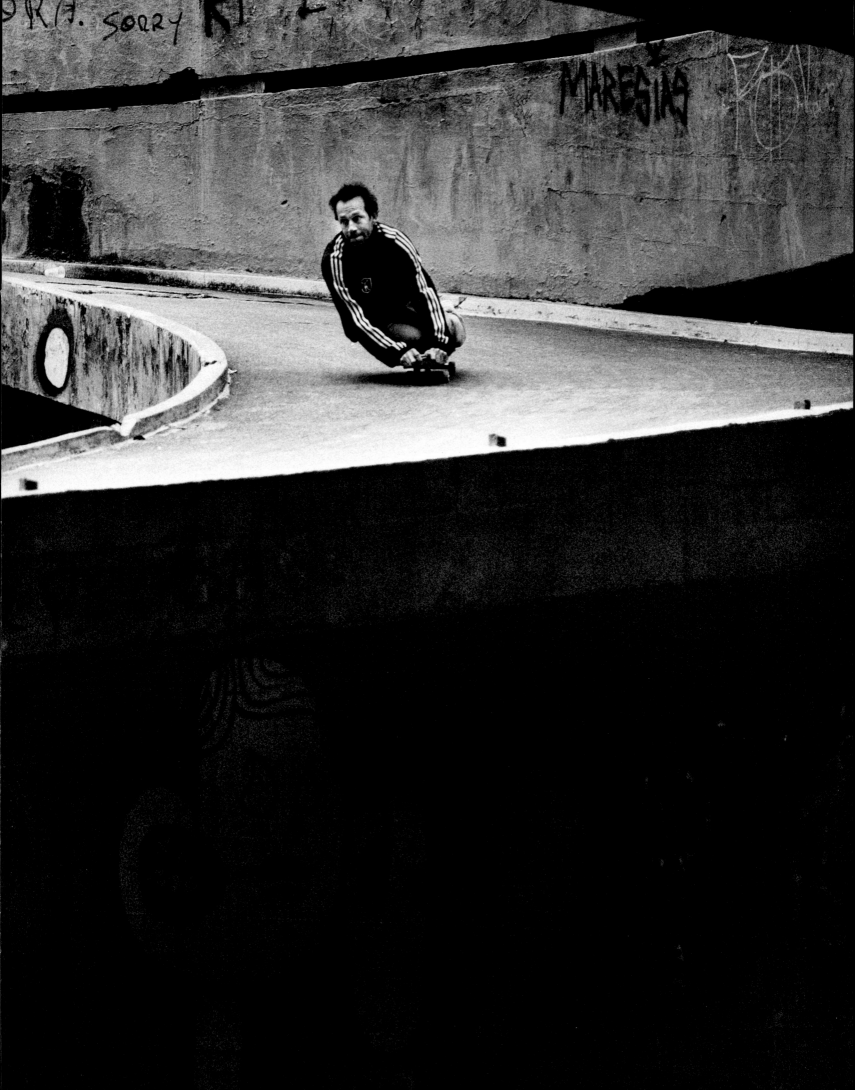

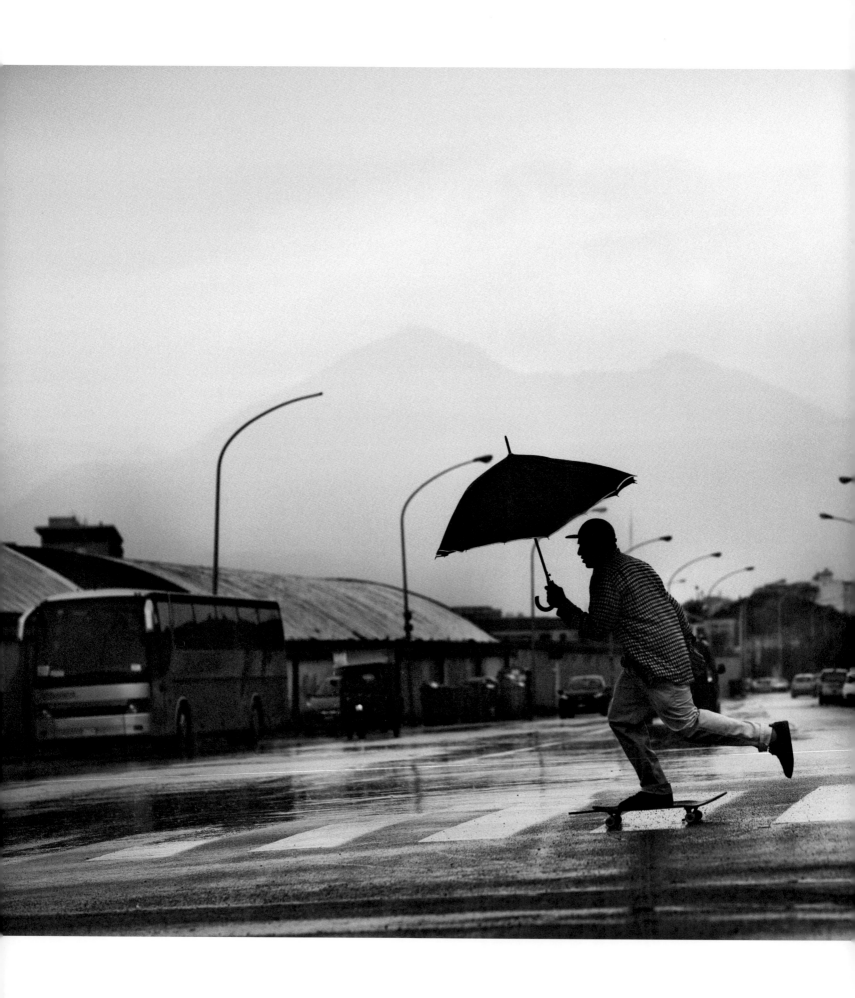

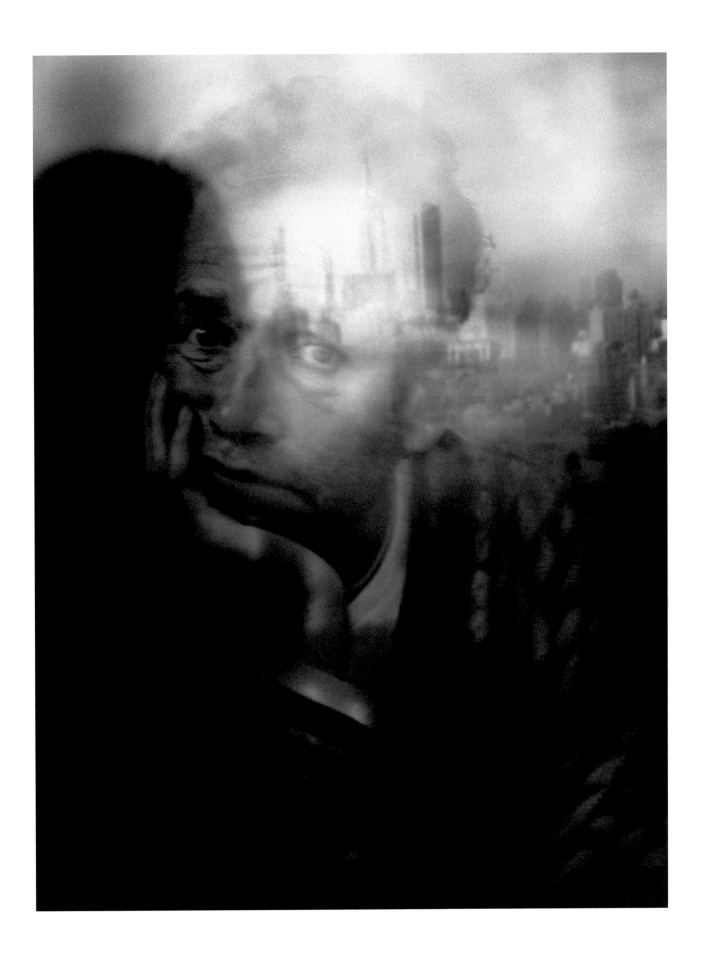

All photographs by Sem Rubio unless otherwise stated.
All artwork and poems by Mark Gonzales.
Artwork and poems courtesy of Franklin Parrasch Gallery,
Chandran Gallery, HVW8 Gallery, and Beyond The Streets.

Art, Poems, and Skateboarding by Mark Gonzales
Created and Photographed by Sem Rubio

CASCADE

Produced by Cascade
Editor: Lou Andrea Savoir
Producer: Julian Dykmans
Art Director and Graphic Designer: Albin Holmqvist
Coordination: Tia Romano Gonzales
External Collaborators: Matt Irving and Ryan Clements
Additional Photography: Benjamin Deberdt, Spike Jonze, Pep Kim, and Skin Phillips
Additional Interviews: Theo Constantinou, Anthony Pappalardo, and Yasha Wallin
All photography by Sem Rubio unless otherwise stated
All interviews by Lou Andrea Savoir unless otherwise stated
Typefaces: Berthold Akzidenz Grotesk, Nimbus Roman No 9, Ivar Display Condensed

Many thanks to Mark, Tia, Ryan, Matt, Yasha Wallin, Gemma Castiblanque, Jorge Angel,
the Parrasch Gallery team, Rachel Sampson and Anna Sinofzik, Göran Söderström of
Letters From Sweden, Adidas, Krooked, Milk Studios NY, and Supreme.